An Introduction to Victorian Painting

AN INTRODUCTION TO
Victorian Painting

Kenneth Bendiner

Yale University Press
New Haven and London

Published with the assistance of the foundation established in memory of F. B. Adams, Jr.

Designed by Nancy Ovedovitz and set in Goudy Old Style type by The Composing Room of Michigan, Inc. Printed in the United States of America by Vail-Ballou Press, Binghamton, New York.

Library of Congress Cataloging in Publication Data

Bendiner, Kenneth, 1947–
 An introduction to Victorian painting.
 "Selected list of books and exhibition catalogues on Victorian art since 1960": p.
 Includes index.
 1. Painting, Victorian—Great Britain. 2. Painting, British. 3. Painting, Modern—19th century—Great Britain.
I. Title.
ND467.5.V52B46 1985 759.2 84-27038
ISBN 0-300-03309-5

2 4 6 8 10 9 7 5 3 1

To Nancy, Ezra, Zachary, and Wanda

Contents

Illustrations

Acknowledgments

I am deeply indebted to Professor Allen Staley for introducing me to the appreciation of Victorian art, and for providing innumerable insights into British painting in his courses at Columbia University. Richard Ormond must also be thanked for the rich material presented in his many publications on Victorian art, and for his assistance in obtaining illustrations. Francis Greenacre and John Halkes were very helpful in my research on S. A. Forbes, which was funded by a travel grant from Boston University. The encouragement of my colleagues, Alice Binion, Fred Licht, and Naomi Miller, and the assistance given by the staffs of the Witt Library, the Frick Art Reference Library, the Fogg Art Library, and the Boston Public Library were vital in the production of this book. The interest and help of Judy Metro of Yale University Press was equally important.

Introduction

Victorian art can be defined simply as British art produced during the reign of Queen Victoria (1837–1901). But this identification of an artistic period with a political period is a convenience, an approximation, rather than an absolute reality. Works similar and directly related to Victorian art can be found decades before and decades after Victoria's reign. Nor was Victorian painting highly dependent upon royal taste or state commissions. Nevertheless, there is some justification for claiming the last two-thirds of the nineteenth century as a separate artistic era. The dates of Victoria's accession and death are by chance also moments of change in British art, and the works of the intervening period display a number of common features.

The beginning of Victoria's reign coincides with a growing tendency toward realism, as demonstrated by the harsh criticism directed against the epic sweep and energy of J. M. W. Turner's romanticism in the 1830s. Painters of smaller scope, of more mundane subjects, and of tighter, less flamboyant styles proliferated at about the same time. Samuel Palmer's career well illustrates the advent of a new sensibility: in the 1830s he turned from mystical evocations of a rural paradise to niggling studies of unspiritualized nature. At the other end of the Victorian age, in the early twentieth century, the Fitzroy Street Group and later the Camden Town Group introduced a new flavor to British painting as French post-impressionism became a major source of inspiration and the dreamy aesthetic symbolism of the late nineteenth century began to disappear. The passing of many eminent and influential Victorian masters at the turn of the century further signaled the end of an era. Frederic Leighton and John Everett Millais died in 1896, Edward Burne-Jones in 1898, James Abbott McNeill Whistler in 1903, and George Frederic Watts in 1904.

Points of transition in British painting thus can be located loosely at the beginning and end of Victoria's reign, and it is possible to identify some consistent features over the intervening seven decades. One can, for example, discern a taste for complexity evident in florid and elaborate contours and an attention to detail that often defies compositional coherence. Senti-

mentality and an interest in charming anecdotal narratives are prevalent, as is an air of earnest moral righteousness and polite decency. The modern social issues of industrial Britain had a profound influence on Victorian painting, motivating not only artists who depicted the problems of the age directly, but also those who sought to escape through the dreamworlds of classicism, medievalism, or orientalism. Finally, Victorian art had a distinctively public nature. Never before in Britain had art been so widely seen and discussed. Hordes of people of all classes attended the annual Royal Academy exhibitions; the popular press reviewed art at length; patronage expanded beyond a circle of educated aristocrats; and artists frequently attained financial success through the sale of engravings to the public at large. The detailed styles, sentimentality, moral tone, and topical and nontopical characteristics of Victorian art can all be read as attempts to appeal to this new mass public.

These generalizations may help to define the coherence of Victorian art, but ultimately they are only half-truths—majority reports that only partially reveal the rich diversity of British painting from 1837 to 1901. For example, major artists such as J. A. M. Whistler and G. F. Watts did not display a taste for complexity and detail. Stanhope Forbes's prosaic fishermen and Albert Moore's dispassionate figures are neither sweet nor anecdotal. There is nothing very moral, earnest, or righteous about Lawrence Alma-Tadema's frolicking ladies in Roman baths. A portrait of a noble stag by Edwin Landseer, or a depiction of an ancient pagan procession by Frederic Leighton, could be viewed as responses to various contemporary social, religious, or environmental problems. But such an interpretation misses the essential meaning, character, and intention of the works. Has one truly understood the core of a Victorian classical subject when one interprets it primarily as an escape from reality? Similarly, public interest or taste is not necessarily of vital importance in the art of an influential painter like Dante Gabriel Rossetti, who rarely exhibited publicly after 1850. Generalizations can enhance our understanding of the unity of Victorian painting, but they remain superficial conclusions unless they are deepened through the lengthy analysis of individual works.

This book seeks to introduce the reader to Victorian painting while avoiding excessive generalizations. The case-study method is employed to achieve those goals. Seven Victorian paintings are examined in detail with varied references to the artists' lives, stylistic developments, critical reactions, political, religious, and social themes, influences, sources, sketches, and related works. Each chapter is devoted to a single picture. Additional painters, larger movements, broad historical changes, and works of other traditions, decades, and countries are considered in specific relation to the individual paintings.

The images are not mere illustrations of events and evolutions. Texts that survey Victorian art already exist, and they provide material that is essential and very useful, outlining basic developments and characteristics of sixty years of British art (see selected bibliography). But such comprehensive studies necessarily treat a major artist in two or three pages, while individual works receive two or

three sentences at most. Minor painters are given little more than a note and are sometimes merely listed. Inevitably, broad conclusions breed freely, without due attention to the enriching contradictions, subtle allusions, and unique features of the works themselves. The present volume does not analyze every significant artist, masterpiece, or historical transition, but was conceived in the belief that an intimate familiarity with a few works of art can reveal the character and issues of Victorian painting with greater depth, meaning, and pleasure than a schematic overview of the subject. The properties of the seven works discussed provide a solid basis for understanding Victorian art as a whole.

Each of the paintings selected for study was completed in a different decade, and the images are presented chronologically, so that historical changes during the course of the Victorian period can be perceived. The seven works also comprise the important subject categories of Victorian art: genre painting and literary subjects, religious and history painting, portraiture, the nude, animal painting, and landscape. These pictures are not necessarily the finest, most innovative, most famous, or most influential works of the era. Instead, they were selected for their capacity to illuminate significant facets of nineteenth-century British art. A few of the works are clichés, archetypal images that have come to lodge permanently in the Western mind despite the hostility of twentieth-century critics. Others are less familiar paintings, previously neglected, or by secondary painters. A work by a minor master can sometimes provide more insights into the attitudes of an epoch than can the creations of a major artist. Each painting serves the purpose of describing important characteristics and developments, but none has been artificially squeezed to fit some preconceived pattern.

Edwin Landseer's *The Old Shepherd's Chief Mourner* (1837) tells much about the meaning of animal painting in Victorian England while inviting discussions of sentimentality, narrative devices, the mythic associations of Scotland, and the portrayal of death in Victorian art. Edward Matthew Ward's *Dr. Johnson in Lord Chesterfield's Ante-Room* (1845) displays many central concerns and tendencies of the 1840s: the yearning for history painting, the role of state patronage in Britain, the unequal distribution of wealth, the hardships of artists, English nationalism, the influence of Hogarth, the mingling of literature and art, the popularity of genre painting, and the fond look backward to a preindustrial age. *The Glacier of Rosenlaui* (1856) by John Brett exemplifies Pre-Raphaelite realism and illuminates the merging of science and art at mid-century, the influence of John Ruskin, the importance of geology, changes in British landscape painting, the meanings of Alpine scenery, and the passionate aspects of objectivity. *The Finding of the Saviour in the Temple* (1860) by William Holman Hunt further defines the character of Pre-Raphaelitism and opens discussions of Victorian religious art, the importance of Protestant sectarian conflicts, the orientalization of biblical imagery, the purported history of Islamic architecture, and typological symbolism. J. A. M. Whistler's *Arrangement in Grey and Black: Portrait of the Painter's Mother* (1871) presents insights into one reaction in the 1870s against realism, the psychological sources of

Whistler's mature style, the changing significance of Velasquez's influence, Whistler's rejection of British portrait traditions, and the oddities of a public icon. *A Fish Sale on a Cornish Beach* (1885) by Stanhope Forbes brings forth such issues as England's dependence upon French realism in the 1880s, antagonism toward the aesthetic movement, the new unsentimentality of British genre painting, the nationalistic and primitive overtones of humble maritime subjects, and the social implications of the growth of art colonies in the late nineteenth century. Frederic Leighton's *Flaming June* (1895) is examined with regard to fin-de-siècle sensibility, contemporary and earlier images of sleep, the taste for ambiguity, the symbolism of life and death, Leighton's reactions to Michelangelo's art, and the rise of classicism in England.

Different art historical approaches are emphasized in different chapters, and each method was chosen to suit the significance of the painting in question. The seven essays are tied together by cross-references and continuing themes, and any one of the Victorian decades cannot be fully appreciated until all the chapters have been read.

The study of Victorian art languished for approximately sixty years after the turn of the present century because historians and the public could find no British artist to compare favorably with Courbet, or Monet, or Cézanne. British nineteenth-century art had many links to France and Germany, and it adhered to the broad development of European art from romanticism to realism to symbolism. But British art had individual qualities, and was not a mere provincial imitation of Continental models. It often diverged from the grand evolution and characteristics of French painting, and this partly explains why British art has been, until recently, unappreciated in the twentieth century. Nineteenth-century art has been prejudiciously studied with the twentieth century in mind. The revolutions of twentieth-century art almost all stem from French art, not English art, and anything that has not contributed to the lauded art of our own time has fallen into disrepute. The un-French achievements of Ford Madox Brown, William Powell Frith, or William Quiller Orchardson seemed irrelevant to significant art historical development. The oedipal antagonism of such influential twentieth-century groups as the Bloomsbury Circle toward their Victorian elders helped make most nineteenth-century British art appear pathetic and laughable. Only Whistler managed to escape censure and neglect. His French associations, combative attitude toward popular British taste, and vocal allegiance to formalist aesthetics saved him. The fact that Whistler had been born in the United States also attracted the appreciation of Americans eager to find a national hero of international fame.

Pioneering reconsideration of Victorian art began on a small scale after the Second World War; the studies of Robin Ironside and John Gere, and Graham Reynolds, were particularly significant. The late 1960s, however, saw numerous new articles, books, and exhibitions of a serious nature dedicated to Victorian art. A selected bibliography of recent literature is included at the end of this volume. The Pre-Raphaelite painters have received the most attention from students,

curators, and historians, for these artists' brilliant colors, fanatic detail, rebellious spirit, and fascinating lives are particularly sensational. But scholars have begun to research other figures, phases, and aspects of Victorian art with equal diligence and enthusiasm. Allen Staley in America, and Richard Ormond and Mary Bennett in England, have been especially important and active Victorianists, but the renewed interest in the field is not limited to a small circle of scholars and their immediate followers.

The resuscitation of Victorian art may be related to 1960s pop art, which bred a sophisticated, half-hateful appreciation of kitsch (and Victorian art at the time certainly was classified in the public mind as kitsch). But the attention given to Victorian art quickly shed any overtones of pop art's sneering, tongue-in-cheek character. Furthermore, pop art and a variety of art movements that followed it turned away from abstraction toward more recognizable imagery, and this general change in taste, which was sometimes antagonistic toward the sacred concepts of modernism, made Victorian painting seem less irrelevant to recent art.

The revival of interest in Victorian art may also be tied to a wider development in art historical studies. Scholars in the 1960s and 1970s began to pay greater attention to subject matter and social context, abandoning their earlier concentration upon stylistic problems. Nineteenth-century French art was reexamined in this light by Theodore Reff, Linda Nochlin, and many others. Meyer Schapiro had taken this approach toward French art decades before, but now it became widespread. The great chain of stylistic development from Courbet and Manet to Picasso and Matisse was no longer the sole focus of nineteenth-century art historians. Art history became cultural history, and many neglected Academic painters of nineteenth-century France began to be studied because they represented their epoch more thoroughly than did a small group of avant-garde artists. In this climate British art was no longer beneath consideration, for it could be as rich in iconographic significance and broad cultural connections as French art.

This volume draws heavily and gratefully upon the work of many Victorianists of the past twenty years. But each of the seven chapters also presents new material, novel perspectives, or original interpretations, and thus the book will be of interest to the specialist as well as to the uninitiated. The student in nineteenth-century art history courses may also use it as a supplement to most of the standard texts, which often neglect British art. The chapters that follow are meant to broaden the reader's comprehension of European art, and to stimulate interest in the very real achievements of Victorian painters.

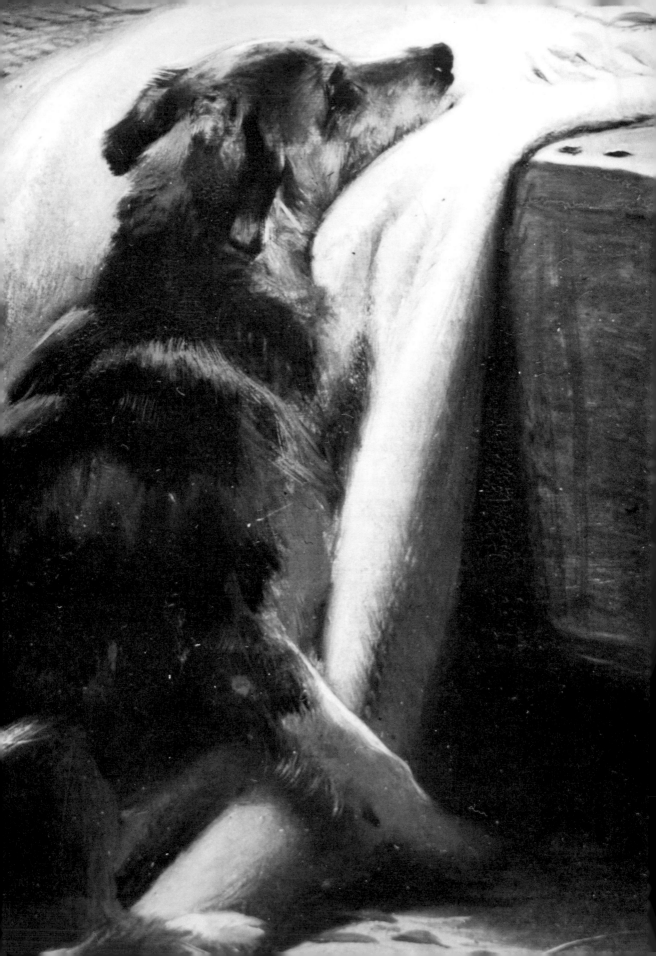

1

Edwin Landseer
(1802–1873)
The Old Shepherd's Chief Mourner

Edwin Landseer's *The Old Shepherd's Chief Mourner* (plate 1) was successfully exhibited at the Royal Academy in 1837, the year of Victoria's accession to the throne.[1] It was later extolled by John Ruskin and reproduced in bas-relief on the memorial to Landseer in St. Paul's Cathedral. This small painting admirably represents the sentiment, romanticism, dramatic powers, and baroque style of the most renowned animal painter in nineteenth-century England.

A poor man's coffin stands in the center of the work, angled into depth, and hugged mournfully by a collie. The dog has pulled down the blanket that serves as a pall, as if seeking warmth in the face of desolation. The light-colored fabric outlines the dark form of the animal and isolates him, heightening his loneliness. The gray and brown colors throughout the picture add to the death scene's somber tone, and the smallness of the dog and coffin in relation to the surrounding space suggests emptiness, loss, and helplessness. The dog's pathetic fidelity to his dead master is made more forceful by the green twigs, which lie scattered on the floor and coffin. These are the tokens of funereal homage left by human mourners who have come and gone.[2] Now only the faithful dog keeps the vigil. The rest of the world seems heartless. The hut and its appurtenances depict the old shepherd's life. The dwelling is barren and tumbledown, a sign of poverty. The rickety chair is empty, an indication of death. On the floor lie a staff and a tam-o'-shanter, attributes of the man's profession and Scottish nationality. On the rude bench at the right rest a Bible and spectacles, references to his piety, age, literacy, and daily observances. And to indicate that this Bible-reading shepherd was not completely dour and abstemious, a ram's horn flask, a container for whiskey, lies on the floor at the left. The scattered placement of the shepherd's belongings on the earthen floor expresses disturbance and obsolescence: a sudden event has upset the proper order, and objects no longer serve their intended purposes. The steadfast appearance of the dog's position contrasts with the floating, ephemeral character of the accessories strewn on the ground. Only faith is eternal. The viewer is an unobserved witness, the *repoussoir* at the left

forming a shield for him and intensifying the privacy of the dog-and-master scene within. The viewer's vantage point, looking down upon the dog, makes the animal seem smaller, more helpless, more pitiful. Yet the viewer is not so high or so distant that the subject becomes remote or beneath his concern. The sense of privacy is necessary, for it illustrates the collie's honesty of emotion: he is not begging for others' attention, nor performing for spectators. We witness a canine soliloquy. The shaft of light illuminates the important forms and sanctifies the despairing solitude. The fluent brushwork activites the scene, dappling the shapes with changing lights and shadows.

Dogs had traditionally been a feature of medieval tombs; they were usually depicted lying at the feet of the human effigy, signifying fidelity, faith in god and an afterlife. Dogs continued to play this role in nineteenth-century art.[3] Landseer's collie at the tomb of his master (and in close proximity to a Bible) may likewise represent religious faith and true belief in everlasting life,[4] and the old shepherd may suggest the Good Shepherd, a figuration of Christ.

Christian subjects and themes appear repeatedly in Landseer's art, and one of his last paintings, *The Baptismal Font* (1872; Coll. H. M. Queen Elizabeth II), is an animal allegory of resurrection and redemption. But the sheep and doves in this late work are placed in a monumentally symmetrical setting, with an ecclesiastical fountain, a representation of Christ, and otherworldly light, so that the abstract ideas overwhelm any sense of naturalism. The *Chief Mourner* is forcefully earth-bound, and symbolism and metaphysics seem of secondary consideration. Emotion and earthly existence are most prominent. The dog, resting his head on the coffin, is personalized, individualized—not made to represent an abstract, universal truth. And the fearful character of that creature does not suggest a shining convic-tion in a joyful hereafter, but a doleful recognition of the loss of love in the here and now. The painting deals with earthly friendship and the pain of death for those who survive. Landseer's painting is a Lamentation translated into pet-and-master terms. As in images of the Virgin weeping over the dead Christ, resurrection is not denied, but is of less concern than the appeal to common human experiences of woe and sympathy.

Landseer's picture is not only a presentation of familiar human sentiment but also a glowing depiction of Scottish life and customs, a portrait of the artist's favorite country. Scottish subjects had become the staple of Landseer's art after his first visit to the Highlands in 1824. The staghunt, mountains, poachers, fauna, and picturesque costumes, as well as the humble way of life, attracted him. In selecting Scotland as a setting and subject Landseer was following a romantic tradition, for Scotland had stimulated artistic imaginations throughout Europe in the late eighteenth and early nineteenth centuries. James Macpherson's fake Nordic epic, *Ossian*, especially had stirred enthusiasm, and artists in France, Italy, England and elsewhere painted the poem's northern Homeric characters amid dense mists and barren crags. *Ossian* became the Scottish equivalent of Classical mythology, and Scotland long continued to be associated in men's minds with a

world of chthonic simplicity and dark nature.[5] Even at mid-century, with rail-roads, highways, hotels, factories and tourists in full evidence, the German art historian Dr. Gustav Waagen on a tour of Scotland was vividly reminded of Macpherson's work.[6] For most of the nineteenth century, Europe (and England as well) tended to forget or to ignore the modern Scotland of rationalist philosophers, scientific achievements, industries, great universities, and cities decked with clas-sical architecture. The fast-disappearing nation of rude existence, outlaws, color-ful tribes, and quaint customs remained the constant image.

In Scotland Dr. Waagen also recalled Sir Walter Scott's historical novels, which even more than *Ossian* helped foster this vision of a primitive land, adven-turously medieval and appealingly rudimentary.[7] Scott's *Lady of the Lake* (1810) is held responsible for great increases in Highlands tourism. Many of Landseer's works of the 1820s and 1830s evoke the force, excitement, and romantic histor-icism of Scott's writings, and in fact a number of his paintings were directly inspired by the novelist's works.[8] Landseer visited Scott on his first tour of Scotland and painted his portrait on several occasions.[9] The *Old Shepherd's Chief Mourner* is not based on any episode from Scott's writings, but its setting alone links it to the author and gives the work a glow of romantic distance, an attractive atmosphere of honest folk and the good old days. Scotland and Scott were insep-arable, and the writer's intimate scenes of humble life were appreciated as much as his swashbuckling narratives and humanized interpretations of high political life. The Scottish subject gives the *Chief Mourner* an archaic authority, an association with the ancestral roots of British culture.

Landseer had been preceded and influenced by David Wilkie in the depiction of Scottish life. In the first two decades of the century Wilkie achieved astounding success with quaint genre scenes of his homeland in the North[10] (fig. 1). The small scale, subdued approach, humble setting, and dark and detailed style of *The Old Shepherd's Chief Mourner* distinctly recall Wilkie's popular works. Wilkie revolu-tionized genre painting in Britain, adding sweet sentiment to the Dutch peasant tradition and treating humble folk with a refreshing honesty and lack of didac-ticism. Wilkie's imitators and followers multiplied as the century progressed. Even J. M. W. Turner sought to rival the Scottish painter, as we can see from the *Blacksmith's Shop* (1807; Tate Gallery, London).[11] Scott's popularity arose at the same time as Wilkie's, and both produced a view of Scotland that was charmingly old-fashioned and unsophisticated. Wilkie based his style on that of the Little Dutch Masters and was dubbed the Scottish Teniers. At the same time, British collectors were buying in large numbers paintings by the seventeenth-century Dutch painters whom Wilkie emulated.[12] This taste reveals not merely one of the reasons for Wilkie's success, but also a general movement away from Sir Joshua Reynolds's high-minded teachings, away from ideal generalizations, the heroic, the monumental, the pompous, and the serious. The Little Dutch Masters— Teniers, Ostade, Terborch, Dou, van Mieris, and the rest—represented realism, honest truth, polished detail, and the appeal of the humble. The taste suggests a

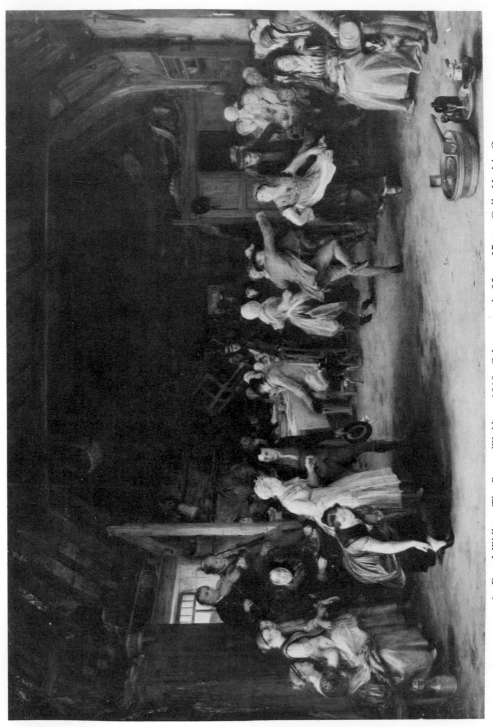

1. David Wilkie, *The Penny Wedding*. 1818. Oil on panel, 25 × 37 in. Coll. H. M. Queen Elizabeth II. Copyright reserved.

broadened social interest, although to see democratic sympathies in this tendency of British collectors is probably wrong. The peasants in the Dutch images and in Wilkie's work are, for the most part, neither aggressive, politically active, or socially discontented. In the Dutch paintings they are often vulgar and stupid; in Wilkie's pictures they are usually polite and wholesome.[13] Neither art celebrates the lower orders of society in a way that would make them seem as threatening to the English ruling class as the sansculottes had been during the French Revolution. Wilkie's common people appear amusing or sweet. Landseer followed Wilkie's path, and just as Wilkie's paintings depict the festivals, rituals, and pleasures of Scottish culture, so too the *Chief Mourner* portrays an anonymous rite of passage in the Highlands.

Landseer's style in this work is also similar to Wilkie's, painted as it is with small strokes on a dark ground, baroque diagonals, shadowy corners, a deep foreground, and a detailed rendering of still-life objects. In such earlier works by Landseer as *The Hunting of Chevy Chase,* (1826; Birmingham City Art Gallery) Rubens's influence, monumentality, and dashing bravura are paramount.[14] But in the *Chief Mourner* the manner of Wilkie and Teniers comes to the fore. Still, Landseer never equaled or attempted to equal those artists' delicate glazes, fragile highlights, and luminous shadows. He was always more painterly and powerful in brushwork, and in most cases the tendency toward realism never led him to allow the replication of individual textures to dominate pictorial unity. Thus the dog's fur in the *Chief Mourner,* though painted with care and a respect for verisimilitude, is composed of brush strokes basically the same size and shape as those found throughout the painting.

The *Chief Mourner* is linked to other cottage interiors by Landseer and may specifically be a response to *A Highland Breakfast* of 1834 (fig. 2). The earlier work depicts birth, nourishment, life, warmth, and close family ties. A mother nurses her infant while dogs feed at a tub and suckle the young; a fire is lit, rich daylight fills the chamber, and animal and human life reflect each other. The whole interior is similar to that of the *Chief Mourner,* but the *Chief Mourner* deals with death, not life. The draped cradle has become the draped coffin in the later picture. The *Chief Mourner* does not require *A Highland Breakfast* to make its meanings clear, and it was not devised as part of a definite series of works illustrating the stages of life. On the other hand, the *Chief Mourner* does not proclaim itself a total narrative, complete from beginning to end. It looks forward to the popular Victorian "problem pictures" of the later nineteenth century, open-ended story paintings in which the viewer is forced to create his own explanation of the subject.[15] These "audience-participation" images reveal the democratizing spirit of the Victorian art world. In the *Chief Mourner,* Landseer implied a longer tale that allows the viewer to imagine further details and events. The *Chief Mourner* leaves out almost as much as it tells making the picture a tantalizing puzzle, for the narrative is not drawn from religious history, or a literary work, or a ballad, the entirety of which is already known. Nor is it an undramatic scene depicting some

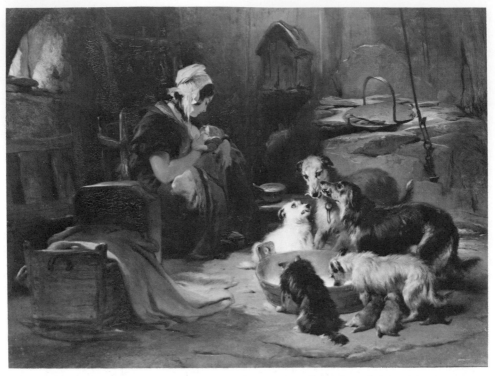

2. Edwin Landseer, A *Highland Breakfast*. 1834. Oil on panel, 20 × 26 in.
Victoria and Albert Museum, London.

common occupation with a familiar result. What will happen to the dog? Had the
shepherd no kin? Of what did he die? Did he live alone? Who were the other
mourners? And the questions do not end there.

Many of Landseer's other works are also problem pictures. In *Suspense* (1834)
(fig. 3), for example, the open-endedness of the narrative is especially notable,
and the viewer must guess what is happening behind the door, where the blood-
spattered feather came from, whose gauntlets lie on the table, and what the dog
will do. Landseer played with his audience, and in such works it is as if we were
looking at the single extant image from a lost cycle by Hogarth, with the connec-
tive details left hanging in midair. The incompleteness heightens the awareness of
time, of one moment or event as but a fraction of an endless stream. Even a picture
of the finality of death leads one to speculate on causes and ramifications and
things to come.

When the *Chief Mourner* was engraved by B. P. Gibbon in 1838, it was paired
with an engraving after an earlier work by Landseer, *The Poor Dog* (1829, fig. 4).
That painting presents a collie mournfully gazing at the freshly cut sods on his
master's grave and was obviously the seed from which the *Chief Mourner* grew. The
unfinished inscription on the tombstone in *The Poor Dog* illustrates the recent date

of the burial and adds a typical note of narrative incompleteness. As in the *Chief Mourner*, the unseen anonymous dead man was a shepherd, for the picture was also called *The Shepherd's Grave*.[16] The white-steepled church in the left distance of *The Poor Dog* gives the same sort of religious tinge and hints of resurrection as does the Bible in the later painting, and the dim light of the landscape matches the somber tonality of the *Chief Mourner's* interior. In both works people have come and gone, and a dog remains the solitary figure, a more loyal substitute for human mourners. The open landscape of *The Poor Dog* creates a more despairing picture of the animal's loneliness, but the room and its accessories in the *Chief Mourner* tell more about the dead man, and the coffin gives the protagonist something more tangible to contemplate. The hugging posture of the dog in the *Chief Mourner* speaks more eloquently of passionate attachment to the dead master. The dog in the earlier painting, while certainly sad-eyed, might be touched more by pity than a lover's sorrow. The title of the picture of 1829 (as it appeared in the Royal Academy exhibition catalogue of the year) is significant. *The Poor Dog* identifies the dog, rather than the shepherd, as the being who deserves our sympathies. Although we know more about the deceased in the *Chief Mourner*, the pathos of the image still largely adheres to the beast. The death itself is not tragic or pitiful.

3. Edwin Landseer, *Suspense*. 1834. Oil on panel, 27½ × 35¾ in. Victoria and Albert Museum, London.

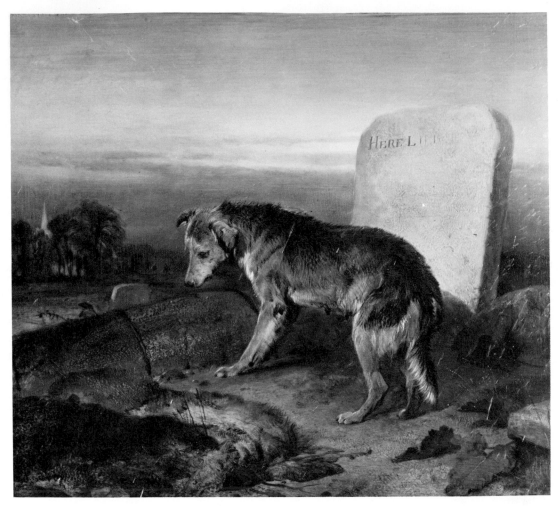

4. Edwin Landseer, *The Poor Dog.* 1829. Oil on panel, 12½ × 14½ in.
Coll. Mark Birley.

Only the effects of that death are meaningful. This peculiar vision of death, in which attention concentrates upon those who remain, is a trend notable in sepulchral monuments from the mid-eighteenth century onward. Spouses, children, relatives, friends, or beneficiaries weep, while the dead stay hidden from view in sarcophagi or urns.[17] A typical example, contemporary with Landseer's work, is William Behnes' monument to Mrs. Charlotte Botfield (died 1825) in All Saints' Church, Norton, Northamptonshire. This kind of memorial depicts neither the eternal life of the soul nor the complementary decay of the mortal shell, but instead refers to immortality rather materialistically, as a quality residing solely in the memories of those still alive on earth.

The dog as vigilant caretaker of the dead appears in other works by Landseer,

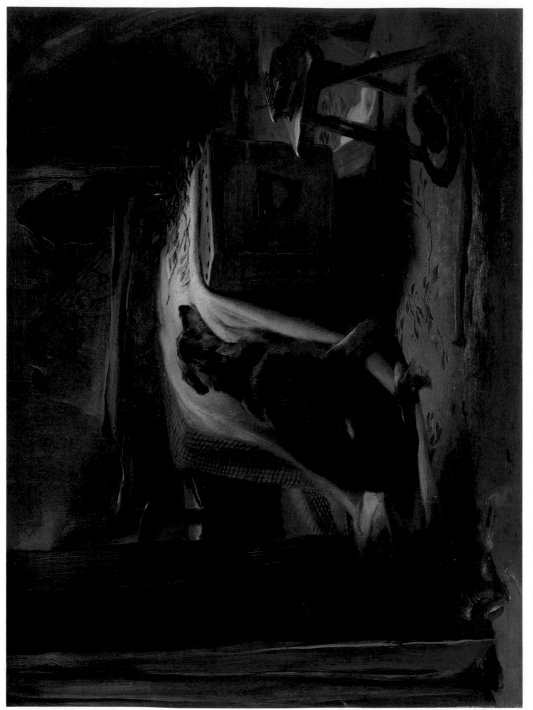

Plate 1. Edwin Landseer, *The Old Shepherd's Chief Mourner*. 1837. Oil on panel, 18 × 24 in. Victoria and Albert Museum, London.

sometimes with the corpse itself, rather than grave or coffin (for example, *Attachment*, 1829, private collection).[18] The entire genre is an elaboration of the image of dog as savior and helpmate, which appeared earlier in Landseer's oeuvre and is most forcefully represented by *Alpine Mastiffs Reanimating a Distressed Traveller* (1820, fig. 5). There, vigorous Saint Bernards revive an injured man in a desolate mountain pass, digging the body out of the snow, warming the limbs, carrying brandy, and howling for additional rescuers. In the *Chief Mourner* the hopelessness of death is brought home by the dog, the now helpless helper, the savior who cannot save.

The dog in the *Chief Mourner* acts and feels the way humans act and feel: the dog is a man in furry clothes, which is true of the majority of Landseer's animals. More than any other artist, he humanized the animal world, so that wild as well as domesticated animals seem to require personal names, for they are not just undifferentiated members of a species. They appear to experience the same suffering, love, joy, desperation, annoyance, curiosity, jealousy, social problems, political concerns, and goals as humankind. Landseer carried animal anthropomorphism to its most extreme in his deliberately comical canvases, where animals dress as

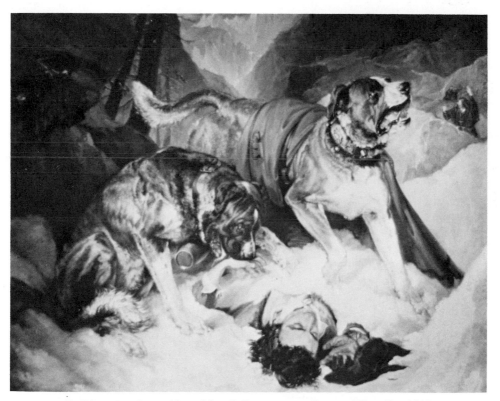

5. Edwin Landseer, *Alpine Mastiffs Reanimating a Distressed Traveller*. 1820. Oil on canvas, 74 × 93 in. The Warner Collection of Gulf States Paper Corporation, Tuscaloosa, Alabama.

men—even sporting hats, spectacles, and pipes—and make human gestures, handle human instruments, and participate in human institutions (fig. 6). The whole effort seems childish to the modern viewer, but these whimsical confections often possess additional levels of subtle humor and all manner of social, historical, and political allusion; if nothing else, they illustrate a deep interest in blurring distinctions between man and beast. Humanoid animals, except for unsympathetic monkeys who satirize the ways of man, were unknown in Western art before the eighteenth century. Veronese painted many charming and animated dogs. Rubens's horses often possess extravagant fury, and Leonardo's drawings reveal a keen observation of animal behavior, but in no case do we see a beast with human personality, feeling, and sensitivity.[19]

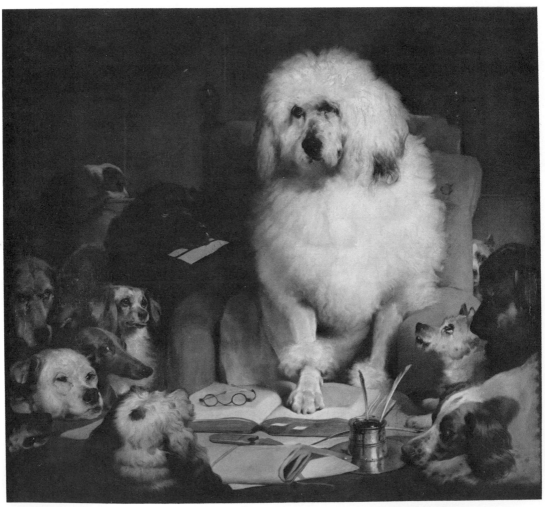

6. Edwin Landseer, *Laying Down the Law*. 1840. Oil on canvas, 47½ × 51½ in. Devonshire Collections, Chatsworth. Reproduced by permission of the Chatsworth Settlement Trustees.

The humanity of the collie in the *Chief Mourner* has little connection to the traditions of sporting art. Paintings of the hunt usually deal with themes of seignorial privilege, human prowess, and man's mastery over brute nature, all unrelated to those of the *Chief Mourner*. The motif of the dog with its dead quarry appears often in sporting pictures, but the *Chief Mourner* can be seen as a pointed reversal of that subject from the hunt. The dog is not a proud victor, standing atop his prey, but a doleful victim, overwhelmed by death. The psychology and sentiment, as well as the reversal of theme, differentiate Landseer's work from images of the chase.

Humanization was not prominent in British animal painting prior to Landseer, The animal pictures of George Stubbs in the eighteenth century remain classically remote, even when they depict the terrifying savagery of lions attacking horses. Perfectly balanced geometrical forms and a cool, polished handling of paint tend to dampen emotional fervor. Stubbs's images show some interest in animal psychology and a great deal of interest in the sublime but have little to do with empathy or a human conception of animal life.[20] Sawrey Gilpin's productions from the late eighteenth and early nineteenth centuries are closer to Landseer's. The quivering sensitivity of *Horses in a Thunderstorm* (fig. 7), for example, invites human involvement with the fears and fate of the creatures. And in his painted illustrations of the talking horses from *Gulliver's Travels* (Yale Center for British Art, New Haven), Gilpin gave a truly human quality to dumb beasts. The Gulliver pictures and the *Election of Darius* (in which neighing horses select the Persian monarch), however, were rather desperate attempts to make animal painting answer Sir Joshua Reynolds's demands for noble history painting. Gilpin seems to have been more concerned with aggrandizing his specialization in horse painting than in revealing the humanlike heart and mind of the animal kingdom.[21]

In the early years of the nineteenth century James Ward pumped emotional power into British animal painting, enlivening horses, bulls, and other creatures with traits of psychological intensity (fig. 8). But in most instances the emotions displayed by Ward's animals are ferocity and terror. The extravagant pain, wildness, and savagery of works such as Landseer's *Deer and Deerhounds in a Mountain Torrent* (1833) (fig. 9) follow the direction of Ward's art, but even here the viewer pities the tortured stag, caught in roaring rapids and beset by dogs. Ward's views of violent nature do not produce the same reaction.[22]

Landseer was influenced in various ways by Rubens, Paul de Vos, Frans Synders, and other seventeenth-century animal painters, but William Hogarth was his most important source of inspiration with regard to anthropomorphism (and to humor as well).[23] Hogarth's famous self-portrait of 1745 (fig. 10) places Trump the pug in the foreground, while the artist himself remains a mere painting, less substantial and less prominent. Hogarth's pet dog takes over the artist's personality, possessing stubbornness, cockiness, pride, honesty, intelligence, wit, and a no-nonsense frame of mind. The animal is the same as the man, and demands our attention as if he were indeed a fellow human.[24] Landseer consciously echoed Hogarth's *Self-*

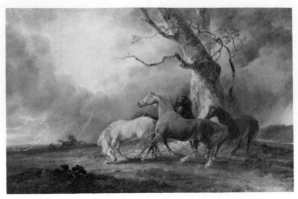

7. Sawrey Gilpin, *Horses in a Thunderstorm*. 1798. Oil on canvas, 33 × 49 in. Royal Academy of Arts, London.

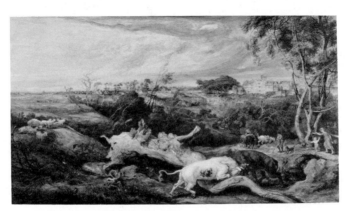

8. James Ward, *Bulls Fighting*. 1800. Oil on Canvas, 51¾ × 89½ in. Victoria and Albert Museum, London.

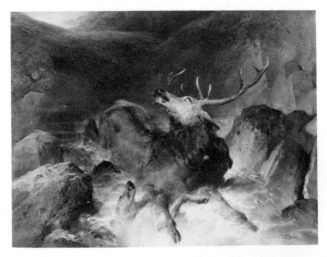

9. Edwin Landseer, *Deer and Deerhounds in a Mountain Torrent*. 1833. Oil on panel, 27½ × 35½ in. Tate Gallery, London.

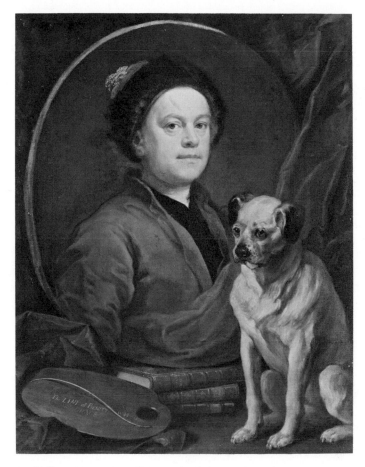

10. William Hogarth, *Self-Portrait with Pug*. 1745. Oil on canvas, 35½ × 27½ in. Tate Gallery, London.

Portrait in *Mustard, The Son of Pepper* (1836, fig. 11).[25] There the terrier Mustard, which was given to Sir Francis Chantrey by Sir Walter Scott (and named after the canine character in Scott's *Guy Mannering*), reclines alertly in Chantrey's studio amid the paraphernalia of the sculptor. And behind Mustard is the shadowy bust of Scott modeled by Chantrey. The dog's self-confident air, territorial command, and steady gaze reflect the traits of Hogarth's Trump. Both Scott and Chantrey play second fiddle (as does Hogarth in his *Self-Portrait*); their personalities and professions have been absorbed by the Dandie Dinmont terrier. The differentiation between beast and man is confused.

From the very beginning of Landseer's career, Hogarth was an inspiration. In a pair of early drawings Landseer contrasted a skin-and-bone French hog with a fat, shiny British boar, closely following the kind of nationalistic satire produced by Hogarth, and the eighteenth-century master surely lies behind Landseer's ingeniously organized story pictures.[26] The details of the cottage in the *Chief Mourner* perform the same function as the still-life objects, settings, and accessories in Hogarth's *Progresses* (fig. 16, 17), enriching the characterization and plot.

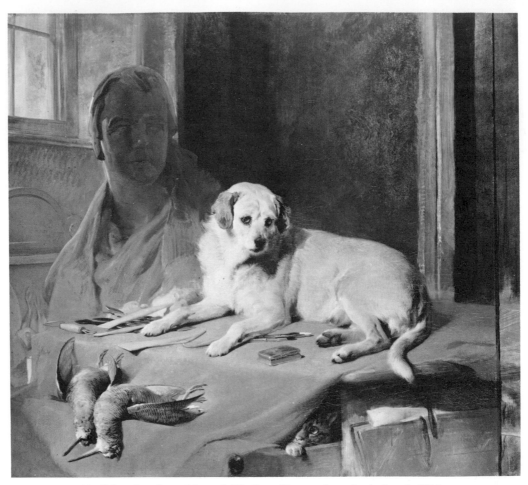

11. Edwin Landseer, *Mustard, The Son of Pepper: Given by the Late Sir Walter Scott to Sir Francis Chantrey, R.A.* 1836. Oil on canvas, 42 × 44¾ in. Coll. H. M. Queen Elizabeth II. Copyright reserved.

The first two plates of Hogarth's *Stages of Cruelty* (1750, fig. 12), as well as his *Self-Portrait*, look forward to Landseer's empathetic creatures. In Hogarth's prints, animal suffering is portrayed with a sympathy reserved in earlier art only for tortured humans. Although Hogarth's larger didactic concern was to portray the pathway of man's debasement, animals for the first time appear as sensate beings whose feelings and lives are meaningful beyond the physical services they perform for man.

Hogarth's humanized understanding of animal feelings had become the norm by the 1830s and in part explains Landeer's popularity. Parliament passed animal protection laws in 1822, 1837, 1849, and 1854, and the Royal Society for the Prevention of Cruelty to Animals was founded in 1824. The eighteenth-century cult of sensibility and romanticism's discernment of a sensitive universe lie behind such legislation and behind Landseer's works.[27] But Landseer did not strictly

continue Hogarth's pedagogical stand regarding cruelty. In fact, in many works he lavishly glorified the death and pain of hunted animals (Landseer himself hunted in Scotland every autumn). But some traces of compassion and melancholy nearly always accompany such scenes. The eyes of the beasts upturn in despair, or the limbs collapse with tragic feebleness. The horror itself, even without any didactic explanation, sounds a condemnatory note. Hogarth's empathetic portrayal of animal feelings still lies at the heart of Landseer's art.

Landseer's animal anthropomorphism is a means to engage the viewer's feelings, to have him enter the sentimental narrative freely. The human quality of beasts such as the dog in the *Chief Mourner* declare that this animal should be understood as men are understood. The fact that an animal rather than a man is depicted further encourages the viewer's rapport, the viewer's release of emotions. The spectator need not consider etiquette or propriety in his relation to this being.

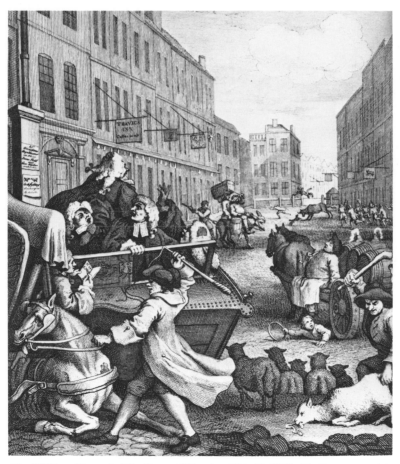

12. William Hogarth, *The Stages of Cruelty*, plate II. 1750–51. Engraving, 14 × 11¹⁄₁₆ in. Metropolitan Museum of Art, New York, Gift of Mrs. Frederick Allien, 1921.

People will embrace and fondle a pet animal more readily than they will unfamiliar persons. Social inhibitions do not apply to even the most human of dumb creatures. Our relationship with animals is on a deep, nonverbal level, and whatever we feel, say, or do will not be told to others. Animals invite private communication. Anthropomorphic beasts also tend to belittle the superiority of man: humanity seems but one species among many equal creatures in the world. Like the blossoming of landscape painting in the nineteenth century, animal anthropomorphism implies a recognition of man's insignificance in the universe, his lack of special honors. But in Landseer's art anthropomorphism's emotional engagement is more powerful than its intellectual ramifications. The sob story of love lost forever recounted in the *Chief Mourner* is the raison d'être of Landseer's anthropomorphism. The viewer is meant to break down, to soften his hardheartedness as did Dickens's Scrooge.

The sentimentality that runs through so much Victorian painting and literature had a religious function. Innumerable Victorian sermons described the surrender to pathetic emotions as a Christian act. To feel others' sadness and to weep like a child was to be reborn, made innocent again, and *The Old Shepherd's Chief Mourner* has that very aim.[28] The Victorian response to sentimental narratives was highly emotional and deeply serious, as exemplified by John Ruskin's praise for the *Chief Mourner* in *Modern Painters* (1851):

> Take, for instance, one of the most perfect poems or pictures (I use the words as synonymous) which modern times have seen:—the "Old Shepherd's Chief Mourner." Here the exquisite execution of the glossy and crisp hair of the dog, the bright sharp touching of the green bough beside it, the clear painting of the wood of the coffin and the folds of the blanket, are language—language clear and expressive in the highest degree. But the close pressure of the dog's breast against the wood, the convulsive clinging of the paws, which has dragged the blanket off the trestle, the total powerlessness of the head laid, close and motionless, upon its folds, the fixed and tearful fall of the eye in its hopelessness, the rigidity of repose which marks that there has been no motion or change in the trance of agony since the last blow was struck on the coffin-lid, the quietness and gloom of the chamber, the spectacles marking the place where the Bible was last closed, indicating how lonely has been the life, how unwatched the departure, of him who is laid solitary in his sleep;—these are all thoughts—thoughts by which the picture is separated at once from hundreds of equal merit, as far as mere painting goes, by which it ranks as a work of high art, and stamps its author not as the neat imitator of the texture of skin, or the fold of a drapery, but as the Man of Mind.[29]

To complain of maudlin sentiment and cheap poor-little-doggie gimmicks that tug the heart strings is to miss the point. The viewer was intended to put aside sophistication, intellectualism and objectivity and become a simple child. Empathy with others' sufferings is a pathway to Christian virtue, a means of becoming a humane human. Dickens's Little Nell and Landseer's pathetic collie in the *Chief Mourner* serve the same religious and emotional purpose.

Although the humble Scottish context of the *Chief Mourner* gives a nostalgic glow and fundamentality to the image, the setting also suggests contemporary social issues. The painting depicts a sorrowful economic state as well as a sorrowful emotional state. Cosmo Monkhouse pointed out in 1879 that the *Chief Mourner* was Landseer's last lower-class subject.[30] Thereafter, the only worker or peasant types to appear are Scottish ghillies, gaily dressed servants of privileged sport. Landseer himself became ever more socially entwined with the upper classes and court, and the strains of this artificial situation have been seen as the sources of his fits of depression and alcoholism.[31] Yet in the 1820s and 1830s—the age of William Cobbett, social and economic agitation, Peterloo and the Reform bill— Landseer often painted sentimental but not sugary pictures of poverty and distress.

The Stone Breaker of 1830 (fig. 13), for example, presents an old Highlander exhausted from his arduous labor, the lowest and most ill-paid work in society. He breaks up stones for the new macadam roadways that were being built throughout Britain. These highways, composed of compact layers of small stones (a method devised by a Scotsman, John McAdam), represented modernity and progress.[32] Although Landseer's stonebreaker is accompanied by a pretty daughter and proba-

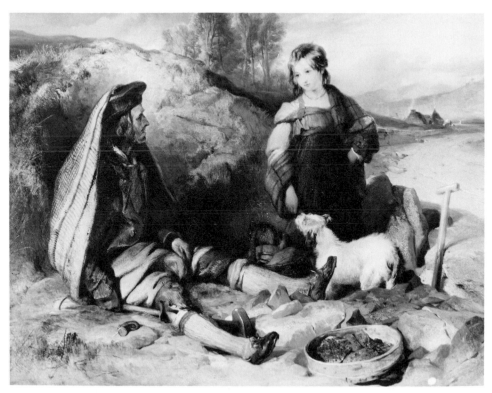

13. Edwin Landseer, *The Stone Breaker*. 1830. Oil on panel, 18 × 25 in.
Victoria and Albert Museum, London.

bly lives in the quaint cottage in the distance, he seems miserable, an unfortunate victim of the new era.

The barrenness of the shepherd's hut in the *Chief Mourner* also speaks of poverty. The austerity not only indicates spartan toughness and rudely honest existence, it also describes contemporary economic conditions. The Highlands were impoverished. Twenty-five percent of Scotland's population was considered indigent, and for thousands emigration was the only means of survival.[33] Landseer's tragic *Chief Mourner* (in spirit so unlike the normally smiling genre scenes of Wilkie) is by no means a violent cry for reform. Modern social conditions take second place to more universal states of being and emotion, but the problems of the age still are evident, and humanoid animal imagery sometimes permitted Landseer to be more socially incisive than had he portrayed humans. Thus in *A Jack in Office* (1833; Victoria and Albert Museum, London), which presents an aggressive terrier guarding his master's meat cart from the attacks of starving dogs as they fawn, snarl, and beg, we see a vision in dog language of British society at the moment of the Reform Bill, fighting over the distribution of rights and wealth. The work has amusing aspects but when translated into human terms becomes quite horrific. In other dog paintings of the time, the contrast between haves and have-nots is delineated with a biting but humorous touch (for example, *High Life* and *Low Life*, 1829; Tate Gallery, London). And in Scottish scenes, human poachers appear not as decorative swashbuckers, but as desperate, hunted men who have violated the property laws of the privileged (*A Poacher's Bothy*, 1831; Hamburger Kunsthalle). The death of the anonymous old shepherd in the *Chief Mourner* can be interpreted as a portrait of the sad lot of the poor.

The *Chief Mourner* also suggests the death of an artificial ideal. Landseer evidently chose to call the unseen dead man a shepherd because that profession immediately implied an intimate working relationship between man and dog, and because sheep farming was a major industry in Scotland. Both the characterization and geographical portrayal were thus enhanced. But shepherds bear certain indelible associations: they are the stuff of pastoral poetry, classical arcadian figures who embody the effortless, simple life.[34] Landseer could not have been unaware of the pastoral tradition in both poetry and painting as it had developed in the previous century. Allan Ramsay's Scottish pastoral masterpiece *The Gentle Shepherd* (1725) was still read, recited, and discussed by a broad section of the public in Landseer's day.[35] More than harvesters, plowmen, swineherds, drovers, milkmaids, or faggot gatherers, shepherds are the rural types most consistently linked to a pastoral golden age. But Landseer did not illustrate the lovely, lounging dreamworld of natural contentment that was so often depicted and lauded in the past. Like John Gay's *The Shepherd's Week* (1705) and other mock-classical poems that put the figures of idyllic pastoral fancy into the manure of contemporary reality, Landseer's *Chief Mourner* brings the arcadian shepherd down to earth—but without Gay's ironic humor. In the *Chief Mourner* we see the shepherd dead, but death is not supposed to occur in the ideal rural world of literature. Like Poussin's *Et in Arcadia*

Ego (where Arcadian shepherds come across a tomb, and realize that they too must die), *The Old Shepherd's Chief Mourner* punctures dreams of eternal joy.[36] In Landseer's somber image any notion that Scottish peasants are like characters from pastoral poetry, leading an uncontaminated existence, is dispelled by the grim presence of death.

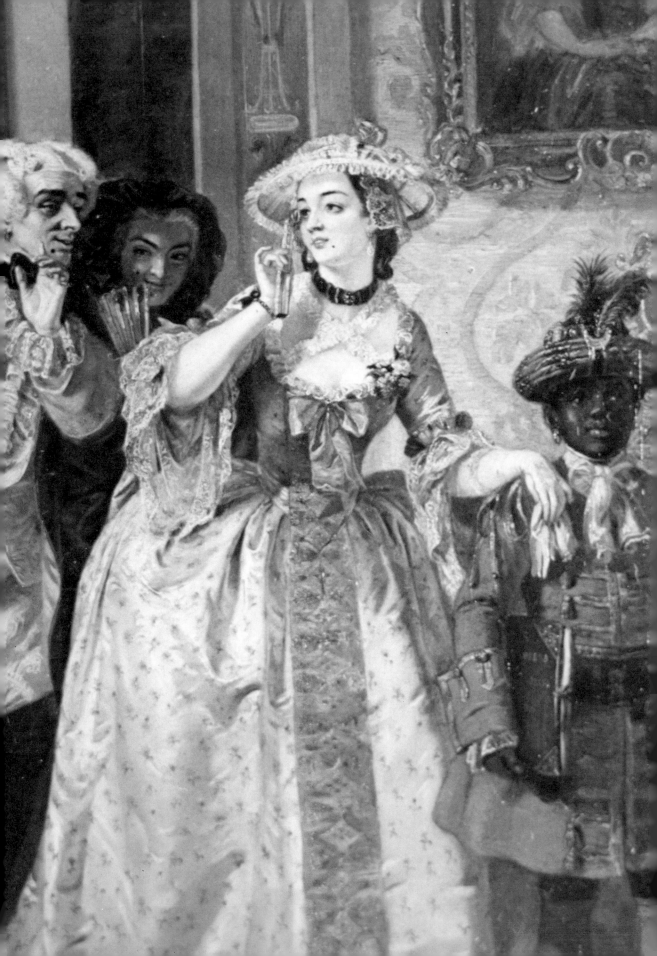

Edward Matthew Ward
(1816–1879)

Dr. Johnson in Lord Chesterfield's Ante-Room

The Houses of Parliament burned down in 1834, and the decoration of the newly built Westminster Palace with dignified murals provided the greatest impetus to the development of British art in the 1840s.[1] From 1843 onward, the government sponsored contests to select artists for the project, and official commissions studied the arts in England, as well as fresco techniques and state-supported art in other countries. Intense public discussion of the Parliament decorations served to excite the ambitions of British painters, who began turning to history painting, public art, and nationalistic themes. But the character and direction of British art in the 1840s are more clearly seen outside the walls of Westminster, in works such as Edward Matthew Ward's *Dr. Johnson in Lord Chesterfield's Ante-Room* (plate 2).[2] Here the new high-flown ideals and history painting merged with the homey and humorous manner of genre painting.

Dr. Johnson in Lord Chesterfield's Ante-Room was a great critical success in 1845 and founded Ward's eminent reputation.[3] He took his subject from James Boswell's *Life of Johnson,* in particular the famous letter Johnson wrote to Lord Chesterfield in 1755.[4] Ward accompanied his painting with the following information in the Royal Academy exhibition catalogue of 1845 (no. 292):

> Scene in Lord Chesterfield's ante-room in 1748; an incident founded on his Lordship's neglect of Dr. Johnson during the progress of his Dictionary. "Seven years, my Lord, have now passed, since I waited in your outward rooms, or was repulsed from your door; during which time I have been pushing on my work through difficulties of which it is useless to complain, and have brought it, at last, to the verge of publication, without one act of assistance, one word of encouragement, or one smile of favour. Such treatment I did not expect, for I never had a patron before."—Boswell

Boswell recounted that Johnson had originally sought to interest Chesterfield in his planned *Dictionary of the English Language,* but the nobleman had in fact provided no support. The author's letter was provoked by Chesterfield's

belated attempts to have the completed *Dictionary* dedicated to himself, or at least to suggest that he had assisted its production.[5] Johnson's letter and Ward's painting concern the hardships and humiliations of the artist, and the frivolity and failure of private patronage. (The picture's themes were obviously relevant to the discussion of state-supported art generated by the Parliament frescoes.)

Boswell denied longstanding tales that a specific incident in Chesterfield's anteroom had inspired Johnson's letter; false stories had arisen that Colley Cibber or some other author or social butterfly had gained access to the great lord, while Johnson waited without success.[6] But it is just such an imaginary episode that Ward chose to illustrate. His painting deals with historical personalities and takes inspiration from a particular document, but is in no way closely dependent upon a specific text or authentic event. Ward's slice of eighteenth-century literary history is embellished with a large cast of secondary characters, who enliven and give meaning to the subject. The documentary source of the picture acts as an iconographic core, about which a lavishly detailed story is spun. One is reminded of the methods of contemporary novelists such as Edward Bulwer-Lytton, who would take some historical event and dramatize the subject with human incidents, local color, and imaginary subplots and characters. In such fiction history becomes humanized, genrelike, and comprehensible in ordinary terms.

Ward's painting presents the anteroom of Lord Chesterfield's opulent London house as a stagelike box space. The planar rear wall opens right of center to form an arched, skylighted corridor, which leads to the great lord's distant chamber. Dr. Johnson, seated squarely on an ornate rococo chair, waits at the left side of the anteroom; his hands are crossed and supported by a walking stick, his hat is in hand, and he wears a sullen expression on his face. He glances slightly sideways, toward the right side of the painting where a group of elegantly dressed figures strolls through the anteroom, having just left Lord Chesterfield's inner chamber. A wigged dandy with mincing steps, a fashionable mole on his chin and a petition in hand, whispers smilingly to his young female companion. She too is dressed ornately and postures with mannered grace; she gazes distantly and perhaps flirtatiously through her lorgnette at the country squire in the left foreground, and he in turn ogles her. The lady's pinky is crooked, and one arm rests on her black servant boy. Her negro, wearing a plumed turban and a lavish livery, holds a portfolio and lute. Also included in this fashionable party are a smirking lady with a fan and a King Charles spaniel that snarls at the waiting-room crowd. The beaumonde figures at the right walk upon a rich carpet; the damned at the left are supported by a mere wooden floor. The people who surround Johnson are equally unsuccessful petitioners, some pitiable, others repugnant. In the foreground, an ugly and supercilious gentlemen loungingly straddles a chair observing the fashionable lady through his lorgnette and stretching out his spurred boots disrespectfully. A dim cleric yawns and looks out the window at the left. An elegant, shifty-eyed figure in the background scratches himself with his scrolled petition. A wizened old military man with one leg sits on the chair next to Johnson's, scowling, and

holding a watch. The aged cripple has obviously been kept waiting a considerable amount of time. Between Johnson and the officer is a worried, spectacled man who chews his fingers in distress. To the right of Johnson, a sympathetic mother and son in plain clothes wait patiently, huddled together; the woman wears the garments of a widow and is lost in thought, but the boy looks out of the picture with the hint of an innocent smile. This innocent couple acts as the antithesis of the fashionable group at the right. The figures form an undulant composition, serpentine in plan, which directs the eye to the bright corridor, the avenue of success, the entrance to Chesterfield's golden chamber. One man peers down the hall, another bows at the distant portal, and in the far background appears the lord himself, flooded with light and surrounded by books, objets d'art, and a standing companion. Chesterfield sits while the petitioner at the threshold bows obsequiously. The lord's richly decorated mantle holds a sculpture of the three graces, and above the pedimented doorway of his chamber rests a classical bust labeled "Maecenas" (the patron of Virgil and Horace). The bust's allusion is ironic, for Johnson, the modern man of letters, waits outside, neglected and humiliated. The sculptural reference to great patronage functions more or less in the same sarcastic fashion as Johnson's own words, "for I never had a patron before." The picture as a whole is a kind of demonically reversed Last Judgment, in which the dictator of secular heaven is a pompous aristocrat, the elect are frivolous drones, and the damned include the good with the shallow.

Ward was true to the spirit rather than the letter of Johnson's missive, and a similar freedom from reliance on fact is apparent in many of the picture's details. The architecture was evidently meant to depict Chesterfield's mansion in Mayfair, Chesterfield House (completed in 1748 by Isaac Ware), but does not in fact represent that lavish house, which was still standing during Ward's lifetime.[7] Ward's architecture serves not to document a specific place but to express the character of its owner. Wealth and taste for finery are indicated. The baroque interior (with a few Palladian touches) teems with ornament, opulence, statuary, and gold. The rooms of Chesterfield House were actually quite sumptuous (fig. 14), but they did not have the grand pilasters, patterned walls, and rich material envisioned by Ward.

The portrait of Chesterfield on the left wall is akin to several paintings of his lordship, particularly that by William Hoare (National Portrait Gallery, London), but is again not an exact replica of any known portrait. This painting within the painting is not a factual record, but it presents historically accurate features of Chesterfield and tells us of the sitter's social status (the star and sash of the Order of the Garter are prominent). The portrait of the lovely woman on the right wall acts as a pendant to the painting of Chesterfield but probably does not represent his wife, Petronilla Melusina von der Schulenberg, Countess of Walsingham. She was by all accounts unpleasing to the eye, and Chesterfield married her solely for financial and political purposes. The woman portrayed with low-cut bodice more likely represents one of Chesterfield's mistresses, Mlle de Bouchet (who bore his

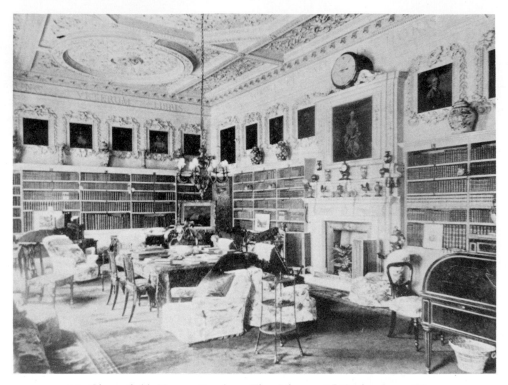

14. Chesterfield House, London, The Library, 1748, by Isaac Ware
(destroyed).

son), or Fanny Shirley, his famous love at the time of his marriage.[8] The impropriety of Chesterfield's private life may thus be depicted. From the time of his death onward, Chesterfield was viewed as an immoral hypocrite and a false sage. His well-known letters to his natural son were seen as declarations of the superiority of manners over morals, as celebrations of insincerity. George Colman's prologue to David Garrick's *Bon Ton* (1775) parodies Chesterfield's fatherly advice:

> Whate're your faults, ne'er sin against *Bon Ton!*
> Who toils for learning at a public school
> And digs for Greek and Latin, is a fool,
> French, French, my boy's the thing, *jasez,* prate, chatter! . . .
> Hearts may be black, but all should wear clean faces.
> The Graces boy! the Graces, Graces, Graces.[9]

And in Charles Dickens's *Barnaby Rudge* (1841), Chesterfield appears as Lord Chester, a father devoted to social facade and financial marriage rather than love.[10] Chesterfield stood for the life of polished veneer throughout the nineteenth century. The three graces that adorn Chesterfield's mantel in Ward's painting undoubtedly refer to the aristocrat's dedication to finesse.

Like the portrait of Chesterfield, Ward's image of Johnson is a recognizable

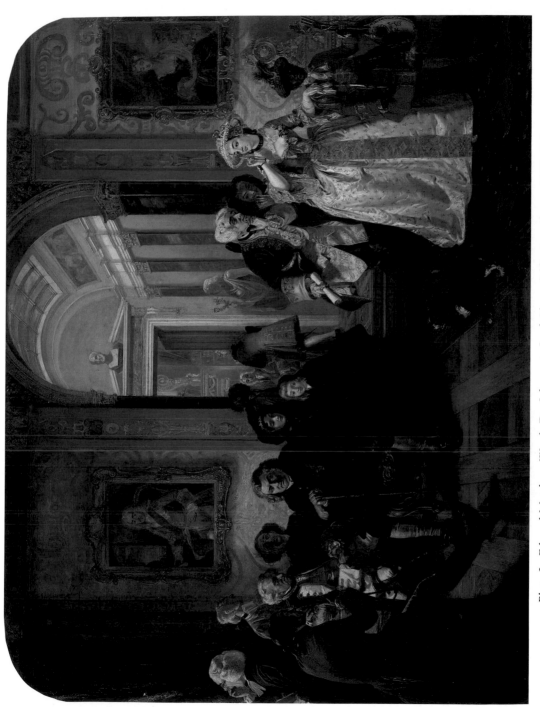

Plate 2. Edward Matthew Ward, *Dr. Johnson in Lord Chesterfield's Ante-Room*. 1845. Oil on canvas, 41¾ × 54⅞ in. Tate Gallery, London.

likeness, a face familiar from the much-engraved portraits of the author by Joshua Reynolds and others, but it depends on no specific eighteenth-century picture. The closest parallel to Ward's representation of Johnson is James Barry's unfinished yet vigorous and animated portrait of circa 1775, engraved by Anker Smith in 1808 (fig. 15). Compared to most portraits of Johnson taken from life, Ward's figure is more sturdy, commanding, and unblemished.[11] Ward toned down the writer's slovenliness, pockmarks, and eccentric features, abbreviating his paunch and ugliness.[12] The plain-garbed, sober Johnson had to appear as an attractive foil to the frilled, effeminate group at the right, and to the mansion as a whole. Firm decency had to oppose foppery.

The contrast created by Ward is completely Hogarthian in spirit. The caricatures, moral indictment of high life, and characterizing role of still-life objects, architecture, and dress are all consciously dependent on Hogarth's example.[13] The waiting petitioners recall the parasitic characters in *The Rake's Progress* (fig. 16), while the interior decoration, fashionable types, and negro servant recall scenes from *Marriage à la Mode* (fig. 17). The crowded stage, rhythmically bobbing line of heads, subplots within the major drama—indeed, Ward's entire literary approach—hark back to Hogarth, as do the very subjects of misguided wealth, faddishness, and the impoverished artist. Although none of Ward's figures exactly reproduces any of Hogarth's figures, almost every one of the personalities, as a type, can be found in Hogarth's oeuvre. The fashionable lady is akin to the society dames touring the insane asylum in the last plate of the *Rake's Progress*, or the woman in *The Lady's Last Stake* (1758–59; Albright Knox Art Gallery, Buffalo).

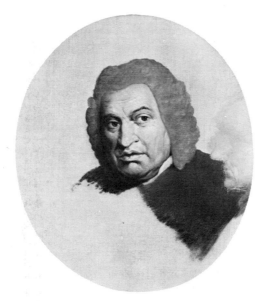

15. James Barry, *Portrait of Dr. Samuel Johnson.*
c. 1778–80. Oil on canvas, 23½ × 21 in. National
Portrait Gallery, London.

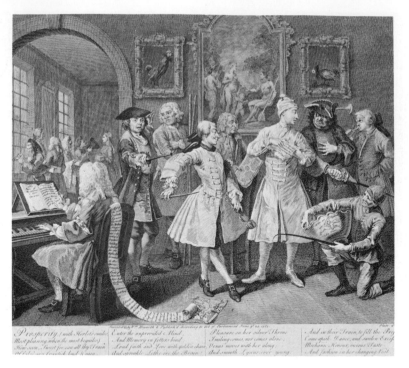

16. William Hogarth, *The Rake's Progress*, plate II. 1735. Engraving, 12½ × 15½ in. Metropolitan Museum of Art, New York, Harris Brisbane Dick Fund, 1932.

The dandy is a cousin of the young husband in the first plate of *Marriage à la Mode*, and the interior itself is reminiscent of the lavish house in plate two of the same series of pictures. Even Samuel Johnson, in attitude and forthright posture, seems to depend upon such works as Hogarth's portrait engraving of Simon Lord Lovat (1746).

Ward's painting presents a scene in 1748, and the contemporary Hogarth is thus an appropriate source of inspiration. But dependence on Hogarth was more than a mere matter of chronological suitability. By the mid-nineteenth century Hogarth had become the quintessentially English artist. He inspired numerous Victorian painters, including the Pre-Raphaelites, who produced some moralizing scenes of modern life (fig. 35), as Hogarth had done, and who named their private exhibiting society in 1857 the Hogarth Club. His realism, literary approach, humor, Protestant morality, chauvinism, and brimming originality made him a perfect exemplar of English taste, sensibility, and genius. For example, George Augustus Sala in 1866 lauded Hogarth's middle-class strength and common sense, and noted that "this philosopher ever preached the sturdy English virtues that have made us what we are. He taught us to fear God and honour the King; to shun idleness, extravagance and dissipation; to go to church, help the poor, and treat dumb animals with kindness."[14]

A British artist's reliance on Hogarth was a means of being nationalistic, but in

17. William Hogarth, *Marriage à la Mode*, painting IV. 1745. Oil on canvas, 27 × 35 in.
National Gallery, London.

Sala's words Hogarth also bears some resemblance to a pious Victorian minister.
Like most nineteenth-century commentators, Sala felt compelled to deplore the
"improprieties" and "vulgarity" of Hogarth's work.[15] In Ward's Hogarthian *Dr.
Johnson* no naughty sexual allusions or other scabrous material surfaces. Only the
portrait of the mistress on the right wall hints at Chesterfield's dubious sex life. In
contrast, Hogarth's scene of the countess's levee in *Marriage à la Mode* (fig. 17) or
of the orgy scene in the *Rake's Progress*, though strongly condemnatory, treat sex in
a more vividly bawdy fashion. In Victorian hands Hogarth is kept clean. This
sterilizing tendency, this willful preservation of polite delicacy, is also notable in
David Wilkie's nineteenth-century reworkings of seventeenth-century Dutch
genre (fig. 1).

Mid-nineteenth-century British art presents fornication and lust in condem-
natory terms, but without any gross portrayal of the sexual act itself or its intimate
accessories. Even Victorian pictures that deal primarily with sexual promiscuity
skirt around anything too unseemly, illustrating only well-dressed scenes of for-
nication's consequences. Thus Augustus Egg's three-part painting *Past and Present*
of 1858 (fig. 18) depicts marital infidelity, but we see no embracing couple or
bedroom in disarray. Instead, we see a discovered love letter and an adulterous
wife's plea for forgiveness in part one, abandoned children thinking of their lost
mother in part two, and the adulteress's sad but just end in poverty and despair in
part three.[16] The whispered approach to evil goes beyond the depiction of sex. In

18. Augustus Egg, *Past and Present,* painting I. 1858. Oil on canvas, 25 × 30
in. Tate Gallery, London.

Victorian art all forms of depravity are tempered, cosmeticized, or alluded to in
absentia. Scenes of truly horrific violence, torture, cruelty, or murder are rare.
Thieving, oppression, chicanery, murder, faithlessness, and heartlessness are de-
picted, but no images can compare with those of Hogarth's *Stages of Cruelty* (fig.
12) or Henry Fuseli's ejaculatory visions of rape and death. The tendency to avoid
grossly repellent imagery began before Victoria's accession and has nothing to do
with that particular monarch's niceties of moral tone. The development of this
sensibility can already be noted by 1819, when Lord Byron wrote in dismay from
abroad about recent British criticism of his unbuttoned subject matter and descrip-
tions: "As to the prudery of the present day, what is it? Are we more moral than
when Prior wrote? Is there anything in 'Don Juan' so strong as in Ariosto, or
Voltaire, or Chaucer?"[17]

The rise of Evangelicalism in England was probably responsible for the changing
taste. For those Evangelical Christians setting forth to improve society, to en-
lighten the physical and spiritual life of the community, a belief in man's correc-
tability and essential goodness was necessary.[18] Perhaps the Victorian painters'
disinclination to portray unmitigated depravity, or horrors and sins so disgusting

that all attempts at reform would be abandoned, can be related to the growing force of Evangelicalism. To correct the errors of Scrooge, one must believe that the heartless miser is not beyond redemption.

Hogarth was most praised in the nineteenth century for his highly original combination of literature and art.[19] He had created the pictorial equivalents of the novel and the play, employing devices of transition, juxtaposition, metaphor, irony, subplot, and development that parallel those in the fiction of Fielding and other contemporary authors. Ward followed Hogarth's example and, like him, thereby elevated his profession by attaching himself to the respected and grand tradition of English literature. British art had never possessed a glorious reputation (Hogarth and later artists had always to defend its merits), but British literature had long before achieved unquestioned esteem. Ward's painting looks like a stage set and is composed in a theatrical or literary manner. The anteroom is a novelistic meeting point where the characters form conflicts and contrasts and reveal their statuses and personalities. The door to Chesterfield's chamber (ironically small) is the dramatic focus—opening, shutting, defining success and failure, causing tension, eliciting emotion, and giving coherence to the narrative. Ward's painting recalls the scenes in novels and plays where the characters all come together at an inn as a device to resolve questions and clarify meanings. Ward's figures respond to one another—turning, glancing, gesturing, congregating—not to create a harmonious design but to produce meaningful drama. The picture must be "read" figure by figure, part by part. It cannot be apprehended in one moment but must be experienced in time, just like a novel or play. Hogarth, of course, had invented this literary structure of art. Like Hogarth, Ward frequented literary circles, was devoted to the theater, and portrayed contemporary actors and writers throughout his career.[20]

Ward may have lacked Hogarth's pungent incisiveness, but he certainly intended to make a strong statement about an artist's sufferings in *Dr. Johnson*. He presented the artist as a man bravely overcoming obstacles in a hostile, uncongenial world. Johnson's letter of 1755 to Chesterfield was viewed by Ward's contemporaries as an early example of artistic independence, a symbol of professional self-respect, a declaration that the artist would not be the lapdog of the rich and powerful. Thus, in the mid-nineteenth century Dr. Johnson stood for many of the same English virtues that were associated with Hogarth: middle-class honesty, a critical faculty, a down-to-earth distrust of finery and foreigners, and a life-loving Protestantism.[21]

Ward's concern with the sufferings of the artist in *Dr. Johnson* was typical of the 1840s. For example, in 1845 John Pye published *Patronage of British Art*, which dealt at length with the long history of artists' neglect and pauperism in England.[22] Pye criticized royal and aristocratic patronage for its favoritism and single-minded attachment to portraiture. He discussed the rise of academies and artists's benevolent associations, noting their insufficient success in alleviating the precarious financial state of artists, and he called for increased funding of history painting.

Hogarth's achievements in broadening the art-buying public (by selling his works in the form of prints) and in helping to found copyright laws were duly praised by Pye. The mood and topics of his book can also be found in the art journals of the period, and hovering about all this talk were the Parliament frescoes, the new entrance of government into the arts in England.

Dr. Johnson is not the only work by Ward that depicts the hardships of the artist. The theme recurs repeatedly in his art; it obviously had a peculiar attraction for him and was not just a passing attempt to appeal to public enthusiasms. Very often a writer, rather than a painter, plays the artist in Ward's works. The clearest precedent for *Dr. Johnson* in Ward's oeuvre is *Dr. Johnson Reading the Ms. of "The Vicar of Wakefield"* (fig. 19) of 1843. The tale recounted there is derived again from Boswell and also concerns an artist's financial deprivation. Reportedly, Oliver Goldsmith, deep in dept and unable to pay his rent, appealed to the slightly more wealthy Johnson for assistance. Johnson sent a guinea to the novelist and visited his humble apartment, only to find that Goldsmith had spent the money on wine. Johnson however soon discovered the manuscript of *The Vicar of Wakefield* in the writer's cluttered room, scanned the novel quickly, immediately sold it to a publisher, and thereby gained sixty pounds for the needy author.[23] In Ward's painting Johnson reads the manuscript while Goldsmith looks on, a bottle of liquor within easy reach. Behind the lounging author stands Goldsmith's landlady with rent bill in hand. Other figures, some with malevolent countenances, have come into the room to observe the commotion and the distressed condition of the novelist. The painting is freely based on Hogarth's engraving of 1736, *The Distressed Poet,* where a similar landlady presents a bill to a similarly unworldly writer. The woman who appears between the landlady and the male observer in Ward's picture reappears in *Dr. Johnson in Lord Chesterfield's Ante-Room* amid the fashionable group at the right. Poverty and rejection are even more evident in Ward's 1851 design for an entrance card to a performance of The Guild of Literature and Art (fig. 20).[24] Decorating this ticket for an artists' and writers' benevolent association, which was supported by Ward, are images of Richard Wilson and Daniel Defoe. The painter is shown taking his pictures to a pawnshop, while the author is shown sadly turning away from a publisher's office, his manuscript of *Robinson Crusoe* in hand. The scene of Defoe had been painted by Ward and exhibited in 1849. He also produced a painting in 1844 of Goldsmith in poverty abroad, entertaining Flemish peasants with his flute in order to earn food and shelter. And in 1869 Ward exhibited *Grinling Gibbons's First Introduction to Court,* in which the great sculptor's work is rejected by the queen on the advice of an ignorant serving woman.[25]

Such images illustrate the romantic conception of the artist as a suffering, misunderstood hero, and there are numerous paintings by others in the century that deal with this theme (for example, Henry Wallis, *The Death of Chatterton,* 1856; Tate Gallery, London). The pain of creation, the melancholy and despair of artistic decisions and failures, however, is not evident in Ward's art (in contrast to Delacroix's images of artists). There is a materialist emphasis in Ward's art, quite

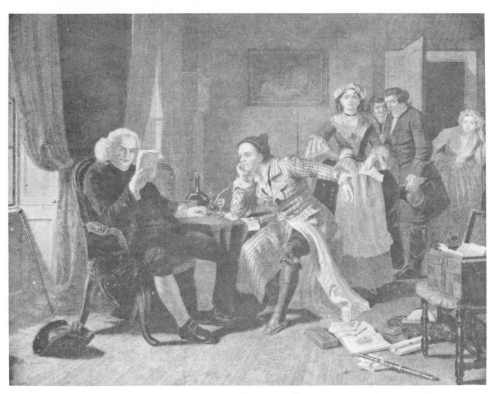

19. Edward Matthew Ward, *Dr. Johnson Reading the Ms. of the Vicar of Wakefield.* 1843. Oil on canvas. Location unknown.

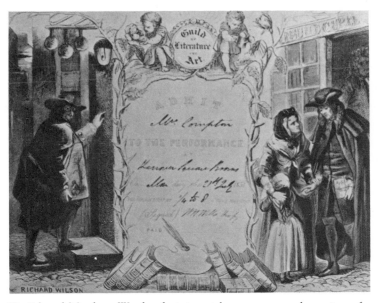

20. Edward Matthew Ward, admission ticket to amateur dramatic performances held by the Guild of Literature and Art. 1851. Etched by Thomas O. Barlow, 8 × 10 in. From Mrs. E. M. Ward, *Memories of Ninety Years.*

in tune with mid-century realism. The sorts of suffering depicted are of the kind that could be alleviated with public finances.

One might wish to see such pictures of artists' poverty as personal testaments, cries of anguish and rejection on Ward's part, or radical criticisms of the state of society and unjust distribution of wealth. Yet the facts of Ward's life and career do not substantiate any such personal hardship or social commitment. Ward was the son of a manager of Coutts Bank and thus, though not very wealthy, certainly far from deprivation.[26] In addition, whatever sympathies Ward might have had for the general emancipation of the poor and oppressed, his views were not of a revolutionary nature. In the early 1840s, as a volunteer constable, he took the side of law and order against the radical demonstrators during the Chartist rallies in London.[27] And in 1848 he merrily traveled through Belgium on his honeymoon, carefully avoiding those countries beset by revolution.[28]

Nor was Ward's career rife with failure.[29] He won the silver palette of the Society of Arts for pen and ink drawing in 1830, was admitted to the Royal Academy Schools in 1835 on the recommendation of David Wilkie and Francis Chantrey, and had already exhibited a portrait of an actor at the Royal Academy in 1834. From 1835 to 1839 he studied in Rome under Filippo Agricola and received a silver medal from the Academy of St. Luke. He also studied fresco painting under Pieter Cornelius in Munich on his return journey, in preparation for the Parliament fresco competitions,[30] and back in England he sold a painting of Napoleon in prison to the Duke of Wellington. Exhibiting regularly at the Royal Academy, he gained accolades for *Dr. Johnson in Lord Chesterfield's Ante-Room* and *The South Sea Bubble* (1847; Tate Gallery, London). He was elected an Associate of the Royal Academy in 1846 and a full Academician in 1855. In 1853, he was chosen to execute eight historical paintings for the House of Commons and also received prestigious commissions from the royal family.[31] From the success of *Dr. Johnson* in 1845 until his death in 1879, Ward led a life that was financially and professionally secure. He married a granddaughter of the painter James Ward and produced eight children (one of whom became the caricaturist "Spy"). Ward was a close friend of Macaulay, Bulwer-Lytton, Dickens, Thackeray, and theatrical stars of the day, and moved with ease in fashionable aristocratic and artistic circles.[32]

Apart from the disdain of Pre-Raphaelites in the late 1840s and 1850s and some rare criticism of his melodrama or unseemly portrayal of royalty, Ward enjoyed a favorable press and public acclaim throughout his career.[33] His life does not appear fraught with misery or lack of success. He had but three minor failures: in 1835 his painting titled *The Dead Ass* (a subject from Stern's *Sentimental Journey*) was rejected by the Royal Academy; in 1840 his painting *Reminiscences of a Scene in the Prisoner's Lock of the Tribunal at Naples in 1838* was hung too high to be seen at the Royal Academy exhibition; and in 1843, after submitting a cartoon of *Boadicea Animating the Britons*, Ward failed to win any prize at the first Parliament fresco competition. The first failure probably led Ward to leave England for Italy; the second hurt his chances to gain critical approval and patrons; and the third

dimmed his hopes as a history painter. These early setbacks perhaps generated Ward's sour vision of the artist's lot, but in fact they would not have been considered harsh failures in the period, and Ward experienced numerous successes to counteract them.

Ward's recurrent depiction of persecuted creators may be due to a somber side of his character, to a touch of pananoia and periods of depression. He became insane in his last years and committed suicide in 1879. We know nothing of this dark aspect of the painter's life (his widow's memoirs reveal only a continuously sunny existence—she does not even mention that Ward killed himself).

Whatever its causes, Ward's *Dr. Johnson* contains obvious social criticism, indicting the wealthy for improper favoritism and callous neglect of genius. Ward's widow described the painting in the 1920s and added:

> It was the custom for relatives and dependents of wealthy and influential men to wait humbly on their patrons, who often put on great airs and graces before granting their requests. Younger sons of aristocrats and parents would be awarded after due humiliation with commissions in crack regiments, appointments in the East India Company, and pensions for life. Such a mode of procedure smacks of rank snobbery in these democratic times. Dr. Johnson of all men was the least likely to endure such treatment patiently, and he took care to remind Lord Chesterfield of the indignity he had suffered.[34]

Mrs. Ward had already been acquainted with the painter in 1845, when he painted *Dr. Johnson,* and she modeled for the fashionable lady on the right side of the picture.[35] Although perhaps not the most reliable of memoirists, she was directly involved in the creation of *Dr. Johnson* and probably correctly caught the critical spirit of the work. One reviewer of *Dr. Johnson* in 1845 praised the painting, but his words also reveal how annoying Ward's social criticism could be, how this image of a writer asking for support could be interpreted as a picture of misspent energy and shallow prejudice. The reviewer's comments also illustrate how high was the esteem of Hogarth:

> Mr. E. M. Ward exhibits to great advantage this spring. He is strong in reminiscences of Hogarth, having looked, and considered, and copied (it may be) the works of England's great moral painter, till he has brought away not merely those literal translations of countenance, attitude, and incident, which, after all, are best rendered by Daguerreotype—but some slight enkindlings of the master's spirit—of his power over character—his intolerance of folly and pretension, and his habit of giving importance to the minutest details and accessories, by which a tea-pot in the hands of a black boy may be subtilized into a poetical indicent, and even a china monster play its part as interpreter in some scene of pathos. Here (292) we have *Lord Chesterfield's Ante-room* in 1748, with Dr. Johnson sitting in sullen attendance, while the Mingotti or Frasi of the hour sweeps smilingly out, happy in her granted audience and successful petition. [One hundred years ago, by the way, the Author had not arrived at the Truth that he who spends his energies in suing the great is well nigh as untrue to Truth as he who spends his patronage in pampering the small.] The luckless lex-

icographer—destined, in his day, to become as unfeeling an autocrat among the clever men and pretty girls of the Streatham coterie, as Lord Chesterfield was in his sphere—has fallen among "the hard bargains," who besiege the doors of persons of condition. The city man—the ill-used defender of his country—the divine, yawning as he looks through the window, and the widow and her son are all there;—doleful and work-day outcasts to the butterfly group of artists, who are sailing forth from the audience, and the gentleman with the obsequious back, whose turn is come to enter the presence. We have already indicated that with all the kindly purpose of this picture, it contains something of a worn-out popular fallacy, if tried by high moral standard; as a work of humorous art, however, it does the artist substantial credit. The story is clearly told, the heads are cleverly discriminated, the coloring is fresh, solid and harmonious. It is a good, national picture, in short; worthy of a place in any contemporary gallery.[36]

This critic was slightly nettled by the social message of *Dr. Johnson,* for it illustrates the ill effects of unequal distribution of wealth, a contentious issue in the "hungry forties," when famine, vagrancy, unemployment, poverty, and Chartism were widespread. Perhaps the greatest expression of the misery of the 1840s is G. F. Watts's unusual *The Irish Famine* (1849–50, fig. 21), where a monumental family in distress sits amid a barren, blackened world. Ward's painting also deals with economic problems of the age, but in terms of artists, and in less frightening and less grandiose form.

Ward's social barbs are mitigated by the eighteenth-century subject. Any criticism becomes softened by the distance of a hundred years; a particular injustice is easier to swallow when it is not an immediate issue. The charming costumes, old-fashioned manners, and lush interior of Ward's painting do not wholly function as social commentaries; they more forcefully express a yearning for a lost past. The 1840s saw innumerable representations of eighteenth-century subjects on the exhibition walls of London. Illustrations of *The Vicar of Wakefield* were particularly numerous, but a host of other genre scenes and dramas culled from literature and the history of the previous century were also evident. The life-loving, strong-willed Dr. Johnson often appeared as a hero, and the extinct or purely imaginary village life of *The Vicar of Wakefield* undoubtedly suggested a simpler and more gracious age, now blotted out by modern life and industrialization.[37]

This tendency to find subjects from the past is a leitmotif of nineteenth-century art in general—a cry of dissatisfaction with the present, a revelation of self-hatred. The manners, dress, and character of modernity were not elevated or appealing enough to attract artistic efforts. David Wilkie produced popular scenes of contemporary life in the first four decades of the nineteenth-century (fig. 1), but his views are almost all rural, depicting a quaint sort of cottage life among the poor that is timeless, old-fashioned, or cosmetically prettified.[38] Little that is distinctly modern ever creeps into Wilkie's genre pictures. Similarly, the genre scenes of John Fredrick Lewis in the 1830s and 1840s are all of foreign peoples, usually backward peasants more closely linked to past centuries than to the modern age. It was only in the 1850s and 1860s that paintings of contemporary Britain truly blossomed.

21. George Frederic Watts, *The Irish Famine*. 1849–50. Oil on canvas, 71 × 78 in. The Trustees of the Watts Gallery, Compton, Guildford.

The pleasures, ills, decorative taste, manners, enthusiasms, and novelities of nineteenth-century existence were catalogued and analyzed by William Powell Frith, Augustus Egg (fig. 18), Abraham Solomon, George Elgar Hicks, William Holman Hunt (fig. 35), Frederick Daniel Hardy, John B. Martineau, and numerous others.[39] But in the 1840s only popular graphic illustrators and the sentimental social indictments painted by Richard Redgrave (fig. 39) portrayed modern life.

Ward's eighteenth-century subject not only made his socially critical image appealing, it also placed it within the realm of history painting, turning it into a picture of past events from the history of England. History painting—the portrayal of religion, myth, great literature, allegory, and ancient and modern history—had never found fertile soil in England. A brief flowering occurred in the late eighteenth century, but patronage for such works was always limited and dwindled rapidly after 1800. Various compromises arose. Joshua Reynolds had often tied history painting to the favored art of portraiture, and J. M. W. Turner, John Martin, and others successfully linked history painting to the newly popular art of landscape painting in the early nineteenth century. But as the artist Benjamin Robert Haydon endlessly complained, opportunities to create unadulterated history painting were extremely restricted in the first forty years of the nineteenth century.[40]

The young figurative artists who gained most favor in this period were men like Wilkie and William Mulready, who were inspired by Terborch and Teniers rather than Michelangelo and Raphael, and who painted intimate, sentimental genre scenes and light literary subjects.[41] Ward and so many others in the 1840s were newly inspired by the Parliament fresco projects to carry out history paintings. Most artists in the Westminster competitions submitted grandiose works filled with old-master references, monumental nudes, and empty rhetoric. The novel use of fresco in England led others to follow the "primitive" linear style of such early Renaissance masters as Fra Angelico and Benozzo Gozzoli, who had worked in that medium (fig. 22). Most of the British primitivizing artists also turned to such earlier art for religious reasons, finding their High Church and Catholic ideals in the works of a more spiritual age.[42]

Dr. Johnson represents a compromise, a merging of history painting with genre-like imagery and form. The sentimental depiction of the sad widow and her innocent son, the cranky old officer, the willowy dandy, and fuming Johnson, are near caricatural types that would be unsuitable in a grandiose history painting. Furthermore, the small scale of the figures, intimate box space, undramatic narrative, bouncy grouping of figures, informality of manners, unmonumental asymmetry, and amusing details also remove Ward's picture from the high-flown mode. The crisscrossing gazes, the yapping dog illustrative of the fashionable people's disdain for the other petitioners, the allusive rather than purely aesthetic character of the paintings and sculptures in the picture, and the dependence upon the normal experiences of the common man all link Ward's image to genre painting. And the reliance on Hogarth, although heightening the nationalistic sentiment, did not produce the same grandeur as would a reliance on Raphael or Carracci. Ward's narrative style is virtually the same as that of the moralizing painters of modern life in the 1850s (for example, Augustus Egg, *Past and Present*, fig. 18), but Ward's story has a specific historical basis, deals with known personalities of national consequence, and is set in the previous century; *Dr. Johnson* has the eminent gloss of history painting.

This mingling of genre and history painting had been attempted earlier in England, most notably by David Wilkie in *Chelsea Pensioners Reading the News of the Battle of Waterloo* (1822; Wellington Museum, London). Furthermore, from the early years of the nineteenth century artists in France, such as François Marius Granet, Pierre Henry Revoil, Jean Auguste Dominique Ingres, and the Englishman Richard Parkes Bonington, developed a mixture of genre and history termed the troubador style.[43] Ingres's *Molière Dining with Louis XIV* (1857; Musée de la Comédie Française, Paris) is a late example similar to Ward's work in subject, but it celebrates the glories of the artist's social status. Ward's approach thus was not an innovation, although it does represent a newly widespread tendency of the 1840s in England. Frederick Goodall, Solomon Hart, and Augustus Egg, for example, created similar productions in the same decade. This general movement can

22. William Dyce, *Virgin and Child.* 1845. Oil on canvas, 31½ × 25 in. Coll. H. M. Queen Elizabeth II. Copyright reserved.

be viewed as a humanizing and democratizing reaction to the Parliament history paintings.

Ward's genrelike portrayal of history, so different from the monumental acts and allegories depicted by such artists as Daniel Maclise in the Houses of Parliament, (fig. 23) may be related to recent changes in the very concept of history.[44] Many nineteenth-century historians moved away from the study of great public moments and battles to behind-the-scenes events and analyses of the state of common people: History was now interpreted in the light of ordinary reality. One writer in

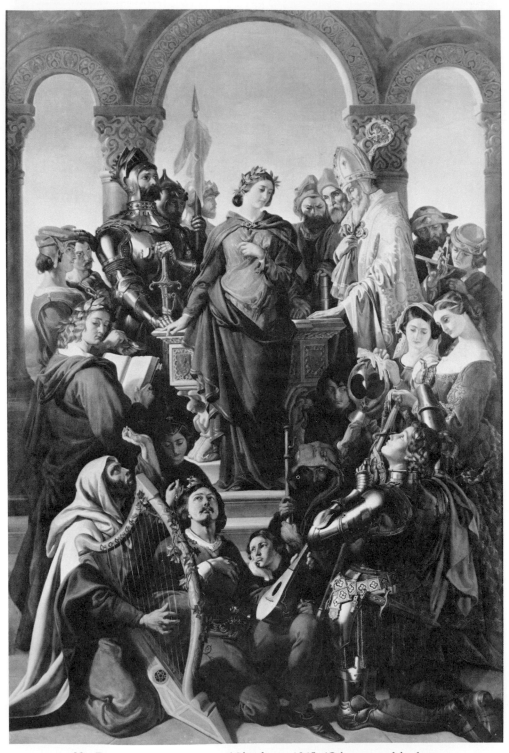

23. Daniel Maclise, *The Spirit of Chivalry*. c. 1845. (Oil version of the fresco in Westminster Palace). Oil on canvas, 49½ × 35½ in. Sheffield City Art Galleries.

the 1870s began an essay on Ward by linking the artist to the new methods of historical investigation:

> It was Macaulay who realised the great fact that history is not made up of the prominent events of sieges and treaties, of coronations and royal marriages, but of the rehearsals of all these behind-the-scenes of the tragic-comedy of *La Vie Humaine*. . . . And as we learn more of a country from the narrow byways than from the broad highways, so do we gain from the great men and women of other days, unwigged and slippered, the picturesque prospects of a sometimes prosaic past. . . . [Ward] reads history by a similar light.[45]

The Parliament frescoes eventually disappointed the public and the artists of England; the products of state patronage seemed unconvincing, weak, and empty.[46] Perhaps that is one reason why many artists in the succeeding decade were no longer so dedicated to monumental history painting and felt free to depict ordinary modern life with intimacy, detail, and moral force. But in between these two alternatives lay hybrids. Ward's *Dr. Johnson* was a typical solution of the 1840s, in which history was viewed from a genrelike perspective, art partook of England's undoubted literary powers, nationalistic yearnings were satisfied by reference to eighteenth-century cultural heroes, social inequality and artists' struggle for respect were treated with polite attention, and the glowing portrayal of the past offered an escape from the unpleasing present.

John Brett
(1831–1902)
The Glacier of Rosenlaui

John Brett painted *The Glacier of Rosenlaui* (plate 3) in the Swiss Alps in the summer of 1856 and exhibited it the following year at the Royal Academy, where it failed to attract critical response.[1] But Brett's small picture is a testament of personal conversion, a revelation of the spread of Pre-Raphaelitism and John Ruskin's ideas, an indicator of fundamental changes in British landscape painting, a bridge between science and art, and a wide-eyed vision of uninhabited nature that strikes the viewer with exhilarating intensity.

On a rock-shelf plateau in the foreground of Brett's painting lie three boulders and scores of pebbles. The large random stones appear unstable, tilted at angles, not anchored in soil or the smooth bedrock. The plateau itself slopes downward to the right, reinforcing the suggestion of instability. Beyond appears the pure white glacier of Rosenlaui, oceanic in its immensity and wavelike crests. The middle ground at the left contains a mountainside, its serpentine strata akin to the waterlike folds of glacial ice. This mountain is capped at several points by dark vegetation, and a few trees appear at the upper left. The edge of another mountainside just peeps into the picture at the right, and thus the glacier seems to be squeezed by the mountains at its sides. This expressive constriction, intensified by the glacier's tightened convolutions, is relieved in the distance, where the ice sheet expands laterally and becomes lost in the blue-white mist and gray sky. The silhouetted peak of the majestic mountain called the Wellhorn rises from the background clouds. Icy blues and whites dominate Brett's painting, and the chilling coloration is hardly countered by the touches of light brown in the cliffs at the left, the note of yellow lichen on a ledge of the cliff, or the dark green of the tiny firs at the upper left. Blue shadows and contours and a gray sky define the light and volumes of the picture. The wealth of minute detail in the foreground focuses attention upon the bumps, scars, fissures, chips, and foliation of the rocks that lie directly at out feet. The viewer immediately faces not a panorama but a close and sparkling assembly of stones rendered with an almost hallucinatory clarity.

The boulders are distinctly varied, evidently unrelated to each other in mineral content or geological origin. The largest rock is metamorphic with undulant foliation; the shalelike stone at the lower right has angular cleavage and sharp edges; the boulder in the very center of the plateau has a granular texture and unlayered form. All three differ from the bedrock and the multifarious pebbles that surround them. These disparate stones, shown to us with such minute precision, did not originate at one site; they could not all be the detritus of a nearby peak. In fact, they are also distinct from the soft limestone bed that lies beneath the glacier. Brett presented a problem: How did these widely differing stones, from places of widely differing geological formation, arrive together at this lofty zone?

One might suppose that the artist merely incorporated in his painting boulders from several distant sites to make a beautifully varied arrangement. But we know that Brett painted this work entirely on the spot, and more important, that such boulders of varied foreign lineage can indeed be found atop the Bernese Oberland. The artist's decision to paint random stones perched before a Swiss glacier was not without meaning. Brett depicted one of the longstanding mysteries of geology that had only recently been demystified. The presence on the Alps of huge boulders, which had come from hundreds of miles away, had puzzled early-nineteenth-century geologists throughout Europe. What natural force could have carried such objects to their resting places? Many had claimed that ferocious waters—the Deluge or other oceanic catastrophes—had lifted the "erratic boulders" to the mountain tops. But the physical power of water would have been insufficient to transport such weights, and furthermore, the erratic rocks were far more common on peaks than in valley lakes. Surely such loads would have sunk to lower levels had they been moved by violent seas.[2] Sir Charles Lyell proposed that the erratic rocks had been lodged in icebergs or ice-rafts and thus floated to their present positions in some deluvial outburst. But this hypothesis seemed unlikely and failed to explain the high altitude and other characteristics of the boulders.[3]

Another answer came in 1837, when the Swiss geologist Louis Agassiz declared (correctly) that glaciers had transported these stones to the mountain peaks.[4] Many Alpine rocks were grooved and scarred, and large areas of the mountains were polished smooth. To Agassiz, these were the results of glacial movement: the enormous ice sheet moved on a bed of pebbles and sand that polished and scratched the bedrock. As the glacier pushed through valley, boulders fell from the various surrounding heights onto the surface of the glacier and were carried great distances—even to the highest peaks of the Alps. Agassiz further proposed that an ice age had once descended upon the earth and that glaciers had thus covered great portions of the globe. Glaciation seemed evident everywhere. But in 1837 Agassiz had not yet successfully explained exactly how glaciers moved; he still misunderstood certain physical processes of glaciation and conceived of the earth's ancient ice blanket as absurdly extensive. Great controversy and opposition ensued. In 1840 he published *Etudes sur les glaciers*, which, in addition to his lectures,

private discussions, correspondence, and continuing research, spread knowledge of his doctrines throughout Europe.[5]

By the mid-1850s Agassiz's theories were widely accepted, and additional studies by other geologists only confirmed and refined his views. In England, the eminent Sir Charles Lyell's ninth revised edition of *Principles of Geology* (1853) definitely attributed the presence of erratic boulders on the Alpine peaks to glacial action, and he also supported the idea of some sort of ice age.[6] William Buckland, who had previously supported the idea of water action, came to agree with Agassiz as early as 1840.[7] The wide acceptance of Agassiz's interpretations in Britain may be gauged by the publication in 1855 of John Phillips's *Manuel of Geology, Practical and Theoretical,* a new edition of a work for the general public originally published in the 1830s. Phillips stated the problem of the erratic Alpine boulders, noted the flood and ice-raft hypotheses, called the problem an unsolved mystery, and termed the rocks "diluvial deposits." The editors of the 1855 edition left the discussion totally unchanged, but they did place a new heading above it: "Glacial Deposits."[8]

The glacier of Rosenlaui figured in Agassiz's writings and research, and in *Etudes sur les glaciers* he illustrated stones from Rosenlaui to support his contentions (fig. 24). Agassiz's detailed, close-up picture of rocks was reproduced in numerous other publications in Britain and elsewhere.[9] From what is known of Brett's personality and later career, it is highly likely that Brett was familiar with issues and developments in geology when he painted *The Glacier of Rosenlaui.* He always had a strong scientific bent. In later years Brett discussed paintings as if they were scientific

24. Plate 18 from Louis Agassiz, *Etudes sur les glaciers* (Neuchâtel, 1840): *Fragmens de roches polies* 1 & 2 from Zermatt, 3 & 4 from Rosenlaui and 5 from Landeron. Lithograph by Bettannier.

documents. He became a member of the Royal Astronomical Society and published his astronomical observations; he invented a portable easel so as to record natural phenomena with greater facility. And when he broke his friendship with the critic John Ruskin (who had worked closely with Brett since 1857), the cause of disunion was not a matter of art, but disagreement over a point of science.[10] Ruskin wrote to a friend in 1865, "I will associate with no man who does not more or less accept my own estimate of myself. For instance, Brett told me, a year ago, that a statement of mine respecting a scientific matter (which I knew *à fond* before he was born) was 'bosh.' I told him in return he was a fool; he left the house, and I will not see him again 'until he is wiser.'"[11]

The glacier of Rosenlaui was a tourist attraction, the white purity of its ice a famed sight, and the Eiger, Wetterhorn, and Wellhorn mountains that rise above it were the common shrines of travelers.[12] But the popularity of Brett's Alpine subject in no way lessens the scientific import of his painting (or explains his emphasis upon the foreground boulders). His intent was to illustrate the recent theory of glaciation. The smooth bedrock at the bottom edge of the painting alludes to the polishing action of glaciers; the melange of pebbles indicates the glacier's means of scouring the terrain, and the erratic boulders illustrate the carrying power and ancient extent of the glacier. In the foreground stand the effects of glaciation, and in the background lies the cause, the glacier itself. The mountainside at the left seems to be eaten away by the glacier. The cliffsides reflect the curves and waves of ice, as if the glacier were actively carving and scraping the mountain at the moment. The mobile undulation of rock and ice adds a sense of energy to the scene, and the baseless, unstable shape of the mountain at the left implies that it is being undercut by the momentous ice sheet. In Sir Charles Lyell's *Principles of Geology* of 1853 we are told that "the agency of glaciers in producing permanent geological changes consists partly in their power of transporting gravel, sand, and huge stones to great distances, and partly in the smoothing, polishing, and scoring of their rocky channels and the boundary walls of the valley through which they pass."[13] And Brett suggested the glacial sculpting of the valley's "boundary walls" at the left side of his painting. Brett's picture, although rigorously painted from the modern reality of the Alps, also envisions the ancient ice ages. The artist selected a site devoid of human presence, a place that reveals the appearance of the prehistoric world. The period when much of the globe was covered and deformed by oceans of ice, the distant past reconstructed by Agassiz, is here imaged. But if Brett pictured an ice age long past, he also suggested the impermanence of that past. He portrayed the rocks and mountains and ice as unstable, active elements, subject to change and the persistent energies of nature.

Brett's *Glacier of Rosenlaui* combines art and science and exemplifies the mid-nineteenth century's search for realism, objectivity, materialist truth, rational understanding, and detailed documentation. But art is always dependent upon art; to translate ideas of truthfulness and reality into visual terms requires some artistic "conventions," some examples of images that appear unadulterated, unsentimen-

talized, unbeautified. For Brett and many other British artists of the 1850s, the art that seemed most completely true to material reality was that of the Pre-Raphaelites. Brett became part of Pre-Raphaelitism, and his career is indicative of this movement's power to convert and spread. Brett's close-up, detailed depiction of complicated surfaces, his composition, lighting, focus, rendering of spatial depth, and even choice of subject were influenced by the rebellious art students who called themselves the Pre-Raphaelite Brotherhood. Brett concentrated only upon the most innovative facet of Pre-Raphaelitism—its realist perception of the world—and his art permits one to study this single element unclouded by other Pre-Raphaelite interests in archaism, modern-life subjects, or symbolism. But to see Brett in proper perspective, one must first look at the original Pre-Raphaelite Brotherhood.[14]

In the autumn of 1848, William Holman Hunt, John Everett Millais, and Dante Gabriel Rossetti, together with four other friends, formed the secret Pre-Raphaelite Brotherhood. Antagonistic toward most of the art of their day, they admired instead the "sincere" and "honest" art of the Italian and northern painters of the period before Raphael. They were also devoted to "truth to nature," the replication in paint of what was before their eyes without regard for traditional standards of beauty, conventions of "good" composition and lighting, idealization, or the purported superiority of general forms over particular details. They found the requisite dark corners, fluent forms, serpentine groupings, and predictable contrasts of type in contemporary works (for example, Ward's *Dr. Johnson*, plate 2) stale and uninspired. All the randomness, eccentricities, folds, creases, spots, specks, lines, colors, and disunities of the perceptual world were to be copied faithfully by the Pre-Raphaelites. Painting out of doors, in the midst of nature, directly before the subject, was encouraged.

But the Pre-Raphaelites never formulated a clear and logical statement of their goals, and indeed contradictions and personal differences are notable in their remarks and pictures. The exact connection between their fifteenth-century sources and their naturalism was never fully explained. Rossetti tended to adhere to the archaistic side of Pre-Raphaelitism, imitating the features of quattrocento art, whereas Hunt and Millais tended to emphasize the naturalistic aims of Pre-Raphaelitism, including in their Van Eyckian pictures minutely precise studies of foliage, rocks, and other natural forms. The brightness, "spirituality," naive awkwardness, and simplicity of fifteenth-century art had appealed to other artists before the Pre-Raphaelites. The German painters called the Nazarenes had humbly worked in the manner of quattrocento artists from 1810 onward, and had influenced William Dyce, John Rogers Herbert, Daniel Maclise, Ford Madox Brown, Cave Thomas, and other British artists in the 1840s.[15] The Pre-Raphaelites continued this movement, but struck a stronger note of realism and avoided perfectly oval faces, stylized gestures, and simplified bodies and garments. The linear, shadowless, brightly colored early Renaissance style was accompanied by a microscopic attention to detail and unidealized forms.

According to William Holman Hunt, John Ruskin had inspired this devotion to unalloyed realism when he advised young artists in the first volume of *Modern Painters* to "go to Nature in all singleness of heart, and walk with her laboriously and trustingly, having no other thoughts but how to penetrate her meaning, and remember her instruction; rejecting nothing, selecting nothing, and scorning nothing; believing all things to be right and good, and rejoicing always in the truth."[16] But there is, of course, no such thing as an objective, accurate transcription of nature, of the outside world. The brain always selects and orders the perceptions. Ruskin realized this, recognized that seeing is a product of the imagination. But Ruskin wanted artists to be true to their imagination, to their immediate sensations of nature. He wanted artists to avoid the traditional rules of art, to avoid conscious attempts to clarify, beautify, recompose, or simplify their perceptions.[17] The Pre-Raphaelites, at least Hunt and Millais, honestly sought to follow such dictates.

Hunt's *Rienzi* (1849, fig. 25) and Millais's *Ophelia* (1852, fig. 26) exemplify their efforts. The natural elements in both works were painted laboriously out of doors, directly before the subjects, without preliminary drawing. Every blade of grass, tendril, petal, stone, and clod was executed with care and detail. Each part of the pictures was studied with the same concentrated focus. Aerial perspective is minimal; spatial depth is lessened; and the perception of reality is not projected as a transient glimpse, but as a prolonged contemplation. Both works clearly rebel against the time-honored codes of refinement, purity, a hierarchy of pictorial parts, ideal forms, simplicity, grandeur, and broad effects, which had been followed by the High Renaissance masters and didactically espoused in England by Sir Joshua Reynolds.

Twenty years after the birth of Pre-Raphaelitism, the French impressionists also painted directly out of doors, avoided preliminary sketches and old-master conventions, used brilliant colors on a white ground, and had similar realist aims. But the impressionists avoided historical subjects, clear drawing, archaistic styles, and overt symbolism. Their vision of reality was also radically different from that of the Pre-Raphaelites, for although the impressionist world was similarly colorful and seemingly random, it was presented in a glimpselike fashion, blurred, in motion, ungraspable. Nature for the impressionists was solely a quality of light, indefinite and impermanent. For the Pre-Raphaelites, reality could be scrutinized at length and was not understood as a fleeting effect of a passing moment.

Pre-Raphaelite realism soon established its own conventions. Certain recurring traits became the standard indicators of "truth," "reality," "honesty" and were imitated by a host of artists in the 1850s. Hedges, ivied walls, rocks and pebbles, and an emphasis on detailed foregrounds became the conventional signifiers of unconventional realism in mid-nineteenth-century Britain. The tiny but notable pebbles that appear in the foreground of Hunt's *Rienzi* (fig. 25), and the overgrown wall that appears in Millais's *A Huguenot* (1852; private collection), were particularly fertile motifs. Paintings of stones and overgrown walls proliferated.[18] Brett's

25. William Holman Hunt, *Rienzi Vowing to Obtain Justice for the Death of His Younger Brother Slain in a Skirmish between the Colonna and Orsini Factions.* 1849. Oil on canvas, 32½ × 47½ in. Private collection.

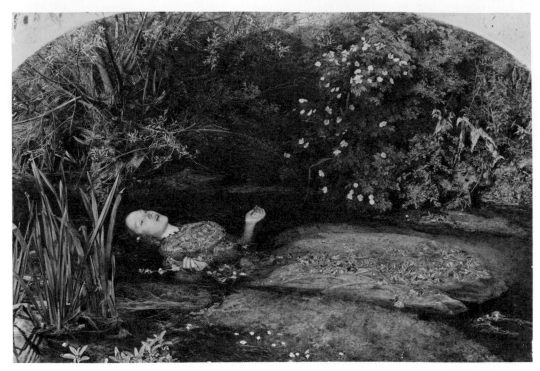

26. John Everett Millais, *Ophelia*. 1852. Oil on canvas, 30 × 44 in. Tate Gallery, London.

Pre-Raphaelitism is displayed in *The Glacier of Rosenlaui* not merely in the attention to foreground detail, willful objectivity, and avoidance of a grandiose arrangement of forms, but also in the choice of a pebbly, stony subject. Brett's rocks are as much a declaration of Pre-Raphaelite realism as a Renaissance nude that echoes the *Medici Venus* is a declaration of classical ideals.

Brett was certainly familiar with Pre-Raphaelitism before journeying to the Alps in 1856. When he entered the Royal Academy schools in 1854 at the age of twenty-three, Pre-Raphaelite art was a major force in the London exhibitions and could not have been ignored. Despite the press's vigorous denunciation of the brotherhood in 1850 and afterward (perhaps because the rebellious painters were purportedly antagonistic toward the Academy, or because their works were supposedly associated with Roman Catholicism and Tractarianism),[19] numerous young artists, and some older painters as well, followed the methods, manner, and aims of the Pre-Raphaelites. By 1854 Pre-Raphaelitism had even gained a measure of respectability, for John Everett Millais had become an Associate of the Royal Academy in 1853. John Ruskin, the Pre-Raphaelites' public defender and interpreter, was read religiously throughout the British art world. Brett was already friendly with intimates and associates of the Pre-Raphaelite circle before 1856, and wrote in his diary on May 18, 1853: "I am going on fast towards Preraphaelitism— Millais and Hunt are truly fine fellows. I greatly admire them and honor them—

Have resolved in future to go through a severe course of training and close childlike study of nature. In short follow their footsteps".[20]

But his first Pre-Raphaelite picture is *The Glacier of Rosenlaui,* and his conversion to the movement came only after his direct observation of a Pre-Raphaelite painter at work in the Alps. Brett's earlier landscapes are broadly painted, soft, and fluent pictures. A close personal relationship and firsthand experience of the hows and whys of style and attitude were the necessary mechanisms of Pre-Raphaelitism's initial influence on Brett. While in the Bernese Oberland he encountered John William Inchbold, who had already absorbed the lessons of Pre-Raphaelitism and had been personally guided by Ruskin. Inchbold was only one year older than Brett but had greater professional experience, and in the summer of 1856 he was hard at work out of doors painting views of Switzerland (fig. 27). Brett carefully watched Inchbold work, and "there and then saw that I had never painted in my life, but only fooled and slopped, and thenceforward attempted in a reasonable way to paint all I could see."[21]

Brett's words, from his diary, are coincidentally similar to those used by Holman Hunt to describe his own revelatory reading of Ruskin in 1847: "It was the voice of God. I read this in rapture and it sowed some seed of shame. . . . after[ward] I set myself to my task with a purpose instead of without."[22] Both artists underwent sudden and emotional conversions, and both appreciated their eye-opening experiences in moral terms: aimless follies and carelessness were replaced by a firm and laborious dedication to visual accuracy. Ruskin himself had had a similar conversion while drawing some ivy in 1842, and he too conceived of truthful seeing and

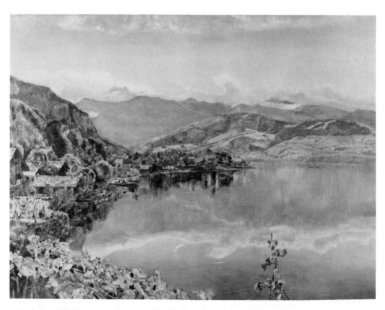

27. John William Inchbold, *The Lake of Lucerne, Mont Pilatus in the Distance.* 1857. Oil on board, 14½ × 18½ in. Victoria and Albert Museum, London.

truthful art as a moral imperative.[23] Pre-Raphaelite realism, the minute recording of that which lies before the eyes without manipulation, omission, or addition, may seem unimaginative, dull, and impersonal. But this realism, often contrasted to the grandeur, melodrama, and subjectivity of early-nineteenth-century romanticism, was at heart equally electrifying, vital, and even mystical. The piling up of facts was a revelation of divine order; the artist humbly submitted himself to nature, as a monk would to God. In the mid-nineteenth century, unadorned physical facts were charged matter, able to inspire passion. *The Glacier at Rosenlaui* was Brett's first picture painted entirely out of doors, detail by detail, and its sparkling clarity conveys not merely diligent concentration, but also intensity of faith, as if a veil had been removed and the world was first seen with crystal sharpness. Brett's new-found devotion was encouraged by Inchbold, who lent Brett money so that the younger man could continue to work on his painting in the Alps.[24] Ruskin succeeded Inchbold in his role of mentor around 1857. Apparently, Brett's surrender to the dictates of nature also required his surrender to the guidance of others.

Brett's relationship to Ruskin was one of dependence. The critic gave detailed suggestions. He very probably encouraged the artist to travel to the Val d'Aosta in 1858, and there personally coached him on the execution of a larger and more ambitious landscape.[25] The resulting painting (fig. 28) is impressive in its accumulation of detail, brilliance of color, and panoramic extent; but it lacks the hallucinatory sensitivity of *The Glacier of Rosenlaui,* and the cultivated terrain depicted is less stark and wondrous than the barren wastes represented in the earlier picture. Differences in size relationships are also significant. In the Val d'Aosta painting the goat and the figure of the sleeping girl provide a clear measure of scale, and the relative size of the rocks, trees, distant fields, and other areas are perfectly legible. But in *The Glacier of Rosenlaui* scale is less certain. Because no figure or house or object of standard size is included, the viewer remains unsure whether the foreground boulders are immense or small; the entire scene could be tiny or galactic. Only the trees at the upper left might give some sense of scale, but those firs are at an indeterminate distance and can be imagined very tall or dwarflike. The spatial relations between the foreground, glacier, and background mountain are also unclear. The unknowability of size in *The Glacier of Rosenlaui,* the possibility of shifting between the microscopic and the gargantuan, creates disquieting tension and mystery, which add an otherwordly character to the picture. Brett may have avoided organic forms so as to concentrate wholly upon his geological interest, but as a result he expressed the passion that underlay his scientific objectivity.

The sensation of intense awareness in *The Glacier of Rosenlaui* is akin to what one finds in Ruskin's written descriptions of nature—oceanic, exhilarated, and gripping. Allen Staley has suggested that Brett's trip to the Alps in 1856 and his concern with geology in this painting stemmed from reading the fourth volume of Ruskin's *Modern Painters.*[26] Brett's scientific bent and subsequent enslavement to Ruskin's personality support such a view. Volume four of *Modern Painters* (1856)

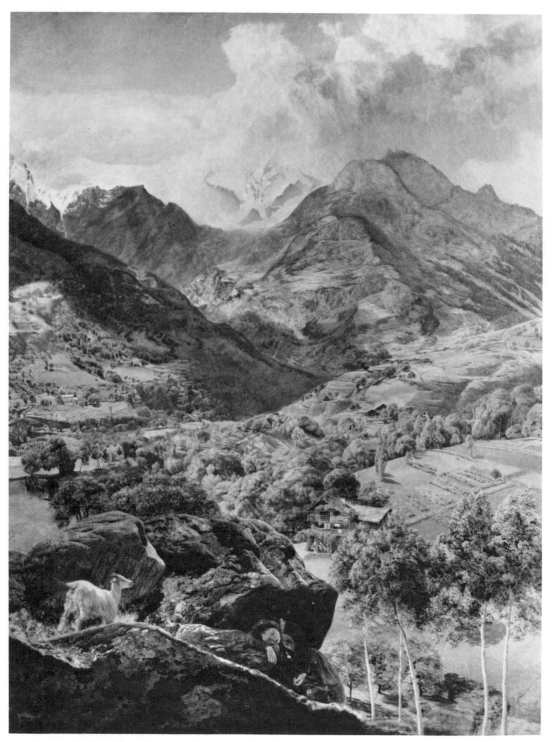

28. John Brett, *The Val d'Aosta*. 1858. Oil on canvas, 34½ × 26⅞ in. Coll.
Sir Frank Cooper, Wiltshire.

treats mountains, rocks, and geology extensively and is devoted more to science than art; it also includes some detailed illustrations of stones. Staley has claimed that the boulders in *The Glacier of Rosenlaui* correspond to some of Ruskin's peculiar classifications of stones: slaty crystallines and compact crystallines. But Ruskin failed to discuss glaciers, and the glacier is, after all, one of the major features of Brett's painting and intimately tied by glacial theory to the foreground boulders. Ruskin was in the Alps in the summer of 1856 and there advised his protégé Inchbold. Ruskin did not meet Brett at that time, but certainly Inchbold would have discussed the master's ideas with his new acquaintance.[27] If nothing else, Ruskin's merging of science and art would have appealed to Brett and surely infuses his painting. Ruskin wrote of painting in one sentence, and physics, optics, geology, or meteorology in the next, often judging art with regard to its scientific accuracy. Artistic truth and scientific truth seem to have been virtually the same in Ruskin's mind.

Brett's selection of the Alps as a place to paint in 1856 need not have depended solely upon Ruskin (although the Alps were among Ruskin's favorite sites), for Switzerland was a popular resort of English tourists in the 1850s. Ruskin's favorite painter J. M. W. Turner may also have been an inspiration to Brett, who wrote admiringly of Turner later in the century; and certainly the earlier master was strongly associated with Alpine scenery.[28] Turner, furthermore, was very much under discussion in 1856 (even though his reputation, despite Ruskin's preaching, was at low ebb): In March of that year the litigation surrounding Turner's will was finally settled, and as a result over 19,000 of his works were bequeathed to the National Gallery.[29] Turner's numerous Swiss mountain views may have stimulated Brett to journey to the Alps, but a comparison of the *Glacier of Rosenlaui* with a work such as Turner's *Glacier and Source of the Arveiron* (1803, fig. 29) reveals more differences than similarities. Turner's wild trees, craggy forms, and turbulent atmosphere deliberately echo the stormy landscapes of Salvator Rosa, whereas Brett's picture does not forcefully ally itself with artistic tradition. Turner's placement of the trees at the left side of the foreground is itself a standard procedure of landscape painters, a means of tying his image to the revered artists of the seventeenth century. Brett did not consciously allude to masters of the past; personal experience and direct perception were more important to him than the respectability of landscape painting. Turner dramatized his view: the trees are whipped and torn: diagonals crash into one another; strong contrasts of light and dark erupt throughout the picture; the blackened clouds roar into depth; and the viewer careens into the valley far below.

Each of Turner's shapes stretches or cracks or stabs to express the ferocity of raw nature. He heightened the terror of the scene (and also created a sense of awesome scale) by including a tiny goatherd with his flock in the foreground. Turner's landscape thus is seen in relation to man—as something threatening, fearsome, more powerful than puny mankind. The glacier and mountains and rocks that visually slide to the left are unstable elements that can destroy man. In Brett's painting one sees natural forces calmly and without concern for mankind. The

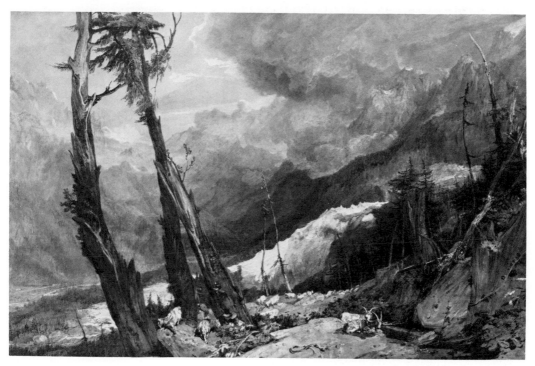

29. J. M. W. Turner, *The Glacier and Source of the Arveiron*. 1803. Water-color, 27 × 40 in. Yale Center for British Art, Paul Mellon Collection.

earth may move with titanic power, carving mountains and carrying boulders, but the movement is a slow process and has nothing to do with man's fate. Turner included a strong diagonal line at the lower right, which lead the viewer's eye swiftly into the tortuous distance. But the viewer of Brett's painting stops in the foreground and need not immediately leap into the glacier beyond. Brett's distant mountain rises from the mist, small and unferocious, whereas Turner's peaks bite the sky. The rhythmic undulations of the glacier and mountainside in Brett's work are descriptive features, expressive of movement and power, but not part of an overall pictorial design. Devotion to factual details overwhelms any attention to a large, coherent composition. The major lines of Turner's trees, clouds, mountains, and glacier, however, come together in a grandiose formal structure, an abstract orchestration of conflicts that is apprehended in its entirety. Turner generalized, whereas Brett particularized, and this difference marks Pre-Raphaelitism's divergence from earlier British landscape painting.

The guiding examples of Claude and Poussin, the imaginative organization of landscape forms into harmonious and poetic compositions, had lain behind British landscape pictures from the time of Richard Wilson in the eighteenth century until the mid-nineteenth century.[30] John Robert Cozens, Thomas Girtin, and Turner had wedded this grand tradition to topography, to the recording of specific places. They depicted real sites in nature with the sweep, monumentality, and moods of the old masters. John Constable also followed this course, painting the terrain of his homeland but aggrandizing those sites with references to Claude, Rubens, and other eminent masters; he generalized the forms, and like Turner, infused his

scenes with rich emotion. Some nineteenth-century landscapists, such as Thomas Creswick, worked in greater detail, but their miniature technique was a consistent mannerism, not a detailed dependence upon what the eye perceived. The Pre-Raphaelites rejected these conventions. The artist's direct and unselective confrontation with a specific place became the core of landscape painting. The viewer's eye wanders about Brett's painting without sure guidance. Niggling minutiae cover the work, suggesting multiple foci. Space is unclarified. We are not shown a set of gradually diminishing forms to understand the scene's depth. Where is that mountainside at left situated with regard to the foreground plateau? In Turner's picture the viewer's eye may leap and plunge, but there are constant horizontal planes (the plateau, the glacier, the mountains) that relate to each other in a receding order and inform the viewer of spatial depth. Brett's picture astonishingly opens up beyond the boulders without calculation or preparation. The Pre-Raphaelite dedication to things as they are produced some radically new configurations of pictorial space.

Brett and the Pre-Raphaelites also departed from the traditions of humble topographers, who like mapmakers provided specific information about specific places. In the eighteenth century artists such as Samuel Scott, Paul Sandby, and Thomas Malton delineated architecture, cities, and monuments. They and their followers in the nineteenth century were unaggrandizing delineators of the man-made. Canaletto was their major source of inspiration. They did not dabble in grandeur, poetry, grace, or expressiveness. But the topographers' geometric reconstructions of space, their artificial systems of light and shade and contour, and their emphasis on clear architectural volume are alien to Pre-Raphaelitism and to Brett's *Glacier of Rosenlaui*.

Brett's concern in *The Glacier of Rosenlaui* with natural rather than man-made forms, however, is part of a larger and older aspect of romanticism. To romantic landscapists from the late eighteenth century onward, truth often lay in uncultivated terrain, where God's handiwork instead of man's predominated. By the early nineteenth century, travelers on the grand tour looked beyond monuments of the past and metropolitan social graces to gaze at natural scenery.[31] This shift in attitude is particularly apparent in the growth of mountain views as a subject, and Brett's painting should be seen as part of a considerable Alpine tradition in British art.[32]

Alpine scenes first appeared in England in the 1770s, and Turner's picture can be seen as a continuation of eighteenth-century sublime mountain imagery. Turner was the first British artist to travel to the Alps (in 1802) with the specific intention of depicting them, although earlier artists had painted the mountains incidentally, while en route to or from Italy, or from memory of such journeys. John Robert Cozens, Francis Towne, and Phillip James de Loutherbourg had earlier produced awesome and horrific pictures of Switzerland—dark, unscaleable, raw, and threatening. The Alps elicited emotions of fear; they dwarfed man, rose to overbearing heights, were the home of avalanches, and thwarted human movement. Continuing to paint Swiss mountains buried in mysterious mist or rising to

monstrous altitudes until his death in 1851, Turner inspired numerous painters of Alpine awe. But Brett's mid-nineteenth-century Swiss view is unencumbered by gigantism or terror. *The Glacier of Rosenlaui* possesses crystalline beauty and icy clarity, but avoids melodrama, vertigo, danger, and impassability. The Alps have become a place of minute scrutiny, a setting for calm scientific exploration, and the Pre-Raphaelite emphasis on intimate foreground detail more than anything quashes conventions of mountain grandeur. Even Brett's distant clouds differ from Turner's mists. Brett's background atmosphere does not magically glow or swirl with mighty energy. The grayish-blue vapor is a representation of a specific meteorological condition, without sweep or majesty; it obscures the base of the mountains and the far reaches of the glacier, hindering spatial legibility, but is not an all-pervading force of divinity or mystery. Brett's clouds are small and insignificant; they do not form a rich skyscape or become Constable's "Organs of Sentiment."

The Glacier of Rosenlaui illustrates the brief eruption of realism that occured in British landscape painting in the 1850s. Before that decade scenery was prettified, or emotion-filled, or tradition-bound, or generalized or metaphoric, or imaginatively based, or religiously inspired. After the 1850s factual recording gradually disappeared. Landscapes became vague poetic suggestions (for example, the works of Whistler and his followers, fig. 56), or idealized visions of pastoral sweetness (the paintings of Myles Birket Foster), or planar arrangements of delicate abstract beauty (the works of George Hemming Mason and the Etruscan School), or bold rectilinear patterns in heavy impasto (the landscapes of the Glasgow School), or French-inspired glimpses of a sunny world, fleeting and unclear (the impressionist works of Phillip Wilson Steer). The scientific landscapes of the 1850s gave way to nostalgic evocations, mood paintings, or artificial plays of form, and the hard physical objects of Pre-Raphaelite landscape were often replaced by ungraspable light, unfocused and insubstantial.

Brett himself eventually moved away from Pre-Raphaelite realism. He continued to paint detailed scenes, and he studied the ocean and light effects on water in particular with scientific precision (fig. 30). But his later paintings exploit a panoramic approach and exhibit gigantic expanses of bold simplicity. Infinite space rather than intimate objects and textures dominates his later art. There are few detailed foregrounds, and his compositions are dramatically reductive. The randomness of the Pre-Raphaelite vision of nature, where no hierarchies exist and a blade of grass receives as much attention as a hero's head, is lacking in Brett's work after the 1850s. And when he painted close-up views of complex objects, such as the seaweed-covered rocks in his later seascapes, the details of texture are faked (fig. 31). Brett apparently pressed paint-splotched surfaces onto the canvas and then pulled them off, leaving a grainy, streaked, richly wrinkled blotch that admirably suggests a rock's weathered skin. (The surrealist Max Ernst employed this technique of "decalcomania" to achieve similar illusions of natural texture in the twentieth century). This method of portraying detailed surfaces is swift and effective. But it has little to do with Brett's earlier dedication to copying what his eye perceived, inch by inch, line by line, grain by grain.

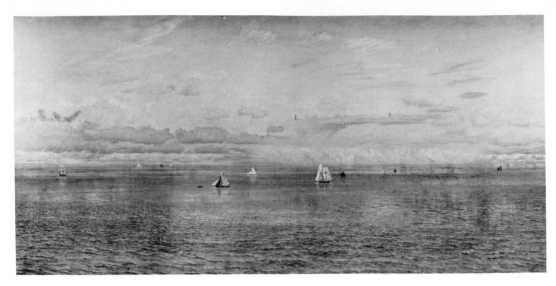

30. John Brett, *Britannia's Realm*. 1880. Oil on canvas, 41½ × 83½ in. Tate Gallery, London.

31. John Brett, *Rocky Coast Scene*. 1872. Oil on millboard, 9⅞ × 14 in. Fitzwilliam Museum, Cambridge.

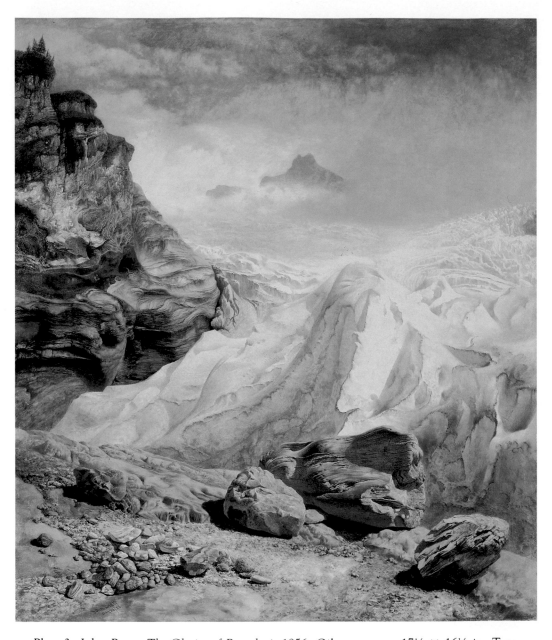

Plate 3. John Brett, *The Glacier of Rosenlaui*. 1856. Oil on canvas, 17½ × 16½ in. Tate Gallery, London.

32. John Everett Millais, *Chill October*. 1870. Oil on canvas, 55½ × 73½ in. ➤ Private collection, on loan to Perth Museum and Art Gallery.

If one compares *The Glacier of Rosenlaui* with *Chill October* (fig. 32), a barren view by John Everett Millais from later in the century (after Millais had given up Pre-Raphaelitism), some fundamental changes in British landscape painting become apparent. Brett's picture includes far more detail, is less simply composed, and sharply lit. But the major difference lies in the meaning of emptiness and frigidness. The uninhabited nature of Brett's work is almost a scientific necessity, a means to remove his factual study from human concerns and drama; the imagination's involuntary coloration of perception is the only entranceway for sentiment. The lack of humanity also serves to envision an epoch when the earth was covered with ice, to picture one of geology's recent theories. The vacant and cold spirit of Millais's painting is man-oriented, even though people are not depicted. The scene is not a document of perception or meteorology or geography, but a metaphor of human emotion.[33] Millais's picture is a mood painting, an expression of feelings of death, loneliness, and despondency, an image of human sentiment and the human condition. This associative function of landscape has a long tradition going back to the fifteenth century.[34] Only in the mid-nineteenth century did landscapists such as Brett attempt to set down their view of the world in major works without humanistic motives, ideas of beauty, or symbolic meaning. The imitative, unreconstructive, selfless method of Pre-Raphaelite painting itself held enough power, significance, morality, and truth.

William Holman Hunt
(1827–1910)
The Finding of the Saviour in the Temple

William Holman Hunt was deeply preoccupied with religion, and his zeal for the ideals of the Pre-Raphaelite Brotherhood he helped found in 1848 was tinged with fanaticism. In his later career he produced major Christian canvases wrought in sincerity and brimming with eccentric devotion.[1] Hunt first imaged his Protestant ideas on an ambitious scale in *The Finding of the Saviour in the Temple* (plate 4), which he began in the Holy Land in 1854 and finally completed in England in 1860. This richly detailed symbolic painting was the first great success of Hunt's career and embodies his deepest convictions regarding science, labor, Christianity, Judaism, and corruption. The thirty-two-figure composition portrays a scene in Herod's temple in Jerusalem. The rabbis of the temple recline at the left side of the interior, surrounded by musicians and attendants. Jesus stands in the foreground with his left leg forward as if to take a step. He has turned his back on the ornate chamber, and he buckles his belt while facing the viewer. At the right, Mary and Joseph have entered the interior, and the Virgin attempts to embrace Christ. A beggar sits on the steps beyond the doorway at the right, and below him are several workers; in the distance rises the Mount of Olives. The figures in the background of the temple include a lamplighter, a boy chasing away doves, a family buying a lamb for sacrifice, and a moneychanger.

The Finding of the Saviour in the Temple depicts an event in Christ's life described in the Gospel of Saint Luke (2. 41–52): the child Jesus leaves his parents, who had come to Jerusalem for Passover, astonishes the rabbis of the temple with his learning and understanding, and when recovered by Mary and Joseph replies to their chastisements "How is it that ye sought me? Wist ye not that I must be about my Father's business."[2] Most illustrations of this passage depict the moment when Christ disputes with the rabbis, astounding them with his erudition (in mid-century England the most famous painting of the subject was the one by Bernardino Luini in the National Gallery, which was then attributed to Leonardo). Hunt, however, selected a most unusual section of the story: the episode when Christ's disputation has ended, and when he has been found by Mary and Joseph. It is a curious sort of reunion,

for Christ does not fully accept his parents' protection and love. As the critic in the *Athenaeum* remarked, "Even his mother's embrace but draws the body closer to her, while the abstracted, vacant range of eye tells us how far off and how devoted is the spirit within. The idea of duty predominates above all."[3] Jesus seems to push away the Virgin's left arm, and stares into infinity. In a preparatory drawing (collection of Mrs. Elizabeth Burt, on loan to Ashmolean Museum, Oxford) Mary kisses her son, but in the final painting the kiss is unconsummated; the Virgin's mouth is left open, a poignant sign of her rejection.

Frederic George Stephens's pamphlet on the *Finding*, written in consultation with Hunt and published during the picture's exhibition in London, makes clear that Christ denies his earthly family so as to carry out his true father's "business," his sacrificial mission for mankind; he tightens his belt "as one who girds up his loins and makes ready for labor."[4] Hunt thus represented the moment of Christ's self-recognition: his conversion, the first realization of his appointed role on earth. A great many of the details in the *Finding* foretell Christ's sacrifice and future acts: a cross decorates Jesus's belt; the Mount of Olives, where Christ would be arrested, appears at the upper right; the moneychangers, whom Christ would chase from the temple, are in the background; an ear of wheat fallen on the temple threshold, Stephens tells us, alludes to the Old Testament sacrifice of the "first-fruits"—another sign of Christ's future death.[5] Stephens also pointed out the "pre-symbolization" of the background scene: "A father has brought his first-born to the temple, accompanied by his wife, who bears the child in her arms; the man has across his shoulder the lamb of sacrifice; a seller of lambs, from whom this has just been bought, counts the price upon his open palm of one hand, while, with the other, he presses back the anxious ewe who would follow her offspring. A boy with a harp goes before a priest, bearing a smoking censer,— the priest is to make the offering."[6] This background narrative not only stresses the sacrifice of Christ, the lamb; it also points back to the family struggle enacted in the foreground. As the ewe is prevented from succoring her lamb, so too does Christ hinder his mother's protective advance. Jesus's free choice of death is thereby underlined.

The painting also identifies Christ as the Messiah: the temple door is inscribed in Latin and Hebrew with a quotation from Malachi (3.1) describing the coming Messiah, "And the Lord, whom ye seek, shall suddenly come to his temple." Hunt also portrayed Jesus as the builder of a new order by depicting the construction workers in the right background. Stephens stated that these laborers are completing the temple; they are "finishing a stone which, when raised, will be the 'head stone of the corner'"—a phrase taken from Psalm 118.22 that refers to the cornerstone of heaven, the "gate of the Lord, into which the righteous shall enter" (Psalm 118.20).[7] Ruskin had employed the same biblical phrase and allusion when he interpreted the symbolism of a painting by Tintoretto.[8] Hunt read Ruskin religiously, and his construction scene, like that described by Ruskin, refers to Christ's building of a new temple, a new law, an entranceway to heaven; Christ

himself is the cornerstone of heaven. Even though Hunt was deeply concerned with historical accuracy and went to great lengths to assure the authenticity of the architecture, costumes, geography, and racial types in his picture, he was certainly inaccurate in showing the temple still under construction. Authoritative authors on the subject, including those read by Hunt, all agree that Herod's temple had been completed by the time of Christ's birth.[9] Hunt evidently felt that in the case of his construction scene, symbolic truth outweighed historical truth.

The workers also act as a contrast to the inactive rabbis reclining in the golden temple. Christ is shown about to leave the perfumed priesthood; he "makes ready to labor," and is thus akin to the workers in the outer courtyard. This robust and strong-limbed Jesus (features emphasized by Stephens) represents the divine dignity of labor.[10] Hunt was engrossed by this theme and elaborated it further in *The Shadow of Death* of 1873 (Manchester City Art Gallery), where Christ appears as a humble carpenter. Hunt said of *The Shadow of Death*, "one of the problems of our age concerns the duty of the workman; [Christ's] life as now examined furnishes an example of the dignity of the laborer."[11]

Hunt's statement and picture reflect the ideas of Thomas Carlyle, who repeatedly declared the sanctity of manly labor. In 1853, a year before Hunt began the *Finding*, Carlyle visited Hunt's studio and roundly condemned Hunt's early portrayal of Christ, *The Light of the World* (fig. 33). Carlyle complained that Hunt had there depicted the Lord as a feeble, pretty priest, decked out in bejeweled finery.[12] In the *Finding*, Hunt "corrected" his vision of Jesus and brought his Christ into line with Carlyle's view by contrasting Jesus with the priesthood in the temple and linking him to the workers.

The finding of Jesus in the temple, St. Luke tells us, happened during the celebration of Passover, and the girding action of Jesus in Hunt's painting alludes not only to labor, but also to the first Passover, when the Hebrews were freed from Egyptian slavery. According to Hunt, the Passover meal was originally eaten in a standing position, "with loins girded," as if to go on a journey. But in Christ's time, noted Hunt, the event was celebrated in a reclining position.[13] Hunt's Christ reenacts the first Passover: he is the new Moses, liberating men from bondage. And among the enslavements which Hunt's Christ rejects is certainly the temple and its inhabitants. In Stephens's pamphlet the rabbis are described pejoratively. Beginning at the left, is an "old and imbecile" blind rabbi; "he is the type of obstinate adherence to the old and effete doctrine and pertinacious refusal of the new." The next rabbi is of the same character. To the right is a rabbi, "eager, passionate, argumentative; his strong antagonism of mind will allow no such comfortable rest as the elders enjoy. He has been arguing with Christ." The fourth rabbi is "proud and self-centered" and "complacent and haughty. . . . He assumes the judge, and would decide between the old and the new." The Levite with the reddish beard who leans over the "judge" is "a time-serving, fawning fellow." The fifth rabbi is "good natured" and "would willingly let every one else be as much at ease." Next to him is a latecomer, "envious" and "acrid," an "evil-looking, greedy souled

33. William Holman Hunt, *The Light of the World*. 1854. Oil on canvas, 49⅜ × 23½ in. By permission of the Warden and Fellows of Keble College, Oxford.

creature." The last rabbi at the right is a fat sensualist, "a mere human lump of dough."[14] In Jerusalem in 1854, Hunt was repelled by the Jews' undue reverence for the physical material of the Torah; they kissed the scrolls' coverings and bowed before it.[15] He considered these actions idolatrous, and in the *Finding* the boy who kisses the cloth and the boy who keeps flies from the Torah with a whisk reveal this idolatry. The despicable character of the temple is further indicated by the boy who chases away the doves. Hunt's doves, following conventional symbolic representations (which stem from Matthew 3.16 and John 1.32) obviously signify the Holy Spirit. As Jesus enters the temple, so too do the doves, and like him, they are unwelcome. Despite Saint Luke's description of Jesus as a beloved and brilliant student in the temple, Hunt's painting presents just the opposite state of affairs: Jesus turns his back on the priesthood. One of the *Finding*'s reviewers noted that Hunt "paints for us as Luther, had he been an artist, might have painted the Son of Man."[16] And indeed, Hunt's painting is loudly Protestant in its rejection of the priesthood; Jesus turns away from the gilded organization of religion.

Much of the symbolism in the *Finding* is typological. In typological symbolism one thing, event, or person looks forward to another thing, event, or person.[17] Thus, Moses, the liberator of the Hebrews, is a type of Christ, the New Testa-

ment's liberator of all men. The background sacrifice in the *Finding* is a type of Christ's future sacrifice. The cornerstone erected by the workmen in the *Finding* typologically foretells Christ's heavenly role, Christ's building of a new temple, Christ's construction of the New Law. Narrowly, typology refers to Old Testament prefigurations of the New Testament, but typological symbolism can also be perceived within Christ's own life. Thus the youthful Christ's action in the *Finding* symbolically anticipate later events in Christ's life. Events of history, forms in nature, and seemingly chance aspects of ordinary life could also be viewed typologically as references to Christ. Typology differs from allegory in that both the signifier and the signified are equally real, whereas in allegory the symbolic object or person or story has no true existence outside of its allusive role. Typological symbolism was not viewed as a clever invention or a literary device; it was a discernment of truth, a revelation of God's hidden plan. Moses's acts were not just incidental parallels to those of Jesus; they were divinely ordained foretellings of those Christian acts. Hunt's utilization of typological symbolism testifies to his faith in the secret design of Christ's life and of history as a whole.

On the other hand, typological symbolism is a commonplace in Western art, a traditional device of artists from early Christian times onward.[18] The Middle Ages witnessed its most prevalent use in the arts (as well as in sermons), but this kind of symbolism continued to be widespread in later ages. Nearly all Old Testament scenes and images of the madonna and child that include eucharistic objects are to some extent typological, and art historians have frequently noted typological meanings in many Renaissance works.[19] This form of Christian allusion never died out. In nineteenth-century England, typological explication of Scripture is found among all Christian sects—Catholics, Tractarians, Low Church Anglicans, and Nonconformists alike. There was nothing novel in Hunt's employment of typology, but the emphasis that he and the other early Pre-Raphaelites placed on it is in accord with their combination of medievalism and realism. Through typology reality and symbol could be merged and given equal weight.

The firmly Protestant character of the *Finding* was something new in Hunt's work. Carlyle had called *The Light of the World* a "papistical fantasy," and Hunt himself admitted that in the early years of the Pre-Raphaelite Brotherhood he had appreciated the Oxford Movement (also called Tractarianism and High Church Anglicanism).[20] Tractarianism emerged in the 1830s as a force within the Church of England that sought to return to the Catholic faith in rituals, regalia, architecture, Mariolatry, monasticism—in short, in every way save belief in papal infallibility and supremacy. The Tractarians especially glorified the profession of the priesthood.[21] Hunt's patron Thomas Combe was an ardent Tractarian.[22] In 1846 Hunt painted *Dr. Rochecliffe Performing Divine Service* (private collection), a subject from Sir Walter Scott's *Woodstock* that presents High Church Anglicans in a favorable light.[23] And in 1852 Hunt painted a portrait of Canon Jenkins of Oxford in garments suggestive of Tractarianism.[24] Hunt's Pre-Raphaelite Brother D. G. Rossetti painted pictures celebrating the Virgin Mary (fig. 46)—hardly a Protestant theme—and Rossetti's sister and mother were deeply within the Tractarian

34. John Everett Millais, *Christ in the House of His Parents*. 1850. Oil on canvas, 34 × 55 in. Tate Gallery, London.

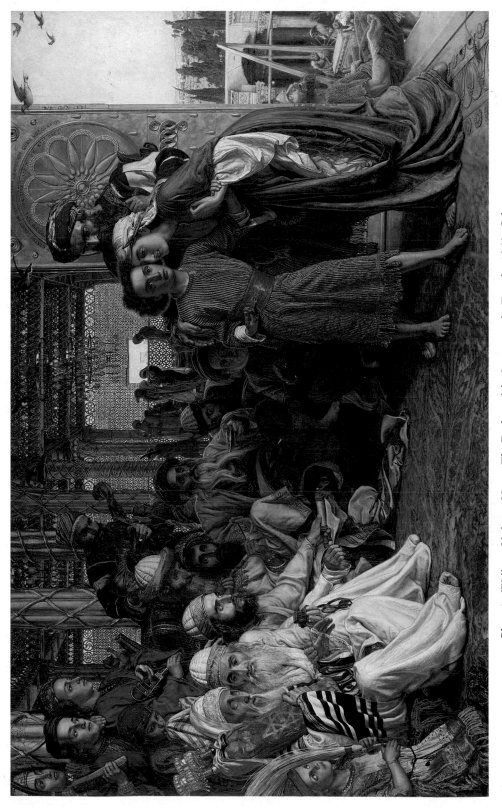

Plate 4. William Holman Hunt, *The Finding of the Saviour in the Temple.* 1860. Oil on canvas, 33¾ × 55½ in. By courtesy of Birmingham Museums and Art Gallery.

fold.[25] James Collinson, one of the original seven Pre-Raphaelites, became a Roman Catholic.[26] John Everett Millais, another Pre-Raphaelite Brother, attended Tractarian services, and his *Christ in the House of His Parents* (1850, fig. 34) is in many ways a Tractarian tract.[27] The archaic, gothicizing, Nazarene-inspired aspects of Pre-Raphaelitism carried overtones of Catholicism in the 1840s and 1850s.

The hostility of the press toward the Pre-Raphaelites after 1850 owed partly to the artists' Tractarian sympathies.[28] The conflict between Low Church Evangelical Protestants and Tractarians was fierce in the 1850s: riots occurred over ministers' garments and the decoration of altars; ecclesiastical trials were held on small matters of doctrine; and violent words erupted throughout England.[29]

There is little doubt that the Pre-Raphaelite circle, Hunt included, was tinged with Tractarianism. Hunt claimed in later years that his conversion to an undoubting faith in Jesus Christ came suddenly in 1851, and his vision of Christ at that moment was depicted "by divine command" in *The Light of the World* (fig. 33).[30] But the crystallization of Hunt's specifically Protestant outlook is apparent for the first time in the *Finding*. The otherworldly gaze of Jesus represents a moment of conversion akin to Hunt's own recognition of religious truth in 1851. (Hunt utilized a similar facial expression to denote Christian conversion in *The Awakening Conscience* of 1853 [fig. 35]).[31] In the *Finding* Hunt embodied an anti-Tractarian conception of Christianity, not only in the presentation of the Savior as one who rejects the ornament and regalia of the temple and its priesthood, but also as one who pushes aside the Virgin. The Mariolatry of the Oxford Movement is distinctly denied.

The *Finding* can be viewed as a specific reversal of John Everett Millais's Tractarian painting of 1850, *Christ in the House of His Parents* (fig. 34). Millais's picture, like Hunt's, includes a mother-son couple in the foreground, a group of workmen, and the same sort of foretelling symbolism (for example, the crucifixion of Millais's Christ is indicated by the child's wounded hand and the instruments of the Passion). But whereas Millais's Jesus calms the fears of his solicitous mother (he seems about to kiss her), Hunt's Savior rejects his mother's advances. Whereas Millais's Jesus is a feeble child, sensitive, girlish, and incompetent in the carpenter's shop, Hunt's Jesus is muscular, commanding, healthy, and setting out to work. Stephens declared in his pamphlet on the *Finding*: "Certain painters have erred in representing Christ as a feeble ascetic . . . and Mr. Hunt is as certainly right in the fine Englishness of his idea of the splendid body of our Lord."[32] Millais's painting had been condemned in 1850 as "hideous" and "ugly," "a collection of splay feet, puffed joints and misshapen limbs."[33] And in mid-century England the portrayal of holy characters as weak, diseased, suffering, or ugly was associated with Tractarianism and Roman Catholicism.[34] In Charles Kingsley's topical novel *Yeast* (1851), a High Anglican complains that his new stained-glass windows are not "Catholic" enough, and another character unsympathetically explains: "He means that the figures' wrists and ankles were not sufficiently dislocated, and the

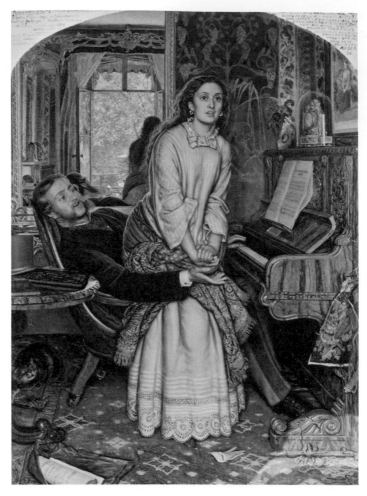

35. William Holman Hunt, *The Awakening Conscience*. 1854. Oil on
canvas, 29¼ × 21⅝ in. Tate Gallery, London.

patron saint did not look quite like a starved rabbit with its neck wrung."[35]
Mortification of the flesh to achieve spirituality was offensive to English Protestant
taste, and Hunt's Jesus with a "splendid body" rejects all that Millais's Jesus
implied.

Hunt's Christian painting also differs from that of Millais in its Near Eastern
details and setting. Hunt did not depend upon the traditions of the (mostly
Catholic) old masters to provide appropriate costumes, character types, and archi-
tecture. Instead, he traveled to the Holy Land in 1854 as if on a scientific expedi-
tion, to gather material for his scriptural paintings and to paint on the sites where
Jesus walked. The Near East was widely considered a living museum of antiquity, a
place untouched by modern life where ancient ways and people still existed.[36] To
find out what Jesus and the Patriarchs had worn and how they had acted, one had

only to examine the age-old modern inhabitants. David Wilkie had journeyed there in 1840 with the same intentions, but he died on the return voyage without completing any of his biblical images.[37] And in France Horace Vernet had successfully carried out similar projects to orientalize religious paintings.[38]

Hunt was aware of these predecessors but sought to execute his authentically Near Eastern scriptural pictures with greater exactitude, Pre-Raphaelite realism, and disregard for artistic convention. No artificial compositions, classical draperies, Apollo-like Christs, generalized settings, or homages to Raphael were to mar his dedication to historical religious truth. Hunt's Jesus wears common Arab garb; the models were Eastern Jews; the rabbinical costumes were studied with care, and the position of the temple in relation to the background landscape is exactly that of the original temple on Mount Moriah. Hunt not only traveled to the place of his painting's subject, but also read Leviticus, Exodus, Josephus, the Talmud and authoritative secondary texts.[39] Scientific investigation and religious spirit were intertwined, and for Hunt this was a particularly Protestant approach. With the Reformation, wrote Hunt, "came the gradual opening of fresh opportunities of research; and these were increasingly used by literary commentators until, in the early years of this century, a positive knowledge of the history [of Christ] had arisen which made the painting of pictures illustrating the Old and New Testament in imitation of the types of far-gone centuries a mere declaration of extinct faith, in the patrons and in the painter."[40]

Hunt contrasted Protestantism's acceptance of reason and science with Catholicism's acceptance of superstition and falsehood. He mockingly noted in Jerusalem in 1854 that "some years ago St. Stephens Gate was on the North of the town: but as some building was undertaken in that quarter to make it inconvenient to show, they [the Catholics] transferred the name to one at the East of the City, which is fully accepted by all pilgrims as the proper place to kiss."[41] For Hunt, "the aid of inexhaustible science should be used to convey new messages of hope to fresh broods of men."[42] And his descriptions and explanations of the *Finding* read like research notes. Stephens noted the unconventional effects of Hunt's unwavering historical accuracy. The *Finding*, he wrote,

> "is based on the national idea of thorough examination and study going before an undeviating and unflinching execution of the principles thence arrived at. Going to the East, and acquainting himself with the manners and customs of a people that have preserved the same unchanged from age to age, Mr. Hunt . . . discarded the old-fashioned blanket draperies of artistic convention. . . . Dealing with an incident of Jewish history, he could not avoid painting those concerned therein as Jews; and what is more, Jews of the soil, where the physical peculiarities of that people are likely to have been best preserved."[43]

The *Finding* is a marvelous jumble of Hunt's "scientific" findings. The corinthian capitals visible in the courtyard where the workers labor stem from the Jewish historian Josephus's description of the temple.[44] The undulantly patterned

marble floor in the temple foreground is based on Hunt's study of the local rocks of Jerusalem, as well as on talmudic descriptions of the temple floor, full of curious veins and resembling a sea.[45] The musical instruments were based on ancient Egyptian instruments in the British Museum, which Hunt studied on his return to London from the East in 1856.[46] The rabbis sit on the floor in Oriental fashion, reflecting Hunt's experience of Eastern customs. Even his symbolic scene of the boy chasing the doves from the temple had some historical justification. The talmudic scholar John Lightfoot, whose books Hunt consulted, noted that the temple possessed a scarecrow of some sort to prevent birds from defiling the holy edifice.[47]

The greatest challenge to Hunt's method was the depiction of the temple's architecture, for no detailed accounts of Herod's temple, the second temple, have come to light. Josephus's brief mention of corinthian columns was duly noted and incorporated, but Hunt admitted that ultimately the character of his interior had to depend on his imagination.[48] He nevertheless selected the forms and styles of his imaginary temple architecture with reason, research, and deference to the architectural theories of his day.

Traditionally, artists represented Herod's temple as a classical structure. Such a convention was perfectly justified, given Josephus's terse account and the dominating influence of Roman culture in the period. But Hunt was antagonistic toward classical taste, not merely because of his Pre-Raphaelite ideas, but also because classical art was pagan. When faced with the beautiful classical architecture of Baalbek in 1855, Hunt despaired, "the riddle forced itself to my mind How all this was done for a false god when the true God could have been found. How was it that men who could have done such work should not have been called to His service?"[49] Hunt certainly intended to portray Judaism in the *Finding* as corrupt and idolatrous, but the Jews' religion and the temple which represented it were still the historic source of Christianity. Hunt preferred to view the fount of Christian truth as a native Oriental monument, something with roots in the Holy Land, rather than a bastardization of heathen ideas. Following the suggestion of the scholarly John Lightfoot, Hunt concluded that in all probability Herod's temple reflected the appearance of the first temple of Jerusalem, built by Solomon and destroyed by Nebuchadnezzer long before.[50] And the Bible contains some complicated descriptions of that revered first sanctuary of the Israelites. Hunt's golden columns derive from the Second Book of Chronicles (3.7). And the pomegranates that decorate the *Finding*'s capitals stem from the description of the temple's brass pillars in the First Book of Kings (7.18). The painting's curiously arboreal, vine-covered columns apparently are based upon John Lightfoot's commentary on the First Book of Kings (7.17).[51]

Stephens justified Hunt's metallic tree-columns, however, not with reference to the Bible's descriptions of Solomon's temple, but to recent archeological discoveries of such columns by Victor Place at Khorsabad.[52] Even though the archeological finds were distant in time and place from Herod's temple, Stephens tried to

bless Hunt's painting with the authority of science. They were also meant to affirm the nonclassical origins of Judaic architecture.

Stephens claimed that Assyria and Egypt provided more accurate clues to the unknown style of Jewish art than did Greece or Rome.[53] His comments also reflect a fad for things Assyrian in the 1850s and 1860s, which sprang directly from the Nineveh reliefs and bulls excavated by Henry Austen Layard and acquired by the British Museum.[54] Assyrian archeology was a matter of justification, not influence. Hunt did not rely on any Assyrian monuments or artifacts for the details of his painting, but he did employ some Egyptian motifs. The musical instruments' Egyptian sources have already been mentioned, and the papyrus decoration on the temple door and threshold are also Egyptian. But the general appearance and many details of Hunt's interior are distinctly Islamic. The rafters and ceiling are embellished with complicated arabesques: teardrop shapes, diamond patterns, and ovals are multiplied and overlapped in a manner reminiscent of Muslim *muqarnas*. In addition, the lattice screen in the background is clearly an elaboration of Islamic design. The whole chamber recalls the luxurious harems of John Frederick Lewis, who had preceded Hunt in the East and whose works were familiar to Hunt (fig. 77).[55] Hunt studied Islamic buildings throughout the East, but he completed the background of the *Finding* in England, and to do so he visited the Alhambra Court of the Crystal Palace in Sydenham.[56] Hunt's temple is largely a free variation on the Alhambra's lavish architecture.

Hunt sought inspiration in Islamic design not only because such decor would pointedly orientalize his scriptural image, or because the corrupt and moneyed temple would thereby be associated with *Arabian Nights* luxury, but also because Muslim architecture was widely conceived by both popular publishers and serious scholars as an expression of ancient native style, and as a late reflection of earlier Judaic forms.[57] In his journal and memoirs Hunt repeatedly denied the Muslims any originality as builders; they took all they knew, he claimed, from Byzantine architecture.[58] As Hunt's temple interior in the *Finding* makes clear, he undoubtedly saw this Byzantine-Islamic style as ultimately Judaic, essentially Eastern in origin. He played up the importance of the Byzantine Christians and played down the importance of the infidel Arabs, because it was vital for Hunt that Christianity and not Islam be the true link with the ancient Judaic and Oriental past. The beauties of Muslim culture could be appreciated with an easy conscience if one believed that they were not basically heathen.

The architecture displayed in the *Finding* as a whole is a conglomeration of styles without harmony. Classical, Egyptian, Islamic, and other styles are freely juxtaposed. The painting's synoptic effect is of a gaudy mélange. Western travelers in the Near East in the nineteenth century, Hunt included, nearly always harped on the region's seemingly jumbled character. Astonishing varieties of people, objects, colors, and beings cavorted before Occidental eyes without order or clarity; wild contrasts of every sort appeared; the East was continually called a hodgepodge, and undoubtedly this perceived character bolstered biased Western notions of Eastern

irrationality, disorder, and inscrutability.[59] But the visual incoherence of the *Finding* is also the result of Pre-Raphaelitism's unselective devotion to detail and Hunt's piecemeal method of execution. Various parts were worked out at different times, and although consistent space is discernible, no firm pictorial structure provides focus and clarity. The lack of order, in one sense, is a testament of Pre-Raphaelite realism. The scattered, random, cluttered character of the normal visual field is captured, undigested and unwashed.

In comparison with earlier Pre-Raphaelite pictures, however, the *Finding* shows signs of change. The colors of the *Finding* are not quite so brilliant. The paint was not applied consistently on a wet white ground, as Hunt and Millais had done previously. The figures are more modeled, and shadows play a more significant role. The figures are also no longer narrow, linear, and gothic types, but full and forcefully volumetric bodies. The quaintness and intimacy of early Pre-Raphaelitism are absent, and a new sense of monumentality appears. The viewer looks upon a grand stage filled with large and active figures.

The altered tone of Hunt's Pre-Raphaelitism hints at some of the broad changes in British art that would occur in the 1860s, changes toward grandeur, idealization, and noble beauty and away from niggling realism.[60] But the *Finding*'s greatest historical importance lies in its full-fledged orientalization of a biblical subject. The representation of scriptural scenes had always been a thorny issue for British Protestants. Puritan iconoclasm lurked in the background, and Hunt felt compelled on several occasions to justify his religious pictures. He attributed the Reformation's destruction of art to a few ill-intentioned fanatics and pointed out that the ancient Jews had produced various kinds of religious art, despite the commandment against graven images.[61] But to take such a defiant stand was rare. Before Hunt, few British artists painted sacred history with any consistency, dedication, or renown. Benjamin West had created a horde of stilted biblical pictures, unattactive homages to the old masters that were famous in their day but forgotten immediately after his death in 1820.[62] William Blake had drawn highly personal biblical scenes touched by fantasy and a mannered style, but they were too eccentric to excite a broad following. The *Finding* gave scriptural illustration in England a powerful focus and a new vitality that was echoed in British religious art through the rest of the century.

Hunt's sectarian viewpoint, naturalistic symbolism, and unsettling mother-son portrayal were not influential. But after 1860 it became de rigueur to include Arab garments, authentic Eastern landscape and architecture, Judaic racial types, and all manner of Oriental accessories in any Old or New Testament image. Ford Madox Brown, Simeon Solomon, John Rogers Herbert, and Edward John Poynter (fig. 36) were but a few of the artists who carried on the lessons of the *Finding*.[63] And more specific reflections of the *Finding*'s figures, lighting, gestures, cluttered composition, and imaginative temple appear again and again for forty years. The *Finding* firmly turned religious history painting away from any dependence on the High Renaissance masters, and also from any stylized medieval manner. The

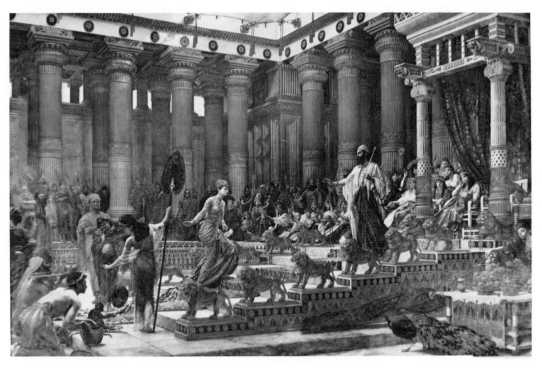

36. Edward John Poynter, *The Visit of the Queen of Sheba to King Solomon.*
1890. Oil on canvas, 91 × 138 in. Art Gallery of New South Wales,
Sydney, 1892.

influence of Hunt's dedication to factual historical accuracy reveals much about
Victorian religion. Earlier in the nineteenth century, a romantic artist such as
Samuel Palmer could find intimations of divinity in an English cornfield, bathed in
moonlight and alive with spiritual mystery. But in later decades God could only be
found and imagined in the actual places where he had physically lived. A material
and rational basis for belief had to be present. One could not conceive of Christ in
any other place than the Near East, where he had lived as a man. As the spirit
waned, the physical history of God was depicted with ever greater emphasis.

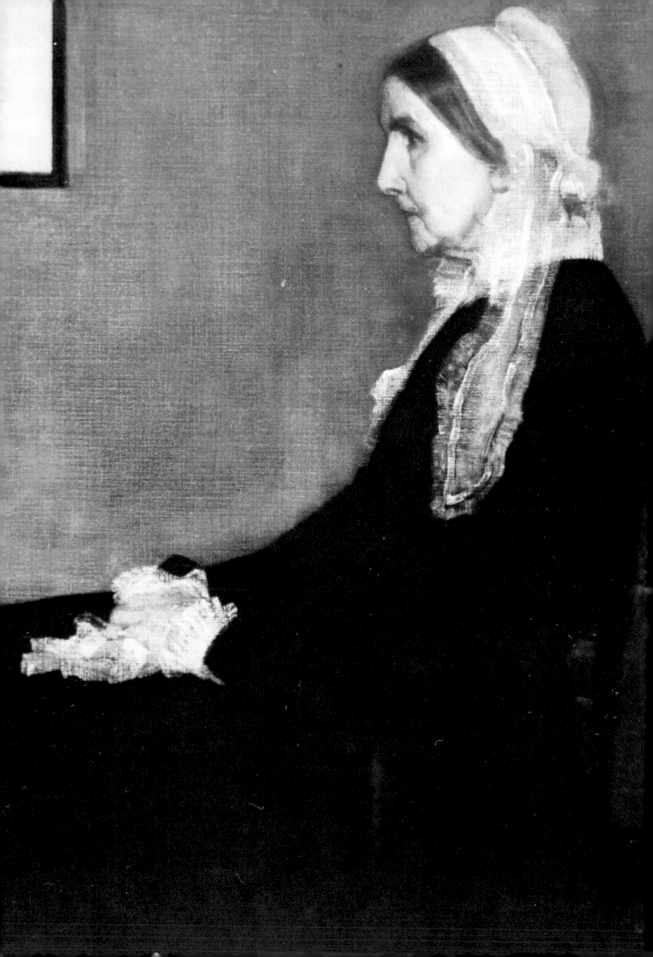

5

James Abbott McNeill Whistler
(1834–1903)
Arrangement in Grey and Black:
Portrait of the Painter's Mother

Whistler's Mother (plate 5) has become a cliché, a resolute portrait of Victorian propriety that has been reproduced, elaborated, and parodied affectionately by advertisers, cartoonists, and illustrators.[1] One popular writer on the picture has declared with assurance that "for thousands her image has come to represent the very meaning of Mother."[2] Yet the status of the image as a maternal archetype in the public psyche is odd, for James Abbott McNeill Whistler's figure lacks any hint of tenderness or nurturing protectiveness. This stiff old woman is not a mother conceived in the appealing form of a traditional madonna. Even the writer quoted above, who viewed *Whistler's Mother* as a loving and sentimental portrait, admitted that "she is cherished as a symbol rather than a person."[3]

Whistler exhibited his painting in 1872 as *Arrangement in Grey and Black: Portrait of the Painter's Mother,* and the cool, impersonal primary title accords with the tone of the work.[4] The figure sits in absolute profile, on our eye level, but facing left with a steady gaze and pursed lips. The gown of the widow creates a flat black silhouette, a stark contrast to the white cuffs, lace cap, and handkerchief in the lap. The soberly framed pictures and black dado on the wall reinforce the severity, rectilinearity, and planarity of the composition. The careful arrangement of large two-dimensional forms produces an asymmetrical pictorial equilibrium, definitive and frozen in time. The dark curtain at the left balances the off-center figure, and its rectilinear shape and planar position reflect the framed pictures. The slender back and legs of the profiled chair echo the narrow black lines of the picture frames and carpet stripes. The softly curving and slightly blurred lines of the lace cap are similar to those in the Japanese floral pattern on the curtain and in the etching hanging on the wall (which represents Whistler's *Black Lion Wharf* of 1859, fig. 37).[5] The correspondences of form generate pictorial unity. The rectangular footstool is tilted slightly upward, and the figure's dress falls beyond the bottom edge of the canvas, affirming the two-dimensionality of the work. The few perspectival stripes on the carpet provide the only sense of space,

37. J. A. M. Whistler, *Black Lion Wharf*. 1859. Etching, 5⅝ × 8⅞ in. Metropolitan Museum of Art, New York, Harris Brisbane Dick Fund, 1917.

and even they are dim, unforceful elements in the painting. The palette consists of subtle shades of gray, black, and white, and additional unity (as well as two-dimensionality) is given by the emphatic weave of the canvas, which creates an even texture of vertical and horizontal strands throughout the picture.

Various pictorial sources have been put forward as the inspiration for *Whistler's Mother:* Roman statues of seated matrons, Tanagra statuettes, ancient grave steles, the works of Alfred Stevens and Alphonse Legros.[6] But none of these suggested prototypes, all of which would have been known to Whistler, is entirely convincing as a direct influence. The Roman works are too forcefully sculptural and imperious (Whistler's mother is not a domineering matriarch); the Tanagra figurines are too small in scale and fragile; the figures by Stevens turn in space, have qualities of elegance, and are surrounded by a wealth of naturalistic detail; the paintings by Legros are too quaintly medieval and filled with curvilinear patterns; the profiled heads on steles are bent downward in melancholy, and the bodies are too weighty. Furthermore, contemporary profile portraits by Whistler's friends Edouard Manet, Edgar Degas, and Henri Fantin-Latour, which bear similarities to *Whistler's Mother,* lack the severity, flatness, or impersonal tone of Whistler's work.[7] For example, *Madame Camus* by Degas (fig. 38) may be a portrait in profile, with a mirror frame on the wall that plays an important formal role, but there the resemblance to *Whistler's Mother* ends. *Madame Camus* is a psychological study, an

image of brooding, and the soft, dark atmosphere helps create a reflective mood. The lighting also adds a note of mystery and tremulous, uncertain depth. The lady's fan suggests leisurely action. In Degas's hands the profile view implies not impersonality but privacy; it indicates a sitter alone with herself, unaware of our presence. The accessories and furniture of *Madame Camus* depict social class and economic status and tell of the sitter's taste. Material lushness is represented, and all the accoutrements portray the life and personality of the woman. Whistler's friends may have influenced *Arrangement in Grey and Black* peripherally, but none seems to have provided a direct spark.

Richard Redgrave's *Going to Service* (1843, fig. 39) includes a profiled widow-mother dressed and positioned like Whistler's figure, and she also rests her feet on a stool in a similar fashion.[8] But even if Whistler was familiar with this closest of prototypes, the atmosphere and context of Redgrave's figure differentiate her from Whistler's creation. The Bible-reading mother in Redgrave's work is part of a narrative and social commentary, a picture of the economic level and sufferings of Victorian governesses. Whistler's isolated and unemotional figure stares to the left, but at nothing. She does not link up with any other character. She is not part

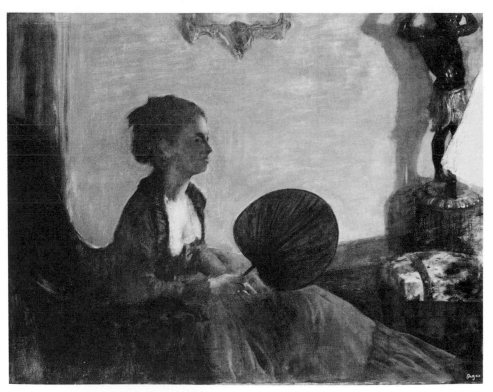

38. Edgar Degas, *Madame Camus.* 1869–70. Oil on canvas, 28⅝ × 36¼ in.
National Gallery of Art, Washington, D.C., Chester Dale Collection, 1962.

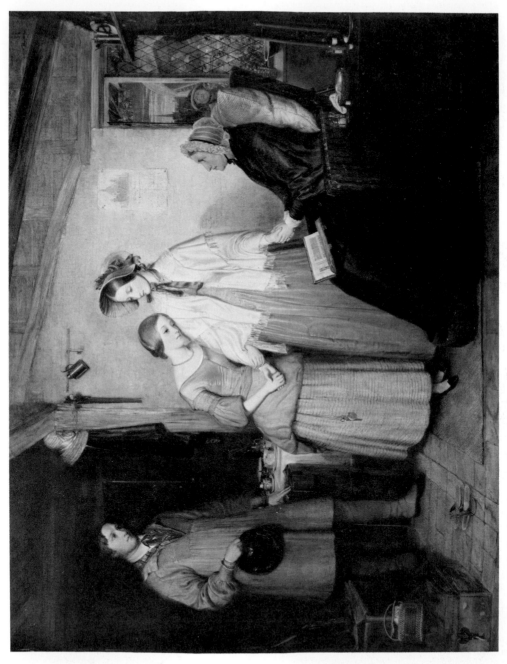

39. Richard Redgrave, *Going to Service*. 1843. Oil on canvas, 31 × 39½ in. Sold Sotheby's Belgravia, London, March 19, 1979.

of any story dependent on duration or development. And the environment of Whistler's mother defines no very particular class, period, status, or place.

Arrangement in Grey and Black, however, did not arise from nothingness. Certain general and longstanding influences on Whistler's art are evident in the portrait of his mother. The two-dimensionality and decorative design of Japanese prints, which Whistler absorbed in the 1860s, find an echo in the portrait, and the ornamentation of the curtain recalls the Japanese stuffs that appear in such aesthetic confections as *Caprice in Purple and Gold: The Golden Screen* (1864, fig. 40). The utilization of an asymmetrical, rectilinear composition with particular emphasis upon framed pictures as structural members can be found in the works of such seventeenth-century Dutch artists as De Hooch, whom Whistler admired. But *Arrangement in Grey and Black* departs from the overly ornate japanisme of his earlier work and from the baroque spatial depth of seventeenth-century Dutch art. As far as general influences are concerned, the art of Velasquez (fig. 41) is equally prominent in the portrait and was the foremost inspiration of Whistler's mature art.

Upon completing *Arrangement in Grey and Black* in 1871 Whistler showed the picture to his patrons, the Leylands, at Speke Hall near Liverpool. There he hung the work in the great dining room between an unfinished portrait of Mr. Leyland

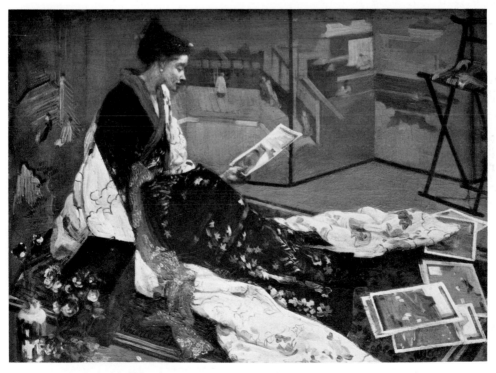

40. J. A. M. Whistler, *Caprice in Purple and Gold: The Golden Screen.* 1864. Oil on canvas, 19¾ × 27 in. Courtesy of the Freer Gallery of Art, Smithsonian Institution, Washington, D.C.

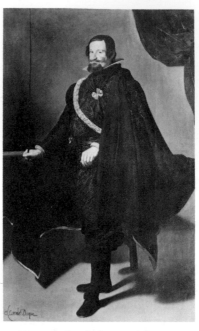

41. Diego Velasquez, *Count Duke of Olivares.* Oil on canvas, 85 × 51 in. The
Hispanic Society of America, New York.

by Whistler (fig. 42) and a painting by Velasquez.[9] Whistler's mother reported
that "the two portraits bore comparison with the painting of the Spanish artist to
his satisfaction."[10] The pose of Whistler's portrait of F. R. Leyland reflects the
stance of many of Velasquez's figures, whereas the seated, profile posture of Whis-
tler's mother does not. But both works partake of Velasquez's sobriety, austerity,
taste for body silhouettes, and dark coloration. The dignified and remote presence,
the sensitive shapes, simplified background, somber monochrome palette, defini-
tive silhouette, and evident texture of the canvas in Velasquez's *Count Duke of
Olivares* (fig. 41), for example, bear a kinship with *Whistler's Mother.*

A taste for Velasquez had become common in France and England as early as the
1820s and 1830s, and by the 1850s it had merged with a realist tendency. Courbet,
Manet, Ribot, and many writers of the mid-nineteenth century saw Velasquez as a
forebear of realism, as a painter of unalloyed, unexaggerated truth.[11] Whistler
participated in this phase of Parisian realism and produced Rembrandtesque and
Courbetesque images of low life and the contemporary world until around 1862.[12]
But Whistler's Velasquezism from *Arrangement in Grey and Black* onward is not an
affirmation of realism. In the eyes of the mature Whistler, Velasquez stood as a
master of subtle tones who mixed all his colors with black, as a creator of rarified
balances, elegant forms, and mysterious indefiniteness.[13] John Everett Millais had
similarly turned to Velasquez in the 1860s—not as a hard-nosed realist who
painted mythological scenes as if they were peasant genre—but as a master of

bravura, a genius of flickering brushwork and subtle suggestion (fig. 43).[14] For both these painters, Velasquez represented beauty, not truth.[15]

Whistler's name was first linked to that of Velasquez by the *Times* critic in 1860. The reviewer wrote of Whistler's *At the Piano* (fig. 44), exhibited at the Royal Academy: "In colour and handling this picture reminds me irresistably of Velasquez. There is the same powerful effect obtained by the simplest colours. . . . The execution is as broad and sketchy as the elements of effect are simple."[16] And *At the Piano*, as many commentators have pointed out, is certainly the most obvious predecessor of *Arrangement in Grey and Black* in Whistler's oeuvre. *At the Piano*, begun in London in 1858, portrays members of Whistler's family, as does *Arrangement in Grey and Black.* The artist's half-sister Deborah and her daughter Annie are presented in a modestly comfortable aesthetic interior. The flat black silhouette of the figure seated in profile, the shallow planar space, the asymmetrical arrange-

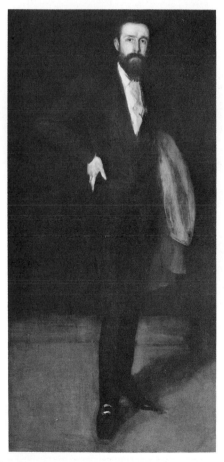

42. J. A. M. Whistler, *Arrangement in Black: Portrait of F. R. Leyland.* 1870–73. Oil on canvas 76 × 36⅛ in. Courtesy of the Freer Gallery of Art, Smithsonian Institution, Washington, D.C.

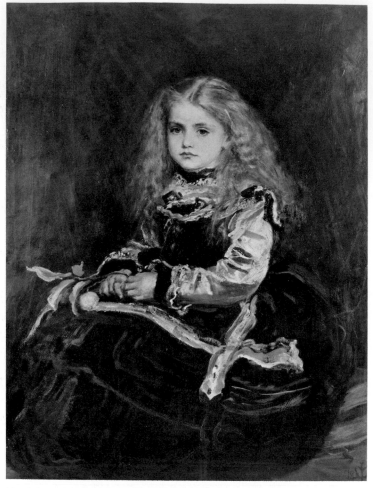

43. John Everett Millais, *Souvenir of Velasquez*. 1867. Oil on canvas, 40 × 32 in. Royal Academy of Arts, London.

ment of forms in a horizontal field, the use of framed paintings and a dado as major compositional elements, the simplified shapes and the muted colors (mixed with black or gray) all relate to the portrait of Whistler's mother painted more than a decade later. Nevertheless, there are some notable differences: the color scheme of *At the Piano* is not so monochromatic as that of the later work; the earlier picture contains a greater number of forms and more complicated shapes and lines. In addition, *At the Piano*, with its intimate communion between player and listener and its presentation of domestic activity, is psychologically very different from *Whistler's Mother*. The familial warmth, movement, relaxation, and suggestion of narrative separate *At the Piano* from the iconic and severe *Arrangement in Grey and Black*. Whistler's half-sister concentrates on her music, and her daughter responds to the sounds, but Whistler's mother rigidly gazes beyond the borders of the canvas to some abstract zone, uncommunicative and unengaged.

Between *At the Piano* of 1858–59 and *Whistler's Mother* of 1871 lie Whistler's

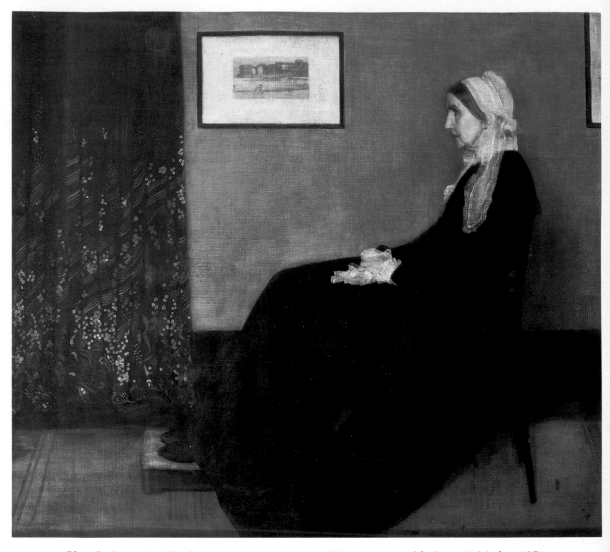

Plate 5. J. A. M. Whistler, *Arrangement in Grey and Black: Portrait of the Painter's Mother.* 1871.
Oil on canvas, 56 × 64 in. Musée du Louvre, Paris.

varied essays in realism, more ornate and complex interior groups, visions of exotic luxury, scenes of raw nature, and an unfinished series of classical compositions.[17] Some of these works are marginally linked to the *Mother* by their sense of pattern, or calm balances, or sensitive silhouettes. But only *The White Girl* of 1862 (fig. 45) is on as ambitious a scale, and like the *Mother,* also presents a monumental single figure, portrays a person intimately tied to the artist's private life (the model for the *White Girl* was Jo Heffernan, Whistler's mistress), and seems to define Whistler's aims and highest abilities at an important point in his career. The *White Girl* is also the ultimate source of the Mother's monochromism, for the 1862 picture is Whistler's first essay in single-color painting. In 1872 Whistler gave the *White Girl* a new title: *Symphony in White, No. 1,* thus identifying his work with the abstract art of music, defining his art as a similarly pure arrangement of form without story, naturalistic justification, or illustrative function.[18] The 1862 painting, Whistler suggested in the 1870s, is expressive but not descriptive, a study of rarified color harmonies and shadings, a subjectless experiment in white on white. Whistler thus tried to associate the early *White Girl* with his later art-for-art's-sake aesthetic. He tried to make the *White Girl* conform to the same unemotional, severe, unengaged sensibility that is found in the *Mother.* But the *White Girl* is not like *Arrangement in*

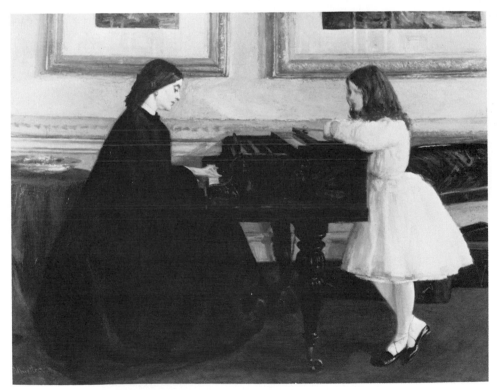

44. J. A. M. Whistler, *At the Piano.* 1858–59. Oil on canvas, 26⅓ × 35⅝ in. Taft Museum, Cincinnati, Louise Taft Semple Bequest.

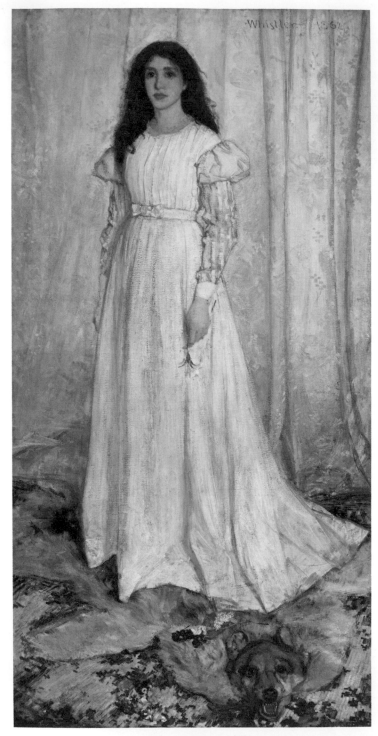

45. J. A. M. Whistler, *Symphony in White No. 1: The White Girl*. 1862. Oil
on canvas, 84½ × 42½ in. National Gallery of Art, Washington, D.C.,
Harris Whittemore Collection, 1943.

Grey and Black, and the important differences between the two pictures lie not so much in pictorial structure as in the expression of emotion and meaning.

The *White Girl,* despite what Whistler implied in the 1870s, is very much a symbolic narrative and a study in human passion. The *White Girl* achieved scandalous notoriety at the Salon des Refusés in Paris in 1863, and the critic Castagnary, who reviewed the work at that time, was right to interpret the painting as an allegory of the loss of virginity, "the morning after."[19] The picture presents a series of paradoxes, of interwoven "befores" and "afters" on the theme of sexual awakening. The girl is slight and fragile; her hands hang defenselessly at her sides. Yet she towers above the viewer, monumental, superior, gigantic. She holds a drooping flower, a symbol of her altered sexual state, a note of loss, of surrender. Yet the woman stands erect atop a ferociously headed wolf skin: she is the conqueror of the virile beast. Her white gown suggests a formal bridal robe, but the unbound, tangled hair indicates a private moment, a view behind the ritual regalia. Her gaze is dreamy and inward, an expression of wonderment, a recognition of change, loss, and power. The white dress and curtain speak of virginity in this work that portrays the death of virginity. The figure is both helpless victim and a dominating femme fatale. The color plays not merely a formal role, but also a symbolic one. The variations of virgin white are modulations of innocence. The shimmering delicacy of the palette suggests the fragility of purity.

The monochromism of the *White Girl,* which was eventually continued in *Arrangement in Grey and Black,* may possibly derive from the white-on-white still-lifes of Jean Baptiste Oudry, an eighteenth-century painter. Whistler in his student days in Paris copied French rococo paintings and may have known Oudry's works.[20] But the whole conception of the *White Girl,* including its monochromism, symbolism, beauty, and somnambulistic air, is more strongly related to the art of Dante Gabriel Rossetti, one of the original members of the Pre-Raphaelite Brotherhood. In 1850 Rossetti completed *Ecce Ancilla Domini!* (fig. 46), a sexually charged vision of the Virgin Mary in which the color white plays a prominent role.[21] Whistler became close friends with Rossetti in the early 1860s and found the Pre-Raphaelite sympathetic in decorative taste and bohemian ways. Whistler may not have actually seen Rossetti's picture, but he would likely have heard about it.[22] The *White Girl* reflects generally Rossetti's neurasthenic portraits of symbolic women, with their richly flowing hair, loose garments, and somnambulistic psychological density (fig. 47). The *White Girl* is essentially part of the later phase of Pre-Raphaelitism dominated by Rossetti, in which the initial naturalism of the movement was abandoned in favor of dreamy beauty, sensuality, nostalgia, and mysterious symbolism.

The differences between the *White Girl* and the *Mother* illustrate some of the changes in Whistler's career. The *Arrangement in Grey and Black* is not overtly tied to a narrative subject, and the distinctly symbolic accessories, expressive glance, and sensual notes are absent. The *White Girl* shows us Whistler as a probing psychologist interested in symbolizing human emotions and relationships, but

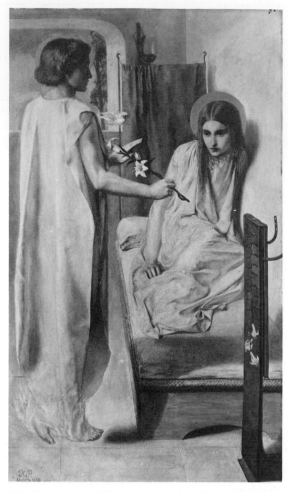

46. Dante Gabriel Rossetti, *Ecce Ancilla Domini!* 1850.
Oil on canvas on panel, 28½ × 16½ in. Tate Gallery,
London.

these concerns seem to be denied in *Arrangement in Grey and Black.* The grays and blacks in the 1872 painting may merely be a homage to the dark tones of seventeenth-century Spanish art and an indication of Whistler's new austerity. Black would be the dominant color in many of his subsequent Velasquezian canvases.[23] But *Whistler's Mother,* the artist's first orchestration of blackness, might still retain some vestige of monochromism's originally emblematic function, some residue of the color symbolism that played such an important role in the *White Girl.* The somber coloration of *Whistler's Mother* may represent widowhood, death, and loss. In the center of *Arrangement in Grey and Black,* and quite clearly painted in gold, is Mrs. Whistler's wedding ring. Like Queen Victoria, Whistler's mother was an eternal widow, always dressed in black, ever observant of the rituals of widowhood. Her husband had died in 1849.[24] Whistler produced an image of a wife bereft, lifeless, all in black, and staring at something not visible. The framed pictures on the wall look like nothing so much as funereal stationery, the standard black-

bordered writing paper of those in mourning. But the understated theme of widowhood is not doleful or a tribute to survival: the picture remains distant, silent, and inexpressive.

Whistler commenced this portrait of his mother in 1871 without much preparation. He had been working on a painting titled later *Annabel Lee* (fig. 48), but his model failed to arrive at the studio, and Whistler therefore began to paint *Arrangement in Grey and Black*, executed on the back of an earlier painting.[25] Mrs. Whistler first posed standing, but finding the stance tiring, artist and mother soon settled for a seated portrait. The quick transition from *Annabel Lee* to *Arrangement in Grey and Black* is intriguing. Whistler could not have moved in a more contrary direction. The first work is a sumptuous frontal nude, wrapped in diaphanous draperies, open, inviting, sensual, and relaxed. The portrait of his mother is strict and remote, a totally different image of womanhood, a mother without life, a widow in black. Perhaps Whistler conceived his mother's portrait in relation to *Annabel Lee,* as a subsequent stage in the process of life, the last step in a portrait of the ages of man.

Whistler's friend Algernon Swinburne in 1888 rejected a purely aesthetic interpretation of *Arrangement in Grey and Black* and wrote that "it would be useless for Mr. Whistler to protest . . . that he never meant to put . . . intense pathos of significance, and tender depth of expression into the portrait of his venerable

47. Dante Gabriel Rossetti, *Lucrezia Borgia.* 1860–61. Watercolor, 17 × 9¾ in. Tate Gallery, London.

48. J. A. M. Whistler, *Annabel Lee.* Late 1860s. Oil on canvas, 29⅛ × 20 in. University of Glasgow, Birnie Philips Bequest.

mother."[26] Swinburne was an intimate acquaintance of Whistler and undoubtedly knew of Whistler's filial devotion, as well as of his artistic aims. We should consider the poet's interpretation seriously, but also note that Swinburne's comments specifically caused Whistler to end their friendship abruptly.[27] Although we can perhaps see the figure in *Whistler's Mother* as a solitary, pure, and resigned widow who elicits our respect, are "intense pathos" and "tender depth of expression" the proper words to describe the emotional context of the painting? Are not these words too passionate? Can we discern any psychological state or emotional character in the figure's face? The eyes do not weep, strain, or fall into revery. The mouth is pinched—but with age, not intense emotion. She does not slump down under some burden, or clutch her handkerchief with desperate force, and her protruding feet suggest neither a commanding presence nor a pathetic weakling. She is neither relaxed nor tense. And does not her strictly profiled position remove her from any intimate relation to us? We are worlds away from the meaningful glance and posture, and psychological richness of the *White Girl*. Perhaps Swinburne's word "venerable" may be appropriate, but even so, the figure is not to be venerated in ecstasy or on some grandiose altar. We are at eye level with the venerable lady, not beneath her. Swinburne may have been influenced by some private knowledge of Whistler's feeling for his mother, but are such feelings really expressed on the canvas? Innumerable critics have, like Swinburne, interpreted the *Mother* as a sensitive, moving portrait. But they have probably done so because they could not believe that the artist would depict his own mother in such a cold fashion. Their concept of motherhood colored their vision. *Arrangement in Grey and Black* is a very unusual image of a mother, uncommon in its complete lack of emotion. Over the decades, parodists have been equally divided between those who see the lady as a poor sweet thing and those who view her as a representative of Victorian rectitude.[28] Significantly, when satirists have paraphrased *Whistler's Mother* with the intention of portraying kindly "good old mom," they have always altered the image radically; they have made the old woman smile, or knit booties, or relax in a rocking chair, or sit in a homey interior.

The critic in the *Academy* in 1872 was perhaps most accurate in noting the "Protestant" character of the portrait.[29] Here was a respectable mother without any hint of Catholic madonnahood. And Anna McNeill Whistler was in fact deeply Calvinist and righteous. Her sympathetic biographer remarked that "some have accused her of being a strict and joyless Puritan."[30] Mrs. Whistler's letters are filled with pious exhortations, biblical quotations, and expressions of unflinching knowledge of the true path.[31] In Russia (where her husband helped construct railways) she spent a good deal of time dispensing fundamentalist religious tracts among the Orthodox multitudes. The coolness of the portrait conveys something of the sitter's unbending religious ideals. But Whistler, true to his public artistic credo, declared in 1878 that

> Art should be independent of all claptrap—should stand alone, and appeal to the
> artistic sense of eye or ear without confounding this with emotions entirely foreign to

it, as devotion, pity, love, patriotism, and the like. . . . Take the picture of my mother, exhibited at the Royal Academy as an *Arrangement in Grey and Black*. Now that is what it is. To me it is interesting as a picture of my mother; but what can or ought the public to care about the identity of the portrait?[32]

Whistler here actually describes his art as two-sided, as having both a public and a more private face. Whistler does not deny his own personal interest in the portrait of his mother, but wishes to keep that sentimental aspect from the spectator's investigation. He is determined to efface emotion and to keep any potent meaning from the public gaze. In *Arrangement in Grey and Black* Whistler selected the impersonal profile view, and all his flattening devices that turn the image into a decorative assemblage of harmonious shapes seem calculated to hinder human expressiveness and emotional rapport with the audience. Whistler's painting stands as an exercise in purifying discipline. His detached aestheticism is a method of ordering and neutralizing psychologically intense subject matter. And there is no doubt that Whistler was very deeply attached to his mother.

"Jemie" was Mrs. Whistler's first and favorite child, and he continued to call her "Mummy" throughout his life. They lived together in London from 1863 until 1875 (Whistler quickly moved his mistress, Jo, out of the house when his mother arrived), and he did not marry until 1888, seven years after Anna McNeill Whistler's death.[33] Whistler allied himself with his mother's Scottish lineage and Southern ancestry and sympathized with the Confederacy in the American Civil War (his father's Irish family was transient and rarely resided in the South).[34] Whistler himself chose to add his mother's maiden name, McNeill, to his own name at the age of seventeen.[35] Mrs. Whistler's letters to family and friends are overwhelmingly concerned with her son's activities, which she followed with great attention, ever ready to dote, console, and praise. She was a constant presence in the artist's life, and the relationship between mother and son was intense. *Arrangement in Grey and Black* makes that relationship remote, quiet, unpassionate. Whistler's art effectively desensitizes and rigorously controls a most passionate subject.

Whistler had begun a portrait of his mother in 1867 which remains unlocated,[36] and he also began a drypoint etching of the same subject at some time between 1863 and 1878 (fig. 49).[37] The print was never completed, but shows his mother standing, head slightly bowed, peering at the viewer with a gentle and kindly expression. Her gown is broad and undetailed, and provides the lively head with a monumental pedestal. This sweeter and bolder presence lacks the significant restraint of *Arrangement in Grey and Black*. From the mid-1860s until the painting of his mother, Whistler unsuccessfully sought a more disciplined art. He worked on the "Six Projects," unfinished attempts at classical nudes with Japanese touches akin to the reserved classicism of his friend Albert Moore. He complained in this period of his improper training, his inability to draw. He longed for the exacting talents of Jean Auguste Dominique Ingres, the French neoclassical master.[38] This unprolific stage in Whistler's career represents a search for a more ordered, less realist art, for classical calm and simplicity. And it was not until the portrait of his

49. J. A. M. Whistler, *Whistler's Mother*. Drypoint. 10 × 6
in. Courtesy of the Freer Gallery of Art, Smithsonian Institu-
tion, Washington, D.C.

mother that Whistler managed to complete a major work. His desire for discipline
had finally found its proper object. The subtraction of sentiment, intimacy, sub-
stance, and psychological depth from significant subjects became the basis of many
of Whistler's paintings. It was his method of dealing with the world. Among the
many memoirs and recorded anecdotes published by Whistler's friends, there is no
truly intimate portrait of the man, no picture of the artist in private without his
public face. We are told only of his amusing repartees, escapades, public disputes,
and bold strivings against philistine English taste. We never meet the man within;
his public life as an extravagant dandy, brilliant wit, man about town, and scathing
critic seems to have been a defensive mechanism to hide his vulnerable self. And
so too are many of his pictures, especially the portrait of his mother, a means of
keeping sensitive affairs quiet. The coolness of Whistler's mature art was not just
an aesthetic doctrine; it was a psychological necessity.

Whistler did not practice his aesthetic abstractions on neutral objects or anony-

mous people and places. He often chose subjects of consequence, topicality, and strong association—only to deflate them, to diminish their meaning, to render them bland and impotent. In the portrait of Thomas Carlyle (*Arrangement in Grey and Black, No. 2*, fig. 50), which sprang directly from the painting of the artist's mother, Whistler presented the revered thinker of the age with a touch of melancholy in the profiled head, but essentially without personality, power, or sentiment.[39] How different is G. F. Watts's representation of the same man (fig. 51). Like Mrs. Whistler, Carlyle becomes a flat shape locked into a decorative construction, rather than a person of substance. The system of horizontals and verticals is exquisitely balanced. The sage's walking stick, aligned with the left chair leg, bends ever so slightly so as to mirror the delicately curved chair back. The subtle play of rounded silhouettes against the rectilinear scheme adds counterpoint but no sense of animation, or any hint that the frozen harmony will ever change. And the artificiality of this volumeless world of gray and black nuances is also brought forth by the unnaturalness of the subject: a man, jammed against a wall, is seated indoors wearing an overcoat, covering his legs with a blanket, and balancing a hat on his knees.

Whistler's Mother and *Carlyle* depart from most portrait traditions and developments in nineteenth-century England. Whistler rejected entirely the eighteenth-century conventions of chiaroscuro, posture, and composition followed by David Wilkie, Martin Archer Shee, Francis Grant, and later Millais. Even an eighteenth-century master like George Romney, in his most severely neoclassical works, portrayed his sitters turning in space, making gestures suggestive of informality, or gazing in the direction of the spectator. From the time of Thomas Lawrence, early in the nineteenth century, many portraits had begun to smile in England; the friendliness and personality of the sitter were thereby implied. The affable smile put the subject on an intimate level with the viewer, avoiding status-conscious hauteur. But Whistler rejected this development toward humanness, just as he rejected the dashing bravura and tiptoe elegance of Lawrence's portrait style, or the exaggerated intensity, implying depth of soul and fervor, found in the portraits of Benjamin Robert Haydon (fig. 52) and other romantics. Whistler's two pictures are also devoid of the intimacy, awkward charm, and fragility that characterize the works of so many early Victorian miniaturists and minor portraitists (for example, Sir George Hayter); and the spaceless and artificially arranged portraits resist the nineteenth-century tendency to portray an individual amid his possessions and in his habitual environment. Ward's homey portrait of Thomas Macaulay in his study (fig. 53), for example, is diametrically opposed to Whistler's works.

Some early Pre-Raphaelite portraits possess rigidity, flat patterning, and Holbeinesque clarity, but in color, wealth of detail, polished surface, cluttered composition, archaism and artistic sources, they are distant from Whistler's images. The great Victorians portrayed by G. F. Watts from the 1860s onward appear with knitted brows, lofty gazes, dignified postures, thoughtful expressions, and gran-

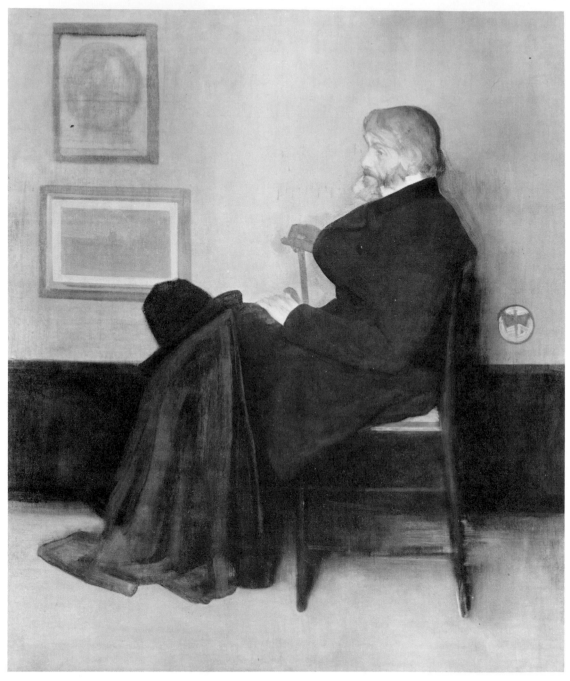

50. J. A. M. Whistler, *Arrangement in Grey and Black No. 2: Portrait of Thomas Carlyle.* c. 1873. Oil on canvas, 67 × 56 in. Glasgow Art Gallery.

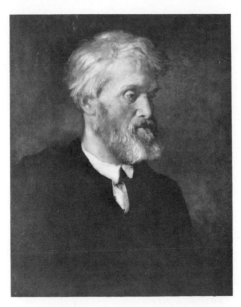

51. George Frederic Watts, *Thomas Carlyle*.
1868–77. Oil on canvas, 26 × 21 in. National
Portrait Gallery, London.

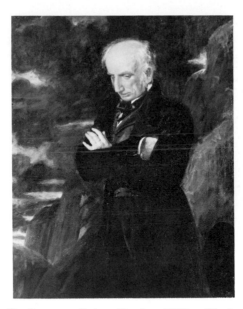

52. Benjamin Robert Haydon, *William Words-
worth*. 1842. Oil on canvas, 49 × 39 in. Na-
tional Portrait Gallery, London.

53. Edward Matthew Ward, *Thomas Babington Macaulay in His Study*. 1853.
Oil on canvas, 25 × 30 in. National Portrait Gallery, London.

diloquent allusions to Renaissance masters (fig. 51). Watts sought to probe the character and elaborate the stature of the sitter. Whistler, in contrast, effaced and controlled his subject, removing any touch of disturbing metaphysics, emotion, and meaning. The icy pomp and dazzle of Franz Xavier Winterhalter's court portraits at mid-century, the suave grace and freedom of John Singer Sargent's works late in the century, and the occasional iconic, frontal portaits of Watts and Frederick Sandys (which give the sitter an awesome power) are all contrary to *Whistler's Mother* and *Carlyle*. A number of the dark and austere male portraits by Millais (fig. 54) and Frank Holl, which first appear only in the 1870s, have a sobriety similar to that of Whistler's two paintings. But in those portraits, often based upon the art of Velasquez, the shadows frequently create a deep and mysterious space; the figures loom out of blackness (instead of becoming a crisp, flat pattern), and the sitter's interior world is always suggested.

Whistler's Mother and *Carlyle* are anomalies not only in nineteenth-century English portraiture as a whole, but also in Whistler's career as a portraitist. His later portraits, in the 1880s and 1890s, are tremulous evocations similar to his

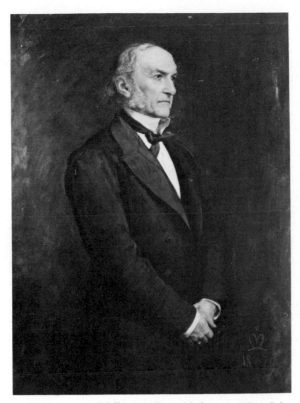

54. John Everett Millais, *William Gladstone*. 1879. Oil on canvas, 49 × 36 in. National Portrait Gallery, London.

foggy, suggestive landscapes. The sitters' heads emerge from mist and stare dreamily or smile in a trancelike state, recalling the mysterious revery of Rossetti's figures. Psychological depths are implied in the wistful, sensitive faces; in some cases hypersensitive elegance is created by a silhouetted posture or mannered gesture. The stern, dry impersonality of Whistler's two famous portraits was never repeated. In the twentieth century, the flattened portraits of Matisse are often deliberately drained of facial expression, telling gesture, and communicativeness. But for Matisse, emotional force lay in the formal manipulation of color, line, shape, and composition. In Whistler's two patterned portraits, the decorative arrangement produces only perfect calm and balance, devoid of human emotion. Even when admirers of Whistler followed the example of the *Mother* and *Carlyle*, they failed to achieve Whistler's resolute mental distance. Thus William Orpen beautifully paraphrased Whistler's *Carlyle* in his portrait of Augustus John (1900, fig. 55), but John turns toward the viewer, his limbs bulk large, his hands convey grace and sensitivity. The harmonious silhouettes and careful organization of Orpen's painting do not dominate the personality, likeness, and presence of the

55. William Orpen, *Augustus John*. 1900. Oil on canvas,
39 × 37 in. National Portrait Gallery, London.

sitter, as they do in Whistler's work. The *Mother* and *Carlyle* are so striking and memorable partly because they are so unusual.

In many of Whistler's landscapes one can find an effect parallel to that of his two portraits. The lovely, elusive, nondescriptive *Nocturnes* by Whistler often depict the Thames, a polluted, commercial ditch in bustling London. Whistler had early in his career delineated the cluttered, filthy river with cutting directness in *Wapping* (coll. John Hay Whitney, New York) and the "Thames Set" of etchings (fig. 37). But in works such as *Nocturne in Blue and Silver* (1872/78, fig. 56) the same area is befogged, made beautiful and unified and mellow by the pervasive monochromatic atmosphere. Soft focus permits the most grim sights to become delicate clouds, suggestive and unthreatening. Just as Whistler's portrait of his dear mother deliberately drained the subject of significance, individuality, and human force, so too the *Nocturnes* turn the fetid Thames into a distant, unidentifiable fantasy of colored mist. The etching that appears on the wall in *Whistler's Mother* is one of the tough early images of the Thames, showing a grubby seaman, the hodgepodge of warehouses, and the scraggly life of London's port (fig. 37). The etching represents a different, more realist approach to the world. It is as if Whistler wanted to compare his new, refined, purified, subjectless, secure art with his older productions. Yet in the harmonious *Arrangement in Grey and Black* the incisive etching is de-fused and repressed, made soft, fuzzy, generalized, and indistinct. The etching is small and carefully kept under control, enframed by a broad mat and black

56. J. A. M. Whistler, *Nocturne in Blue and Silver: Battersea Reach.* 1872–78.
Oil on canvas, 15½ × 24¾ in. Isabella Stewart Gardner Museum, Boston.

borders, made to fit into the overall composition. That which smacked of low life and unadorned reality has become safely unobtrusive.

Artists' portraits of their mothers are usually warm, pathetic, ideally beautiful, or sentimental. Even the supposedly impersonal Edouard Manet portrayed his mother as a gentle-eyed helper, assisting the artist's father. Whistler's mother, however, seems unsuccoring, unfriendly, untouchable, unattainable. She is not dominating, but ensconced in her remote, immutable arrangement of forms. There is no carnal body beneath her widow's garb, nor is there an angelic de-materialization. Mother here stands for cold order, and the painting's endless fascination (even if only as a cliché) for the public at large perhaps involves our culture's inmost vision of itself. The iconic mother's chilly distance from the viewer-son suggests the famed alienation of modern man, his feeling of aloneness, even in the presence of the original source and first protector of his life.

Stanhope Alexander Forbes
(1857–1947)
A Fish Sale on a Cornish Beach

The artist colony in Cornwall known as the Newlyn school became a prominent force in British painting in the 1880s, and the French-inspired art of its members is best exemplified by Stanhope Alexander Forbes's realist masterpiece of 1885, *A Fish Sale on a Cornish Beach* (plate 6).[1] This monumental genre painting presents the ordinary activity and economic foundation of the quaint village of Newlyn. In a bold three-tiered composition Forbes depicted the Cornish fisherfolk displaying their catch for sale on the wet sands of Mount's Bay. Three large figures converse leisurely in the foreground, one leaning against a beached rowboat, another seated on a fish basket, and the third standing solemnly in the posture of the Doryphoros. The diagonally placed boat, basket, and seated figure direct the eye toward the middle ground, where villagers trade, chat, and wait. A crowd at the right stands about a bell-ringing auctioneer and a buyer's donkey cart. In the center background fishermen carry baskets of fish from rowboat to beach, linking the shore to the high horizon where the fishing boats lie at anchor and sail in the distance. The crowd of boats at the upper left dwindles to a few isolated craft at the right, balancing the figures in the middle ground, who mass together at the right and break into smaller groups toward the left. Mirror reflections of the figures on the moist sand strengthen the vertical elements of the composition, countering the insistent horizontality of shoreline and horizon. The reflections also particularize the damp climate and muted light of an overcast day. Gray atmosphere pervades the picture, adding to the effect of moisture and dulling the colors of the figures' garments. The seafood, the means of the villagers' livelihood, lies scattered in the foreground and middle ground in seeming disorder, but serves to connect the figures and pictorial parts, curving into depth from the bottom edge of the canvas and pointing toward more distant groups. The zigzag movement into space is particularly helped by the directional force of the dead rays with their long pointed tails.

Forbes applied his paint with a large square brush, creating a patchwork of rectangular strokes throughout the picture. With this technique strokes of

paint do not flow in the direction of the depicted forms and lines. The patches of paint pull across the forms, creating a mild tension, and edges of shapes are defined not by drawn contours but by the meeting of paint splotches. In some areas, outlines are sharpened by dark colors which lie beneath two contiguous patches of paint; the outlines appear through a very narrow gap between them. The squarish touches are gently rough-edged, suggestive of texture and the play of light, but the depicted forms are nevertheless crisply defined and do not melt into an envelope of atmosphere. The flat patches of paint, generally vertical or horizontal in orientation, invite a two-dimensional reading of the image. But the volume-enhancing shadows on the forms and the foreshortened and perspectival elements create an illusion of three-dimensional space.

Forbes borrowed the square-brush technique wholesale from Jules Bastien-Lepage. Like many British painters in the late 1870s and early 1880s, Forbes studied in France, where he followed the contemporary enthusiasm for painting humble subjects out of doors, in natural light, and in the immediate yet detailed style of Bastien-Lepage—who was considered an impressionist, a follower of Manet, and a relentless devotee of truth to nature.[2] Bastien-Lepage depicted the peasants of his native Damvilliers (fig. 57), and many of his admirers emulated him by painting the working folk of Brittany and other French regions who were thought to be "primitive"remnants of a simple past. In the warm seasons, informal artist colonies with an international membership sprang up at Pont-Aven, Cancale, Fontainebleau, Gres-sur-Loing, and other picturesque locales. The Barbizon school was also a strong influence on the development of the colonies.[3] Paul Gauguin's radical innovations at Pont-Aven in 1888 continued this tendency among Parisian painters to spend months at some archaic site, working side by side with other artists and forgetting the degenerate culture of the modern city.[4]

Bastien-Lepage and his followers advocated painting directly before one's subject, preferably in the open air, a realist method to inhibit studio conventions and assure spontaneity. But the sort of light favored by Bastien-Lepage was unlike that of Monet, Renoir, Pissarro, and most artists whom we now associate with impressionism. Bastien-Lepage painted gray, muted light, not the brilliant sunshine of Monet. Bastien-Lepage pressed rather than brushed his paint onto the canvas, and his patchlike technique probably stemmed from Courbet's palette-knife application of pigment, although in color and modeling early Manet seems more influential.

Like Monet and Renoir, Bastien-Lepage utilized high horizon lines and did not work from sketches; unlike them, he avoided urbane subjects, nonchalance, and a sense of well-being. Without social indictment, he painted massive, awkward peasants in disturbed psychological states. In such paintings as *The Haymakers* (1878, fig. 57), one finds not the faceless, statuesque laborers of J. F. Millet, but a portrait of inexplicable mental pain or confusion in which the ungainly postures reinforce the mood of disquiet. Bastien-Lepage's followers copied his painting technique and rural subjects, but they usually renounced his unsettling psychologi-

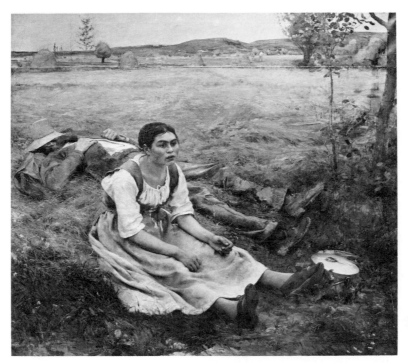

57. Jules Bastien-Lepage, *The Haymakers*. 1877. Oil on canvas, 71 × 76¾ in. Musée d'Orsay, Paris.

cal themes, which depart from the stereotyped visions of peasantry traditional in Western art.

Bastien-Lepage, rather than Monet or the other "true" impressionists, proved so attractive to Forbes and other British artists probably because he was more conservative, more accepted by the public, and less strictly urbane in subject matter. Forbes's paintings reveal a lack of interest in modern subjects; he sought instead a timeless, unchanging rural past. To him, the flickering instantaneity of impressionism, the passing glimpse, the never-stable fragment of reality, were too suggestive of flux and change. It is easy to forget how negligible the impressionists appeared in the French art world of the 1870s and 1880s. Monets and Renoirs were not to be seen in every dealer's window, and most of the public knew impressionism only through the more acceptable works of such conservative practitioners as Giuseppe De Nittis, Jean Béraud, and Bastien-Lepage. In his letters from France, Forbes never even mentioned Monet, Renoir, Degas, or Pissarro. Bastien-Lepage was considered an ardent realist rebel, but he never received the harsh criticism leveled against the impressionists.

After studying at the Lambeth School of Art and the Royal Academy, Forbes went to Paris in 1880; over the next three years he shuttled between Léon Bonnat's Paris studio, his parents' home in London, and the Breton artist colonies of Cancale, Pont-Aven, Quimperlé, and Concarneau, where he painted with his friend H. H. La Thangue, met artists of every nationality, and fell under the spell

of Bastien-Lepage. Forbes's experience, direction, and taste paralleled those of George Clausen (fig. 58), William Stott of Oldham, Henry Scott Tuke, John Lavery, H. H. La Thangue, and most of the painters of the Glasgow school. The widespread devotion to Bastien-Lepage evinces a new internationalism among young British artists, and the obvious foreignness of their art met with some opposition in London, even though Frederic Leighton, G. F. Watts, Whistler, Albert Moore, and others in the 1860s and 1870s had received inspiration from the Continent or been trained abroad. In 1885 it was rumored that *A Fish Sale on a Cornish Beach* had failed to receive the Chantrey Bequest purchase prize because the picture was "too positively the outcome of a foreign school."[5]

In 1886, Forbes became a founding member of the New English Art Club (NEAC), an exhibiting society of French-trained British artists who felt unwelcome at the Royal Academy.[6] The NEAC did not, however, represent a radical break with the established powers of the Academy and the London art world. It was, like the Grosvenor Gallery (established in 1877), a means of gently broadening the exhibition space for artists in England, and its members continued to show their work at the Royal Academy. Forbes himself became an Associate of the Royal Academy in 1892, but that was years after the NEAC had become dominated by Walter Richard Sickert (fig. 59) and other artists under the sway of Whistler and Degas, who were antagonistic toward the followers of Bastien-Lepage. Both groups, however, looked across the Channel for inspiration, and as the formation of the NEAC might

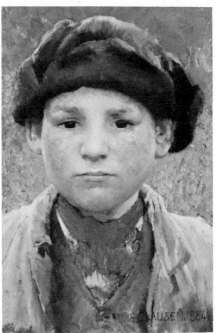

58. George Clausen, *Head of a Peasant Boy.* 1884. Oil on canvas, 14½ × 10 in. Ashmolean Museum, Oxford.

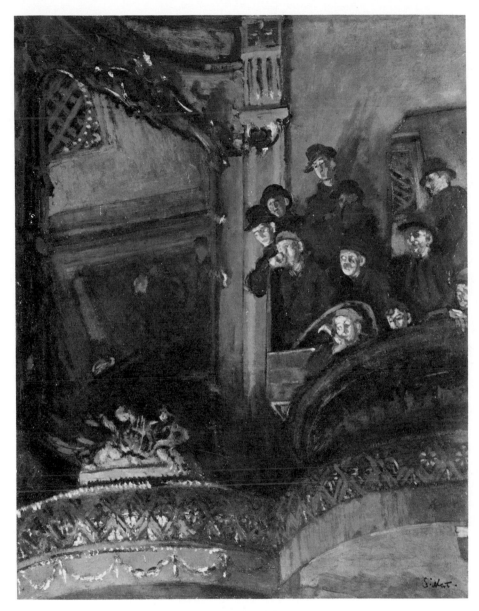

59. Walter Richard Sickert, *The Old Bedford*. c. 1890. Oil on canvas, 29 × 24½ in. Walker Art Gallery, Liverpool.

suggest, the influence of contemporary French art upon British painters in the 1880s became an issue, as it had not been earlier. Sickert's circle, even more than the followers of Bastien-Lepage, saw their French-derived art as progressive, avant-garde, and opposed to most traditions of English art.[7]

Young British artists thus exhibited a lack of confidence in British culture, a feeling that native art was weak or misdirected. Belief in Britain's artistic inade-

quacy was nothing new; ever since Hans Holbein had arrived in England, dependence on Continental models had been a mainstay of British art and taste. From the mid-eighteenth century onward, however, British artists and many of their patrons developed some pride in English accomplishments. Curiously, the dwindling faith in British artistic traditions in the 1880s came just when the country's wealth and political power were at their zenith. Sickert's group and the admirers of Bastien-Lepage felt the superiority of French art, but both factions turned to specifically British subject matter as if to counter the Frenchness of their styles, as if to integrate themselves into their native culture, as if to find some roots at home.

Sickert eventually turned to London low life and popular pleasures (fig. 59), while Forbes and the Newlyn school in general turned immediately to the poor fishermen of Cornwall, nationalistic subjects representative of Britain's traditional maritime life. George Clausen and others in the NEAC were even more deeply inspired by Bastien-Lepage than was Forbes; they employed the square-brush technique to the point of mannerism, allowing the contours of their forms to become rectangularized.[8] But A Fish Sale on a Cornish Beach was the most ambitious large-scale work painted in the new style, and it came to stand for the ideals and sensibilities of the entire group of British artists trained in France.

Forbes, like Clausen, had at first depicted French subjects, peasants of Brittany going about their daily tasks. His Street in Brittany (1881, fig. 60) was one of his major efforts prior to A Fish Sale. Unlike many of the French painters in Brittany, especially Pascal-Adolphe-Jean Dagnan-Bouveret (who had also been influenced by Bastien-Lepage), Forbes ignored the religious aspects of Breton life and did not dwell on the quaint devotional rites called Pardons or the faithfulness of the peasants.[9] For Dagnan-Bouveret, Gauguin, and numerous others, Brittany was a place of archaic Christianity—a spiritual outpost—and their pictures of Breton religion are the beginnings of that mystical strain so evident in symbolism of the 1890s.[10] Forbes's disinclination to depict the picturesque religious character of Brittany was not just the Englishman's normal anti-Catholic bias, for he was an agnostic freethinker, a rationalist, and certainly unattracted to all forms of religion. In letters from Cornwall he railed against the bigotry and narrowness of the Methodists, nor did he have a kind word for any other Protestant sect.[11] His large painting devoted to the proselytizing efforts of the Salvation Army among the Cornish fishermen (Soldiers and Sailors, 1891, unlocated) may actually be semisatirical.

A Street in Brittany (fig. 60), painted on the spot in 1881, portrays the women of Cancale at their domestic occupations, wearing traditional habits and wooden shoes. Although the young woman in the foreground gazes pensively at her feather duster with a hint of the psychological twinge found in Bastien-Lepage's workers, Forbes's painting is essentially an image of a firmly bound community of working people. The women converse, sit together, and enter into the public road. The narrow street, lined with the typical stone dwellings of the region, is not a squeezed passageway suggestive of restriction, but an avenue of security, closeness, and

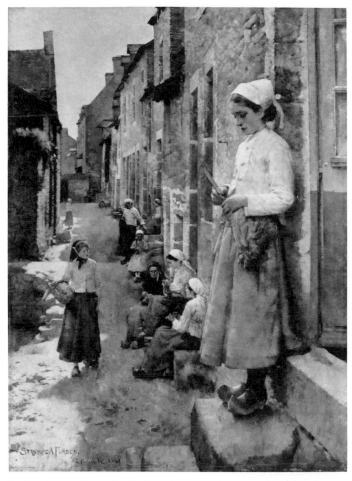

60. Stanhope Alexander Forbes, *A Street in Brittany*. 1881. Oil on canvas,
41 × 29⅞ in. Walker Art Gallery, Liverpool.

solidarity. If the foreground figure seems alienated and isolated, this is probably more a matter of the young artist's incomplete skills than of social commentary. Forbes obviously had difficulty in relating the foreground to the receding street; the steps are impossibly high. The spatial definition of the distant end of the street is also confused, and the picture's blue coloration is too forceful and all-pervading. But the Bastien-Lepage square-patch technique is masterfully applied. Four years later, in *A Fish Sale*, not only is the rendering of space more convincing, but the painting technique has been refined and made less obtrusive.

Forbes, whose mother was French, was fluent in the language and had spent childhood vacations in French-speaking areas of Belgium. Thus he was not a completely ignorant tourist in Brittany, and he was not unaware of the hard and meager lives of the picturesque fisherfolk whom he depicted at Cancale. While at work on *A Street in Brittany* he wrote to his mother of a "poor unfortunate woman

who lost her husband at sea leaving her with three small children. One of them was a charming little girl of two years. . . . On Monday . . . I heard that the little thing was dead. It must have been the croup that killed her. . . . They were too poor to afford priests. It is a dreadfully sad case altogether and it seems to me the best thing for the poor woman will be for her approaching confinement to kill her which is after all only probable."[12] Forbes's seemingly harsh and pessimistic view of this incident finds no echo in his Breton painting. His peasant women are not tragic victims or pitiful underdogs, but neither are they frivolous, jolly, or amusing characters. A *Street in Brittany* displays a certain gravity and an unsentimental appreciation of these steadfast, humble people. The unemotional, unmoralizing, and unidealized approach to genre painting remained part of Forbes's art for years. It is a realist's approach similar to that of many nineteenth-century French artists, but a different one from that of most English genre painters.

Forbes returned to London from France late in 1883, and in January 1884 took the train to Falmouth in order to find a suitable place to paint in Cornwall, a region that had been recommended by a friend. Forbes admired the novels of Thomas Hardy and may also have been inspired by the author's Cornish settings.[13] Forbes explored various sites but finally settled upon Newlyn, a fishing village that rises up a steep hill in the vicinity of Penzance; he began to plan A *Fish Sale on a Cornish Beach* soon after his arrival. Having depended upon parental finances for years—his letters home are filled with detailed accounts of his expenses—he felt compelled to prove his potential for economic independence by producing a salable picture. But he wrote to his mother from Newlyn, "The wish to do something that will sell seems to deprive me of all power over brushes and paints."[14] His very trip to Cornwall stemmed in part from a desire to attract the British public and its monetary rewards.

In June 1884 Forbes planned a picture of children on the Newlyn beach, "it being a busy scene which most English people have witnessed I hope it may prove more interesting to the masses than blue bretons whom they perhaps have never seen."[15] Newlyn was in many respects merely Brittany in English clothes, a means for Forbes to continue his earlier French subject matter while appealing to English familiarity and nationalism. Forbes wrote home in February 1884, "I am sure Newlyn is a sort of English Concarneau and is the haunt of a great many paint-ers. . . . The girls here are quite pretty in spite of their rather ugly english cos-tume."[16] And he certainly saw his choice of subject as in line with European realism. He told his mother, "I wonder at your inviting my attention to the worthless opinion of the Times critic. Did any one ever find fault with Israels for taking his subjects from the life of the Dutch fisherfolk or Millet—from French peasant life—why not Cornish people?"[17] The mention of Jozef Israëls was apt, for Forbes's wealthy uncle, James Staats Forbes, was an avid collector of the Dutch painter's works, and Forbes at one point planned to paint a boy on the beach holding a toy boat, a subject that had already been treated by Israëls in several canvases.[18] Cornwall was the closest thing to Brittany that Forbes could have

found in Britain, but there still remained disconcerting differences. He wrote to his father in 1884:

> I fear that the comparison [of Newlyn with Brittany] would not be flattering to our country. These dirty untidy looking people are indeed different from the Marie Bidons and other bretonnes whom you have seen posing for me at Cancale and Quimperlé. But to be just to them I should say for England they are very good samples of fisher folk in outward appearance at least and it is the fault of the entire country that they revel in fringes, pigtails, crinolettes and other freaks of fashion all very well on stylish London beauty, but appalling with these surroundings of sea, boats, fish, etc. We are accustomed to think too in England that in all sanitary arrangements and general cleanliness we are centuries in advance of those benighted foreigners. This at least in Newlyn, Porthleven and Cornwall generally is a sweet fiction.[19]

The Newlyners thus did not wholly satisfy Forbes's desire for a well-scrubbed archaic world far from modern society. Nevertheless, he told his father that "it is one of the greatest merits of this place that we are so near to [fashionable] Penzance and yet far enough for the place to be quite primitive and suitable for artistic purposes."[20]

The initial inspiration for A Fish Sale, however, came not from the ancient life of the fisherfolk, but from the light effects on the watery beach. Forbes wrote to his mother on March 17, 1884:

> I think I have struck oil down here in the way of subjects. I have not however, commenced anything very important yet—but see my way to do good and new things. The thing that pleases me is the wet sand. Anything more beautiful than this beach at low water I never saw and if I can only paint figures against such a background as this shining mirror-like shore, the result should be very effective. I am experimenting now getting used to the people, the moisture, the difficult effect, the tides, etc., playing on this delightful stuff. But when I am more at home on the beach I am thinking of starting a real big thing with lots of figures, fish being brought in boats, etc. It will be a terrible thing to undertake but I am sure worth trying. I believe no one here has tackled such subjects before.[21]

In later years Forbes reaffirmed that the reflective beach at Newlyn was the starting point of his most famous picture.[22] To appreciate Forbes's first idea for the painting, one must imaginatively remove the figures, boats, fish, and objects from A Fish Sale. The image is then devoid of sturdiness, solidity, and measurable space, a floating, ambiguous realm of grays and tans where earth, air, and water are nearly indistinguishable; one is aware only of an untouchable fragility, a quiet radiance, a miragelike wisp of reality. Turner had explored similar evanescent and shimmering beach effects in several works, notably Calais Sands (1830; Bury Art Gallery), but the romantic painter infused his image with power, grandeur, and the sensationalism of a setting sun. Forbes's landscape, though broad, is a little corner of the world rather than the universe, and it depends solely upon delicate modulations of modest colors. Closer in time to A Fish Sale are the foggy water scenes of Whistler

(fig. 56), but Forbes's monochromatic seascape is in comparison strangely lucid, touched by a clear pearly light rather than the moody shadows of Whistler's fuzzy evocations of space.

Forbes could not follow the trail of Turner, whose images by the 1880s seemed hackneyed and bombastic. In a letter home, Forbes mocked one of the Newlyn sailors who had suggested that the artist would do better to paint St. Michael's Mount with the rising sun behind, a Turneresque subject par excellence.[23] Forbes also felt hostile toward Whistler, the foppish, urbane aesthete. The whole cult of hypersensitivity, dreamy beauty, and avoidance of reality—the aestheticism with which Whistler was associated—held no attraction for Forbes.[24] The *Fish Sale* was a deliberate slap in the face of aetheticism, which tinged the art of numerous British painters from the late 1860s through the 1890s. The luxurious classicism of Frederic Leighton (fig. 68) and Edward John Poynter, the somnambulistic visions of Edward Burne-Jones (fig. 73) and Rossetti (plate 8), the rarified color symphonies of Albert Moore (fig. 72) and Whistler, the erotic suggestions of Simeon Solomon and John William Waterhouse all partake of that languid devotion to the beautiful known as aestheticism.[25] Artists often expressed several contradictory sensibilities simultaneously and cannot be rigidly classified. But in a broad view of late nineteenth-century British art, Forbes should be grouped with likes of Sickert (fig. 59), Phillip Wilson Steer, Hubert von Herkomer, and Luke Fildes (fig. 61), all of whom sought inspiration in ordinary reality rather than in the mysteries of the imagination. In 1900 Forbes, the painter of inelegant fishermen, actually praised the love of beauty, but he immediately disassociated his praise from the esoteric, neurasthenic ecstasies of the aesthetic movement: "Do not think I mean by this, striking foolish postures before a lily, but that feeling of healthy and honest admiration for all that is fair in the world around us, which comes naturally to all right-minded people."[26] The subtle, poetic vision of the looking-glass sands of Newlyn that first stirred Forbes was quickly filled with substantial people and tangible fish, not only because Forbes saw himself as a painter of figures rather than landscape, but also because he distrusted the precious, aestheticized character of his original response. The realist hauled the visionary down to earth.

Forbes meant to capture the "natural," unrefined appearance and manners of the Newlyners; beauty lay not in ideal proportions, but in the fitness of a figure to its environment. Forbes wrote years later, "That which might seem awkward and rough, suited as it is to the condition of its life, and in harmony with its surroundings, may be most beautiful."[27] At Newlyn "people seemed to fall naturally into their places, and to harmonize with their surroundings. . . . The figures did not clash with the sentiment of the place, making one sigh for the good old days of picturesque costume, but actually seemed appropriate and just."[28] The Newlyners were examples of "natural man" humbly at peace with the universe, a contrast to the alienation of modern society.

Although Forbes painted *A Fish Sale* on the spot, out of doors, and employed common fisherfolk as models, his figures are obviously posed, artificially arranged.

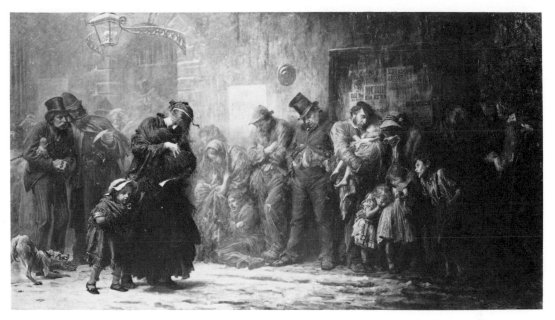

61. Luke Fildes, *Applicants for Admission to a Casual Ward*. 1874. Oil on canvas, 54 × 96 in. Royal Holloway College, Egham.

His group is also an assemblage of single figures, each painted separately and inserted into the picture, not an indissoluble mass of people whose unity dominates individuality. And that effect diminishes the sense of community. The postures chosen reflect studio conventions and requirements. The foreground figure leaning against the boat is not idealized, but her pose clearly stems from the necessity of having a model stand in a position that could be kept for a considerable length of time. The same is true of the seated woman at the right. The large figure of the fisherman, whom Forbes described as the perfect example of an "old salt," is even more the product of studio practice.[29] He stands in contrapposto and harks back to such revered prototypes as the Doryphoros and Michelangelo's *David*. He may carry fishing gear, rather than a spear, sling, or some other instrument of dignified associations, but his "artistic" lineage is obvious. Forbes may have included this classical fisherman to make a statement about these villagers, likening them to the ancient Greeks of Western imagination: noble, simple, harmonious, natural, and pure. Even the composition of the foreground triumvirate reflects standard studio procedures, for it contains heads in profile, back, and frontal view, giving a classical completeness to the group. And the middle-ground chorus of buyers and sellers at the right have their heads carefully placed in a line, in accord with the perspective formulations of the Renaissance masters.

Nevertheless, A *Fish Sale* still possesses strong doses of Bastien-Lepage's realism. The figures are chunky, ungainly, weatherbeaten, and of unrefined facial feature. The hands and inelegant boots are stumpy forms. The clothes are rough and common, and the fish unbeautifully dead. The gray light runs counter to the

conventions of chiaroscuro and gives a forceful specificity and naturalness to the scene. The undramatic working-class subject is another element of the picture's realism.

Scenes of fisherfolk appeared regularly at the Royal Academy throughout the nineteenth century, and the best-known specialist in this field of genre when Forbes exhibited *A Fish Sale* was James Clarke Hook.[30] For decades Hook had painted the life of fishermen with sentiment, delight, and drama. In 1885 his typical contribution to the Royal Academy exhibition was *"Yo Heave Ho,"* which depicted men and women hauling ashore a boat in rough water. Hook's *Fish from the Dogger Bank* (1870, fig. 62) is most similar to Forbes's painting, presenting women and men with fish on a beach. Occasionally Hook employed highly dynamic perspective (for example, *Crabbers,* 1876; Manchester City Art Gallery) and usually portrayed the sea from the land, as Forbes did, seeing the ocean and the fishing industry in relation to people and activities on shore. His scenes most frequently focus upon a heartwarming human incident or some dramatic act of fortitude. Hook was the most celebrated painter of fishing genre, but numerous other artists in England depicted similar subjects in a similar manner. Forbes thus joined a well-worn tradition that had nationalistic overtones in its depiction of Britain's maritime character, roots, and power. The sea itself could be a symbol of the nation; John Brett painted a picture of the broad ocean in 1880 and titled it *Britannia's Realm* (fig. 30). One critic in 1885 wrote, "In the pictures of the sea we

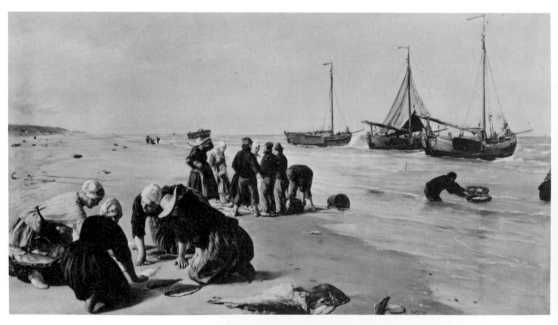

62. James Clarke Hook, *Fish from Dogger Bank.* 1870. Oil on canvas, 30 × 54½ in. By courtesy of Birmingham City Museums and Art Gallery.

[English] are pre-eminent; we have Mr. Hook, Mr. Colin Hunter, Mr. Brett, Mr. Henry Moore, Mr. Bartlett, Mr. Hole, with 'The File of the Boats,' Mr. Hemy with a dozen vigorous and taking views of weather and water, Mr. Stanhope Forbes with a work that, technically speaking, is of the best quality."[31] But Hook and many other British genre painters of the sea differed from Forbes. Hook's people are usually smiling, sympathetic souls; mothers and children often appear; close family life is emphasized; the figures are small, quaint, sweet, jolly, or "rough diamonds." A cheery domesticity and nationalistic sturdiness pervade Hook's pictures, reinforced by such titles as *Hearts of Oak* (R.A. 1875; Nottingham Castle Museum) and *Home with the Tide* (R.A. 1880; Tate Gallery, London). Forbes's painting is more geographically specific than Hook's works, its title is neither saccharine nor quaint, and the painting does not present grinning fellows or maternal types. Forbes's figures are deadpan. No lively event dramatizes the scenes. Narrative is limited to buying, selling, and bringing the fish to market. In comparison to Hook's pictures, *A Fish Sale* is reserved and without anecdotal spirit.

The lack of warmth, liveliness, and story in *A Fish Sale* is deliberate, for Forbes habitually considered carefully the plot, action, and expression of his pictures. For example, in 1887 he wrote to his finacée, the Newlyn painter Elizabeth Armstrong, of a Cornish quarry scene that he planned to paint:

> The various schemes I have are as follows. Firstly—and the one I think I shall pin on An Accident—Quarry men in a group round the victim a little way off. Large figures in foreground screaming out to the men working below and pointing towards the spot where the mine has fallen. It sounds awful written out but I really think it might be managed—Then there is preparing for the blast—with children scuttling off in the foreground. Then simply the men at work, with a kind of glorified quarry man against the sky. It is very difficult to get some kind of leading incident—I fear the accident is a bit sensational but it pulls the whole thing together.[32]

In this case Forbes gave up the subject entirely until 1894, when he painted *The Quarry Team* (private collection), an uneventful picture of a cart driver, "a glorified quarry man against the sky." The figures in *A Fish Sale* possess gravity, but they are not overly dignified and certainly not glorified. The deliberate deadpan tone of *A Fish Sale* complements the French painting technique, for this untheatrical quality can be found in numerous French realist genre paintings (by Courbet, Millet, Manet, Bastien-Lepage, and others), but is rare in English pictures of common folk. From the works of Wilkie (fig. 1) early in the nineteenth century onward, English genre painting had devoted itself to sweetly amusing or sympathetic scenes. The Pre-Raphaelites added a less prettified intensity but relied on dramatic incidents or symbolic attributes to enliven their genre images (fig. 35). In the 1870s several British artists turned genre paintings into bold social statements by portraying the suffering of the lower classes. Richard Redgrave (fig. 39) had initiated this tendency during the economically depressed 1840s, but it attained a new fervor decades later in such works as Luke Fildes's *Applicants for Admission to a Casual Ward* (1873, fig. 61) and Hubert von Herkomer's *Eventide*

(1878; Walker Art Gallery, Liverpool), a picture of elderly inhabitants of a work-house. Fishermen appeared in some of these portraits of misery from the 1870s. Frank Holl painted *No Tidings from the Sea* in 1870 (fig. 63), an image of a poor family's despair and the mortally dangerous conditions of a fisherman's occupation. Such pictures continued to be produced in the 1880s. Forbes's fellow member of the Newlyn school Frank Bramley painted *A Hopeless Dawn* (Tate Gallery, London) in 1888, a reprise of Holl's picture portraying a family's fruitless vigil for a fisherman lost at sea. Whistler had denounced the English penchant for story-telling pictures and sentimental effusions, and in a less tendentious fashion Forbes took a similar stand. In *A Fish Sale* he refused to pull the heartstrings and instead gave his work a French air of objectivity. Nevertheless, *A Fish Sale* may not be without some social concern or subjective meaning.

Forbes's painting concerns economics. It deals with buying and selling; it illustrates not the heroics, dangers, domestic life, or pleasures of Cornish fisherfolk, but the exchange of produce for money. And Forbes facetiously saw the marketing subject as parallel to his own professional interest in creating a salable picture; he wrote a punning letter to his mother describing his proposed canvas: "Group of girls in the foreground with creels, fish, etc. and in the distance sea and boats—Landing fish, people buying etc. It ought to be taking and selling in a double sense."[33] Market subjects—including fairs, food vendors, shop scenes, home-

63. Frank Holl, *No Tidings from the Sea.* 1870. Oil on canvas, 22 × 36 in.
Coll. H. M. Queen Elizabeth II. Copyright reserved.

from-the-market dalliances, and huskster-dupe images—are as old as genre painting, and are common in Western art from the sixteenth century onward. *A Fish Sale* follows that tradition, but Forbes also seriously attempted to understand the workings of the Newlyn economy, and he was particularly concerned with the vicissitudes of the marketplace. He was first struck by the fruitfulness of the fishing industry, the glowing sense of plenty indicated by the huge catches: "Were it not that fish is so cheap the people would all be rolling in money. . . . The salesman's bell is heard each minute and the beach is always crowded with buyers. Tant mieux for me since I wish to study the life of the people. I only trust that all this prosperity may not have made my models independent."[34] But shortly thereafter Forbes wrote home: "Is no one eating mackerel in London? and why? The boats arrive here every evening and can find no buyers for their fish, and absolutely are forced to heave thousands of fine fresh mackerel into the bay. Each boat last night threw away several thousand. And yet there are people almost starving. I suppose the heat is too great for the fish—The result of all this is great grumbling of course and bad smells and I long for rain."[35]

In *A Fish Sale* the salesman's bell is ringing, but the scene is not a celebration of bounteous wealth. The catch displayed on the beach seems meager. The mackerel, herring, or pilchards normally caught in the thousands are not numerously present. The baskets on the beach lie empty, and the prominent inclusion of rays hardly represents lucrative merchandise. Forbes noted that he bought three huge skates for nine pence, and that they were only appreciated for eating in France.[36] The foreground contains sellers without a buyer, and the unlively expressions and gestures do not suggest brisk trade. Forbes portrayed subsistence living, a spare yet working economy. The harbor at Newlyn was enlarged from 1884 to 1886, the North Pier was built in the 1890s, and new warehouses replaced old cottages, but the brief expansion of the fishing industry never altered fundamentally the life of the community or brought significant wealth to the village. Modest incomes, frugal ways, and traditional methods remained the norm in Newlyn in the late nineteenth century.[37] The sufficient yet unbountiful harvest on the beach in *A Fish Sale* provided not only an accurate picture of Newlyn's economy, but also a scene of a community outside the progressive development of Britain.

Forbes was a liberal in politics and came from a family that helped direct and expand the great railroads of Britain and the Continent.[38] But what he sought in his art and in Newlyn was a place untouched by modernization. In *A Fish Sale* no steam vessels appear, the creels, donkey cart, and fishing lines speak of traditional ways, and the relatively meager catch reinforces the point that these people do not participate in Britain's wealth-generating growth.

Forbes, like so many artists from the late eighteenth century onward, attempted to envision a simple, more sincere, rudely honest world. Some of these men had been inspired by the ancient Greeks, others by the Middle Ages, the early Renaissance, exotic cultures, folk art, or tribal societies. The fisherfolk of Newlyn were one more category of primitive purity. This goal reveals the dissatisfaction of the

age, the self-hatred of modern civilization. Another facet of this attitude was the formation of artist colonies, little communities of like-minded creators in rural settings far from the capitals of progress and modernity, and from society as a whole.

When Forbes arrived in Newlyn in 1884 the village had already been visited and inhabited by painters. Walter Langley settled in Newlyn in 1882 and had painted there previously. Thomas Cooper Gotch was visiting when Forbes arrived, and Legh Suthers, whom Forbes had met in Brittany in 1883, was also present. Other artists descended on the village not long after Forbes: Henry Scott Tuke, Chevallier Taylor, Frank Bramley, William Fortescue, and Elizabeth Armstrong (whom Forbes married in 1889). Numerous other painters came in succeeding years, including Fred Hall and Norman Garstin. The group's membership was fluid. Some artists stayed for a few months, others visited at regular intervals, and a number resided permanently at Newlyn. There was no formal organization or standard aesthetic philosophy, but most of the artists at Newlyn in the 1880s had studied abroad or been influenced by contemporary foreign art, employed the square-brush technique, and practiced plein air painting. Forbes was unquestionably the colony's most talented and significant artist, the one whose works claimed most attention, and A *Fish Sale* crystallized the direction, methods, meanings, and ideals of the Newlyn school (a term first used by critics in 1888).[39]

The Newlyn colony stemmed directly from the loosely organized and impermanent artist groups that arose in France in the 1870s and 1880s, particularly those in Brittany. These in turn seem to have grown out of the example of the Barbizon artists, who lived and painted in the region near Fontainebleau.[40] The interest in isolated communities, rural village life, and the timeless pursuits of peasants living close to nature distinguish all these colonies from most earlier congregations of artists in great cities. Jacques-Louis David's rebellious and primitivizing pupils, the "Barbus," organized themselves in Paris, the Nazarenes in Vienna and Rome, the Pre-Raphaelites in London, the urbane impressionists in Paris, and these groups were more exclusive, more strictly bound by common codes and personal bonds than late-nineteenth-century artist colonies. The artistic circles of mid-eighteenth-century Rome were mostly informal, but they were part of the life of a sophisticated metropolis and international in outlook. The clubs and exhibiting societies of provincial capitals in Europe and Britain were merely smaller variants of the academies and organizations of major urban centers.

Newlyn was not the first artist colony in Britain. In the mid-nineteenth century the village of Cranbrook became the residence of a number of painters, notably Thomas Webster, Frederick Daniel Hardy, and John Calcott Horseley, who depicted the life of the people with sympathetic humor and warmth.[41] Cranbrook, however, was not part of a general cultural movement throughout Europe. At about the same time that Newlyn became established, nearby St. Ives became a popular artists' resort. Groups also formed in other parts of Cornwall; both landscapists and genre painters visited and lived in these communities. In Germany

Plate 6. Stanhope Alexander Forbes, *A Fish Sale on a Cornish Beach*. Oil on canvas, 47¾ × 61 in. Plymouth City Art Gallery.

Worpswede, established in 1889, became the best-known rural colony, and France was dotted with similar communities at Fontainebleau, Gres-sur-Loing, and throughout Brittany (Vincent Van Gogh's desire to found a colony at Arles in the late 1880s was part of this trend.) In Holland, Italy, and virtually every European country artist colonies began to appear in the 1880s and 1890s; the fishing village of Skagen in Denmark became a center for Scandinavian painters. Small art schools frequently grew around one or more artists in these communities. Hubert von Herkomer's school at Bushey can be considered part of the artist-colony movement, and Adolf von Hoelzel's group at Dachau was similar. Forbes and his wife set up a formal school of painting at Newlyn in 1899. Such educational institutions provided a focal point and sense of permanence for the artist colonies, many of which were only seasonal or made up largely of transients. The ideal of isolation from sophisticated, metropolitan culture linked all these scattered groups.

Forbes wrote of Newlyn at the turn of the century: "I have so often seen the great city open its voracious maw to swallow up my friends, that I own I dread the arguments [to return to London]. . . . The painter can live the quiet life of the country without too much isolating himself and losing the companionship of his fellow workers. . . . It is a charming and fascinating country, this little Bohemia of ours, in which we are privileged to dwell."[42] He also looked back on his formative student years in France: "Painters began to see that it needed more than an occasional visit to the country to get at the heart of its mysteries; that he who wished to solve them must live amongst the scenes he sought to render. . . . Most of us young students were turning our backs on the great cities, forsaking the studios with their unvarying north light, to set up our easels in the country districts . . . under the open sky."[43] More than artistic companionship and the charms of country life motivated Forbes to live at Newlyn. He was also inspired by an almost monastic desire for isolation from worldly distractions, the better to carry out his professional duties. He wrote to his mother from Newlyn in 1885: "In the first page of the first book I took up to read I came across this curiously appropriate passage: 'Prompted by these motives I now begin my self imposed occupation. Hidden amid the far hills of the far west of England surrounded only by the few simple inhabitants of a fishing hamlet on the Cornish coast. There is little fear that my attention will be distracted from my task and as little chance that any indolence on my part will delay its speedy accomplishment.'"[44]

Despite the artists' dependence upon the exhibition and sale of their works in major cities, Newlyn and the international artist-colony movement as a whole represent the alienation of the artist from society, a significant gap between the standards and language of creators and the ideals and direction of established culture. The creation of miniature communities devoted to art, surrounded by "primitive" villagers and untouched nature, reveals the artist's turning inward, away from the public eye and public taste. The divorce between art and modern mass society, which became manifest in the 1880s, is to a great extent with us still.

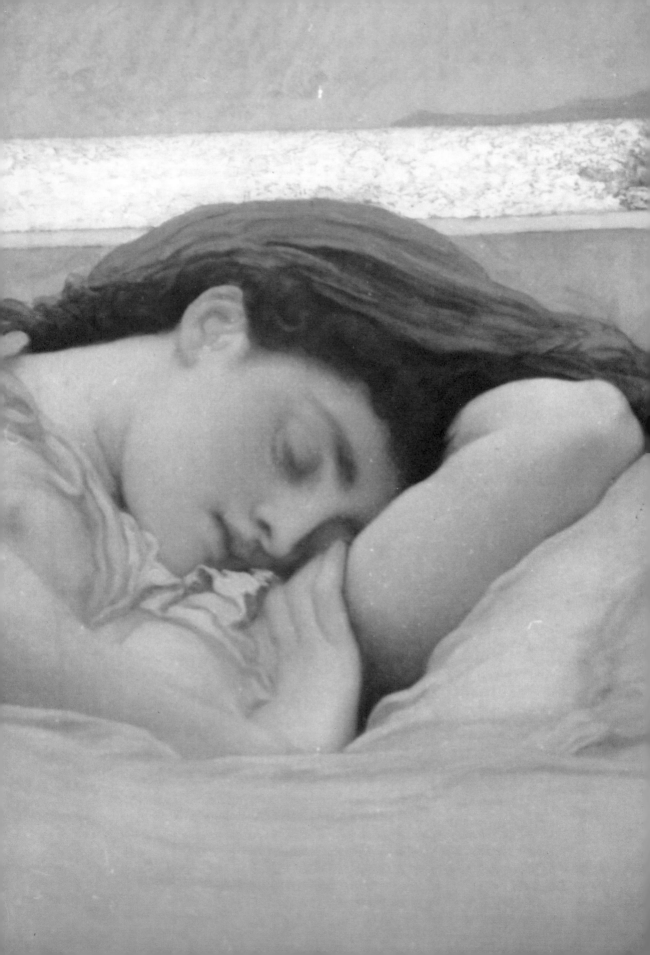

7

Frederic, Lord Leighton
(1830–1896)
Flaming June

The square canvas of Frederic Lord Leighton's *Flaming June* (plate 7) is occupied by a massive Michelangelesque woman, asleep in a convoluted posture.[1] Flaming apricot-orange draperies wrap the figure diaphanously and elaborate her wheel-like form. Above the sleeper's classical bench appears a band of sea and sky, hazy and dusky, yet the water reflects the brilliant midday sunlight. Across the top of the painting runs a strip of golden awning. ornamented with a Greek fret and supported by a red pole, and at the upper right, invading the pictorial symmetry, hangs an oleander branch, which has crept over the parapet. The flattening horizontals of the painting are countered by the figure's foreshortened left foot, which jabs the viewer's space. The short diagonal lines on the marble floor create a foreground entrance for the viewer and help direct the eye to the distant shining sea. The upper half of the figure is small compared to the giant thigh that lies across the center of the canvas, and the contrast in size further enhances the spatial recession. The woman retreats from the viewer, cradling herself, the head tucked behind a barrier of legs, the curled body, despite its sculptural force, entirely enclosed within the amoeboid draperies.

The preparatory drawings for *Flaming June* show Leighton carefully orchestrating the limbs of the figure. Like Michelangelo, he made some studies for the woman from a male model.[2] And in the tradition of the Renaissance masters Leighton first drew the figure in the nude, and then draped the naked form. Bulging Michelangelesque features are more prominent and active in the drawings (figs. 64, 65). Leighton subsequently enfolded and softened the forms to create an undulant flow of line. For example, in an early drawing from a model (fig. 64) the left hand's fingers protrude above the outline of the figure's right arm. But in a later draped study (fig. 65), and in the final painting, the fingers are made to follow the contour of the arm that they grip. The muscular pressure of one form pushing against another seen in the early drawings is replaced in the final work by the submissive interweaving of limbs. Conflict gives way to harmony, producing an air of détente.

Flaming June, exhibited at the Royal Academy in 1895, is strongly related

64. Frederic Leighton, Drawing for *Flaming June*. From *The Magazine of Art* (1895).

to several earlier works by Leighton and crystallizes many of the dominant strains of his mature art.[3] The *Magazine of Art* noted that the figure of *Flaming June* had made a debut in Leighton's *Summer Slumber* of 1894 (fig. 66) as a small bas-relief decoration on the depicted fountain tank.[4] This initial figure lacks the flowing articulation of the woman in *Flaming June*. The figure in the tiny illusionistic bas-relief is more hunched; the arms do not undulantly unite; the drapery is heavy and bundled; the oval head is half-obscured; the figure's left foot does not project forward; and the right foot does not bend at the toes. The latter feature in the painting of 1895 adds a directional note, a curve upward into the swing of drapery, a means of creating continuous movement. The bent foot in *Flaming June* also provides a hint of physical pain, a minuscule form angled in support of the upper body. It is a memory of the feet of Michelangelo's Sibyls and Ignudi that gives a touch of discomfort. The languid form of *Flaming June* suggests détente, but the pose in literal physical terms is knotted and agonizing. The large main figure of

65. Frederic Leighton, Drawing for *Flaming June*. From *The Magazine of Art* (1895).

Summer Slumber, who reclines upon the fountain tank wall, is centered and asleep like that of *Flaming June.* Although the earlier woman clasps her hands and crosses her legs, she is far more outward-moving. Her hair and limbs and clothing ripple in all directions; they do not pulse in orbit about a concentrated nucleus. The woman of *Summer Slumber* is more freely receptive or vulnerable to her environment and has more space in which to move. Many more accessories accompany her. Statues, trees, bushes, pigeons, a cloud-strewn sky, potted plants, a cat, and architecture give opulence to the theme of sleep, but they also clog the picture and distract the attention.

In *Flaming June* Leighton did more than enlarge and refine a peripheral detail of *Summer Slumber:* he strengthened and monumentalized his treatment of the earlier painting's central theme. The major figure now rivets all attention, fills the image, and comes closer to the viewer (even though she is more remote psychologically). One looks up at the august figure of *Flaming June,* but down upon the slender girl of

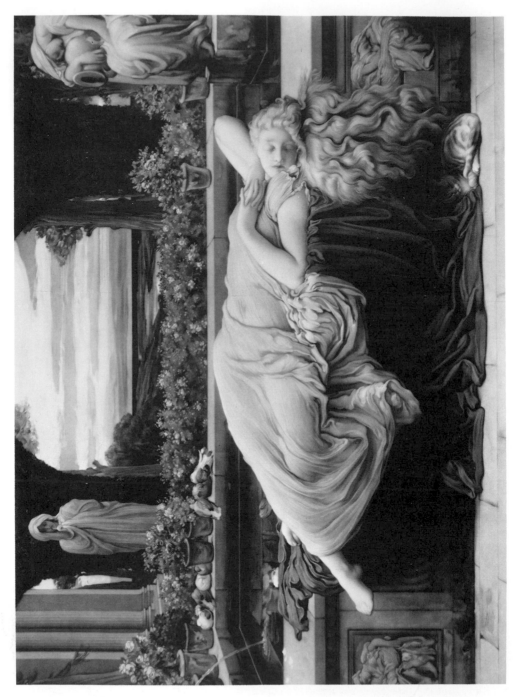

66. Frederic Leighton, *Summer Slumber*. 1894. Oil on canvas, 45½ × 62½ in. Private collection, India.

Summer Slumber. The square format of *Flaming June,* unusual in Leighton's work, also serves to make the figure dominate her surroundings, opposing the horizontality of landscape.

The single sleeping figure first appeared in Leighton's art in *Ariadne Abandoned by Theseus* of 1868 (fig. 67). This figure, like that of *Flaming June,* resides in a cocoon of drapery set against a Mediterranean seascape. But Ariadne is comparatively rigid; her right arm stretches out stiffly, upsetting the flow of lines, and there is no Michelangelesque foreshortening. Ariadne seems unrelated to her setting, as if a model from the studio had been inserted into a previously painted landscape and her couch masked with drapes. *Flaming June* reveals no such dissonances. The volutes of the bench echo the sleeper's neck and limbs; the watery folds at the sides respond to each other; the light on the sea, the brightest area of the canvas, floats above the figure's head in the very center, and soft warm colors spread throughout the picture. By the 1890s Leighton was obviously more concerned with aesthetic completeness, the painting as an integrated whole. *Flaming June* also departs from *Ariadne*'s narrative context. One is aware of a story behind the latter image, of previous episodes and events to come, for Ariadne's melancholic character arises from the plot familiar to the educated viewer. The title

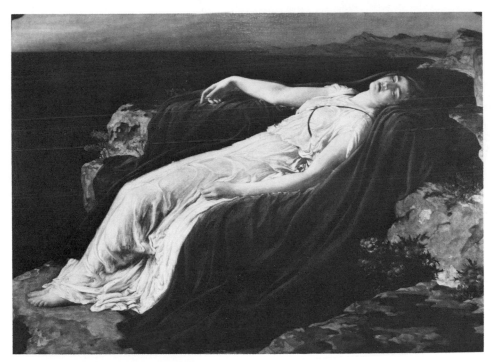

67. Frederic Leighton, *Ariadne.* 1868. Oil on canvas, 45 × 62 in. Salar Jung
Museum, Andhra Pradesh, Hyderabad.

Flaming June, however, imparts no literary associations. It refers to a season, to weather or color; all is vague and suggestive. The world of specific individuals, of drama, actions, causes, of consequences and human relationships, has been abandoned. Compared to *Ariadne*, *Flaming June* is more civilized. Raw nature—rocks and shrubs—form Ariadne's environment, while the later figure sleeps in a man-made realm, protected by artistic decoration and shielded from the empty sea beyond and the sun above.

Ariadne may be alive or dead: the viewer remains uncertain. Ariadne here may be asleep, left by Theseus and about to be discovered by Bacchus (as in the famous classical sculpture of Ariadne in the Capitoline Museum). But in some versions of the myth Ariadne dies on the island of Naxos.[5] Leighton ambiguously titled the work in the exhibition catalogue of 1868 *Ariadne Abandoned by Theseus: Ariadne Watches for His Return: Artemis Releases Her by Death.* Did Leighton depict the first episode, where Theseus steals away from the sleeping heroine, or the final one, where Ariadne dies? Sleep and death are confused and intertwined. It will become apparent that in this aspect *Ariadne* is akin to *Flaming June*.

The clearest early forebear of *Flaming June* in Leighton's oeuvre is *Summer Moon* (1872, fig. 68), which is similarly seasonal in title, vague in reference, classical in accessories, Michelangelesque in figure type, simple in arrangement, and devoted to the theme of sleep. In both works, and indeed in many others by Leighton, the draperies possess a life of their own, not wholly responsive to gravity or underlying volumes. The floating character of the folds may derive from Leighton's habit of studying draperies on the floor, looked at from above.[6] The independence of the draperies suggests the entrance of some irrational breeze or unearthly force; a mysterious levitation is produced. The rhythmic doubling of forms in the two-figure *Summer Moon* creates a luxurious movement through the picture, and the curving bodies and sweep of architecture assist the cadence. *Flaming June* relies more exclusively on the undulation of garments to produce a similar breathing motion of form. *Summer Moon* ties sleep to love, as the companions link hands and rest against each other. But equally prominent in this work is the presence of death. Creeping through the architectural opening and lying on the ground are pomegranates, traditional symbols of death, and fruit of the underworld.[7] In *Flaming June* the oleander may play a similar role, for that beautiful plant is virulently poisonous in all its parts.

Death was assuredly on Leighton's mind in 1895. *Lachrymae* (fig. 69) was exhibited with *Flaming June* in his studio and at the Royal Academy exhibition of 1895, and that work is an uncontestably death-laden image in purple and black. This vision of mourning is a classicized version of those bowed and weeping statues that populate Victorian graveyards; death is shown through its effect on the living—at a distance from the event itself. The cypress behind the mourning woman is the favored tree of cemeteries, a traditional symbol of death, and illustrates the artist's interest in emblematic vegetation.[8] (In *The Daphnephoria* of 1874–76 [Lady Lever Art Gallery, Port Sunlight] Leighton devoted one of his

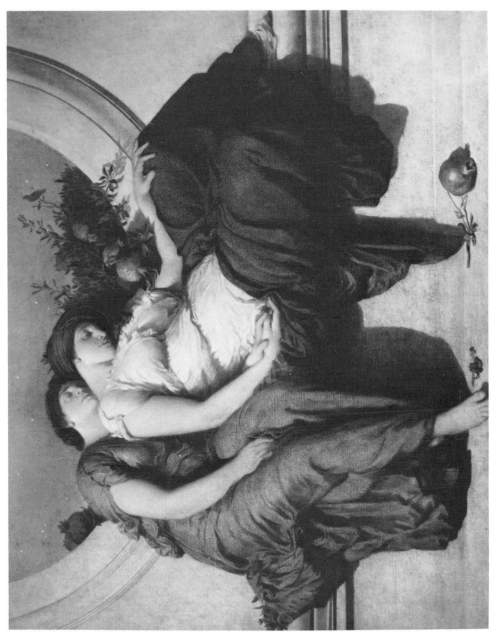

68. Frederic Leighton, *Summer Moon*. 1872. Oil on canvas, 39½ × 50½ in. Private collection, India.

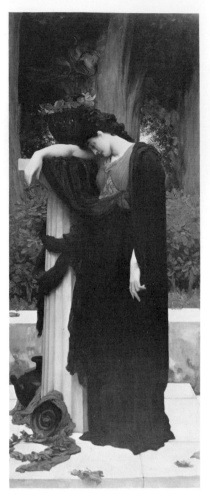

69. Frederic Leighton, *Lachrymae*. 1895. Oil on canvas, 62 × 24¾ in. Metropolitan Museum of Art, New York, Wolfe Fund, 1896.

largest canvases to a ceremony dedicated to the laurel.)[9] The deathly import of the noxious oleander in *Flaming June* thus should not be ignored. Richard and Leonée Ormond see Michelangelo's *Night* (fig. 70) as a primary source for *Flaming June*, and that work, which Leighton considered one of the supreme acievements of Western art, has strong associations with death.[10] It is part of the Medici Chapel, a memorial to two members of that family who died young, and *Night*, like the other times of day in the complex, rests atop a sarcophagus.[11]

Sleep may represent death in *Flaming June* and *Summer Moon*, visions of mortality's beauty, or euphemisms to avoid depicting the horror of death. Leighton never dwelled upon the grim or terrible. But the sleeping figure in *Flaming June* is also filled with life. Her breasts are full, the climate is warm, the sun shines, and the organic ripplings of drapery produce an Art Nouveau pattern of vitality. There seems little doubt that Leighton associated undulant curves with life. In *Hercules*

Struggling with Death for the Body of Alcestis (1869–71; collection of Mr and Mrs. J. Tannenbaum, Toronto), the twisting forms of the living contrast boldly with the rigid body of the dead Alcestis. Although not all of Leighton's sleepers exhibit overt attributes of mortality, a forbidding mood of death nearly always enters the picture. Even a painting such as *Cymon and Iphigenia* (1884, fig. 71) is not totally free of funereal suggestions. The sleeping heroine, aglow with supernatural light, embodies the purifying effects of beauty. Iphigenia will civilize Cymon, the rude and stupid boy who stares at her recumbent form. In Boccaccio's tale these two characters eventually live happily ever after. Nevertheless, this image filled with serpentine sleepers and one onlooker, is dark and brooding; an eerie, menacing, disquieting mood prevails, and tellingly, this work probably inspired Ferdinand Hodler's death-ridden *Night* (1890; Kunstmuseum, Bern).[12]

Summer Slumber (fig. 66) is another painting ambiguously touched by both life and death. The figure is surrounded by roses and pigeons, hardly signs of death. The statue in the left background puts finger to mouth, an emblem of silence. The other statue-figure in the painting is asleep, and her overturned urn is now presumably empty. This may be a symbol of extinction, but less clearly so than pomegranates or cypresses.[13] At the very least, sleep is the closest parallel to death in living beings, and in literature of all ages sleep has been employed as a synonym for death: "Sleep and Death, two twins of winged race / Of matchless swiftness, but of silent

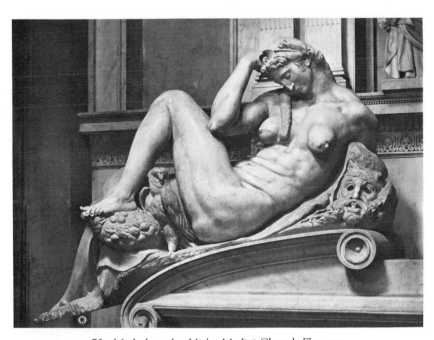

70. Michelangelo, *Night*. Medici Chapel, Florence.

71. Frederic Leighton, *Cymon and Iphigenia.* 1884. Oil on canvas, 64 × 129 in. Art Gallery of New South Wales, Sydney.

pace."[14] All Leighton's motionless, unconscious, gazeless figures might just as well be dead as slumbering. Leighton's friend Robert Browning wrote, "Prone as asleep—why else is death called sleep?"[15]

Any interpretations of sleep in Leighton's art must go beyond Leighton's art alone, for lethargy and somnolence abound in British paintings of the late nineteenth century.[16] For example, in 1887 Albert Moore exhibited *Midsummer* (fig. 72), a picture much like *Flaming June* in its drowsiness, seasonal title, brilliant orange color, symmetry, remoteness, elegance, calm, decorative richness, and absence of narrative (although Moore typically mingles classical elements with Japanese accessories).[17] Moore repeatedly depicted somnolent classical figures from as early as 1869, and Edward Burne-Jones also portrayed slumber on numerous occasions.[18] In the early 1860s Burne-Jones illustrated Perrault's *Sleeping Beauty* on a set of tiles. He later elaborated that tale in paintings of the 1870s, 1880s, and 1890s, the ultimate statement of the subject being the *Briar Rose* series (fig. 73) at Buscot Park, Berkshire, a continuous frieze filled with sleeping knights and ladies in flowering thornbushes. Burne-Jones's largest painting is the unfinished *Sleep of King Arthur in Avalon* (1881–98; Ponce Museum, Puerto Rico), another medieval epic of magical suspended animation.[19] John William Waterhouse painted a narcatose Saint Cecilia in 1895, surrounded by music-making angels.[20] Lawrence Alma-Tadema's *In the Tepidarium* of 1881 (fig. 74) displays a sumptuous nude asleep or drowsy in the indulgent splendor of a Roman bath.[21] These are but a few of the innumerable sleep images that filled the English exhibition halls in the last decades of the century.

Sleep had been depicted previously in British art, but in very different ways— more moralizing, light-hearted, socially conscious, anecdotal, and explicable.

Sleep had appeared in boisterous "fairy pictures" and scenes from *A Midsummer's Night Dream* as the initiator of wild and fantastic dreamworlds (fig. 76). Or sleep had been part of pictorial social statements, a sign of exhaustion in pictures of overworked seamstresses (fig. 75),[22] or a representation of idleness and unemployment in pictures of contemporary society (for example, Ford Madox Brown, *Work*, 1852–65; Manchester City Art Gallery).[23] In late-nineteenth-century sleep images, somnolence has no connection with the earthly realm of labor, social questions, or morality. The sleep images of Leighton, Burne-Jones, Moore, and even the more factually minded Alma-Tadema are dreamlike, but totally alien to the whimsical hodgepodge depictions of the unconscious that had prevailed before the

72. Albert Moore, *Midsummer*. 1887. Oil on canvas, 62½ × 60 in. Russell-Cotes Art Gallery, Bournemouth.

73. Edward Burne-Jones, *The Sleeping Princess* (from the Briar Rose Series). 1873–90. Oil on canvas, 48 × 90 in. Faringdon Collection Trust, Buscot Park, Berkshire.

74. Lawrence Alma-Tadema, *In the Tepidarium*. 1881. Oil on panel, 9½ × 13 in. Lady Lever Art Gallery, Port Sunlight, Merseyside.

1860s (fig. 76). Above the heads of Leighton's sleepers rise forms and spaces of richness and emptiness, as if they were emanations from the depths of the figures' minds. The entire pictures, figures included, may also be seen as dream visions, silent, beautiful, and mysterious. Similarly, in Burne-Jones's *Briar Rose* series (fig. 73), the figures' stupor is attractive and inviting, exquisitely entwined with lush flowers and unearthly softness. In all these works the world of the unconscious is beautiful, serene, sensuous, and worthy of embrace.

Allen Staley has pointed out that Rossetti's lethargic, musical watercolors of 1856–57 (plate 8) probably lie behind the somnolent images of Moore, Burne-Jones, Leighton, and others.[24] A similarly mysterious inertia and colorful richness grips Rossetti's dreamy, medievalizing works. None of them actually depicts sleep, but all the figures seem like sleepwalkers. Social, moral, and psychologically dramatic concerns have been replaced by an escapist never-never land of ornament, love, and narcotic pleasure. In the 1890s F. G. Stephens interpreted these works by Rossetti as musiclike compositions of color, shape, and line, but Stephens was probably influenced by the post-1850s aesthetic doctrines of Whistler and Oscar Wilde.[25] The avoidance of factual truth and didactic message is perhaps the most prophetic aspect of these Rossetti watercolors. Enervation became a new attribute of feminine beauty in Rossetti's art, a quality in women not condoned by conventional etiquette. Lassitude in Rossetti's works remains largely inexplicable, contributing to the atmosphere of mystery and abnormality. But given Rossetti's career-long fascination with the sentiment, power, and meaning of love, sleep-

75. Charles West Cope, *Home Dreams*. 1869. Oil on canvas, 25 × 30½ in.
Yale Center for British Art, Paul Mellon Fund.

iness probably represents the enchantment of love and love's freedom from the restraints of normal consciousness.[26]

Flaming June lacks Rossetti's fussy, claustrophobic interiors and the fairy-tale flavor of the Middle Ages, but it too presents a socially silent scene indefinite in geography and time—vague in meaning but filled with beauty. As in Rossetti's works, drowsiness does not appear to be regrettable. It seems to be an ideal condition, far from the dictates of society, history, reason, and worldly affairs. Sleep is an inactive state where moral control is lax, a liberation from or a means of avoiding unpleasant realities.

Rossetti is not the only possible source of late-nineteenth-century somnolence. John Frederick Lewis, a painter of Near Eastern genre scenes, dwelled upon sleep and lethargy from the 1850s onward (fig. 77). His drowsy harem girls, slaves of love, recline in silent, lush interiors beyond the bounds of Western morality, recalling the sumptuous sensuality of the *Arabian Nights*. The Near East was a land that Westerners viewed as indolent, luxurious, erotic, and sleepily indifferent to the march of history. It is significant that Alma-Tadema, Moore, and Leighton all

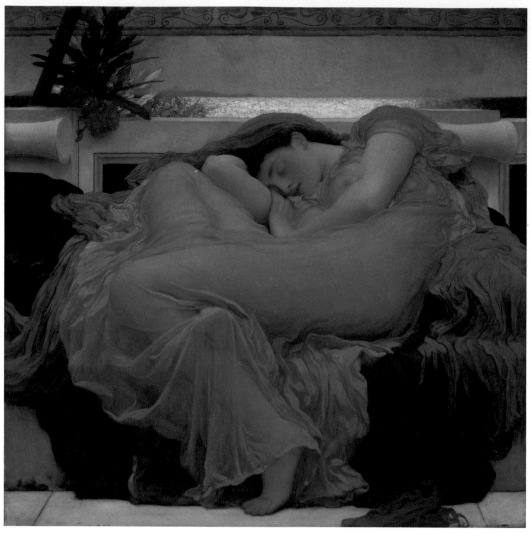

Plate 7. Frederic Leighton, *Flaming June*. 1895. Oil on canvas, 47½ × 47½ in. Museo de Arte de Ponce, Fundación Luis A. Ferré, Puerto Rico.

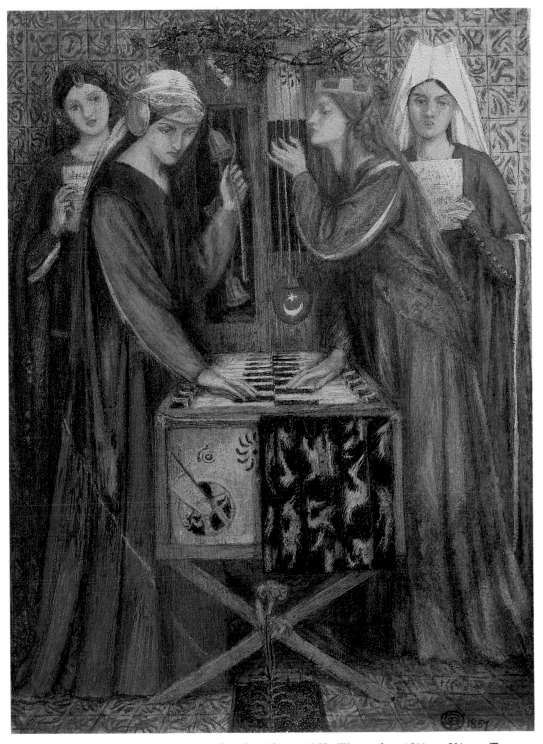

Plate 8. Dante Gabriel Rossetti, *The Blue Closet*. 1857. Watercolor, 13½ × 9¾ in. Tate Gallery, London.

76. John Austen (or Anster) Fitzgerald, *The Stuff That Dreams Are Made Of.*
1850s. Oil on canvas, 14½ × 18 in. Coll. Sir David Scott.

dabbled in Near Eastern subjects before turning to the classical world. The familiar
Levantine love object, the quiescent harem girl, seems to have remained in their
art, but dressed in Greek draperies.[27]

Love and death and freedom from ordinary existence are not the only themes
that may underlie British paintings of sleep. Slumber has been explained by some
commentators as a corollary of art-for-art's-sake aesthetics, a handmaiden of the
desire to concentrate upon the abstract form of the picture rather than upon
narrative or moral messages.[28] Albert Moore's contemporaries interpreted his
drowsy pictures in this manner.[29] The passivity of the figure and lack of psycholog-
ical contact between viewer and figure may encourage the purely formal apprecia-
tion of paintings. The goal of abstract rather than illustrative beauty had been
championed first by Walter Pater and then by Whistler and Oscar Wilde, and
became a common viewpoint in the late decades of the century.[30] Critics discussed
images of sleep in purely formal terms. Thus the reviewer in *The Times* wrote of
Flaming June: "It is the single figure of a girl asleep in the full June sunlight, in an
attitude which the painter has seemingly chosen mainly as an exercise in the

77. John Frederick Lewis, *The Siesta*. 1876. Oil on panel, 34⅞ × 43¾ in. Tate
Gallery, London.

drawing of complicated line. The mass of drapery is of that peculiar reddish orange
of which Sir Frederic Leighton's palette seems to possess the secret, and this is
harmonized, in that manner of his which is so familiar, against other draperies of
dark crimson and pale olive."[31] But does the image of sleep truly inhibit the
psychological, story-telling, extraformal trappings of art? To gaze upon a sleeping
figure is not so distancing as might first appear. Figures such as that in *Flaming June*
are vulnerable and can be aroused by us. We calculate our position and register our
attitude. We are voyeurs of a private act and can disturb or take advantage of the
privacy.
 In Burne-Jones's *Briar Rose* series (fig. 73) we are placed in the position of the
handsome prince. The beautiful dreamers in all these works are in our control,
more malleable because they are unaware, and no other event deflects our poten-
tial action. The viewer becomes aware of the restraint and responsibilities of the
waking state, and of the freedom and defenselessness of sleep. A strange sexual
confrontation arises, for eroticism is certainly linked to sleep in these late Vic-
torian works, where women are nearly always the somnolent figures. All the
sleeping Venuses of Western art are recalled. The luscious nudes of that tradition,
which stems largely from Giorgione's and Titian's *Sleeping Venus* of circa 1500 (fig.
78), are laid out for our delectation and made more vulnerable by their somnolent
state. Sleep in the traditional images of Venus also suggests the power and peace of
love, the physical and spiritual softening that comes with love's embrace.[32] In such

images the object of desire is presented to the viewer, but without speech or glance or mental rapport. The viewer alone is aware of his desire, and this strengthens the private, imaginary character of the sexual engagement. The figures in late-nineteenth-century sleep paintings may not all be completely nude or definitely Venuses, but they echo the imagery of *Sleeping Venus* and hint at that work's luxurious sexuality.

The eroticism associated with sleep is, however, far from passionate or vulgar. It is composed of quivering suggestions, and imagined responses. Leighton's distaste for the physicality of Pan is apparent in his remarks of 1895 on the ideas of Max Nordau: "What, for instance, can we say of a man who asserts, as a truism, that aesthetic and *sexual* (!) feelings (not sensual but 'geschlechtlich') are not merely akin but actually cover one another to a very large extent. I doubt whether there is anything chaster than the sense of beauty in abstract form; he has no inkling of this."[33] The sleeping woman in *Flaming June* is passively tempting, but she curls up and retreats; her remoteness quiets any urge for immediate physical action on our part. Sensual love is a thought, not an act, when sleep is present.

Sleep in *Flaming June* (and in many late-nineteenth-century British paintings) thus carries several associations: death, love, aesthetic purity, and the world of dreams. Sleep perhaps most significantly reveals the change in attitude from early Victorian painting. If death is represented by sleep, the cause, purpose, and rewards of death are unclear and uncertain (whereas in works such as Leighton's *Romeo and Juliet* [1853–55; Agnes Scott College, Decatur, Georgia] death is a

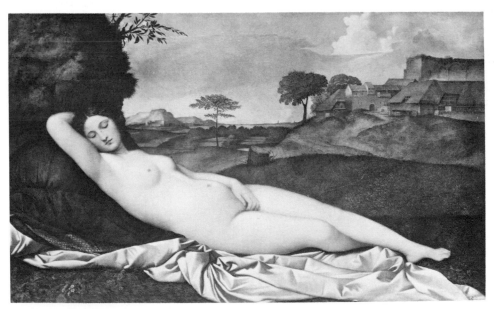

78. Giorgione and Titian, *Sleeping Venus*. Oil on canvas, 42½ × 68¾ in. Gemäldegalerie, Dresden.

tragic yet reasonably understood phenomenon). If love is depicted, the passive sensuality expressed is not innocently playful or socially ordered to fit the codes of decency revealed in earlier paintings (for example, Augustus Egg's *Past and Present*, fig. 18). If aesthetic purity is the aim, then the didactic and truth-to-nature bases of art have been subverted. If dreams are suggested, they make the unconscious mind appear more mysterious and inviting than in earlier works. In late Victorian paintings sleep overall seems to stand for freedom from ordinary constraint. It is the new ideal, an embrace of the imaginary, a quiet, amoral, deathlike trance, a passive escape from physical reality. The celebration of sleep implies that inaction is preferable to action. In harmony with this attitude, Walter Pater claimed that art, beauty, feeling, and understanding rest upon "being rather than doing."[34]

The classicism of *Flaming June* is a natural complement of those ideals embodied in the image of sleep. British classicism in the second half of the nineteenth century, of which Leighton was a major figure, represents a turn away from Pre-Raphaelitism and detailed naturalism to grand tradition.[35] This classical tendency became notable in Leighton's work around 1864, when he exhibited *Orpheus and Eurydice* (Leighton House, London). Instead of slender early Renaissance figures, large-scale, big-boned figures with ideal features based upon antique or High Renaissance prototypes became his standard production. In the 1880s and 1890s Leighton frequently employed as a model Dorothy Dene, an actress whose Junoesque gravity and grandiose body exactly matched the remote dignity of the artist's classical ideals. Dorothy Dene was almost certainly the model for *Flaming June*.[36] Burne-Jones and Albert Moore moved toward classicism at the same time as Leighton. In the 1860s, Rossetti's work also became more monumental and Titianesque, and Alma-Tadema turned to Greek and Roman scenes. Whistler experimented with classical figures and turned his back on Courbet in the same decade, while G. F. Watts had begun to exploit an enobling, generalized, tradition-bound style as early as the 1850s, although his influence cannot wholly account for the shift in values noted above. The European experiences and training of most of these painters may partly account for this development. Precedents in France, Germany and elsewhere can be found (for example, Puvis de Chavannes, Anselm Feuerbach), but British painters turned to classicism while they worked in England, not when they lived abroad. Leighton had studied in Frankfurt, Antwerp, Paris, Florence, and Rome, but classicism did not forcefully or consistently appear in his art until after he had settled permanently in London in 1859. Classicism must have struck a responsive chord and filled a deep need in England, for Leighton's position as President of the Royal Academy (from 1878 until his death in 1896) and his critical success are measures of classicism's esteem. The turn from Pre-Raphaelitism toward classicism in the 1860s marked a shift of attention from what is to what was or might be. The intimate, physical world represented previously was regarded as too unpleasant, incoherent, or cut off from tradition.

Victorian classicism differed from the more severely puritanical variety of the late eighteenth and early nineteenth centuries, which had emphasized heroic

themes and passionate drama.[37] In Alma-Tadema's classical works Greek and Roman culture is English country-house life in antique dress: polite, elegant, leisurely, dedicated to amusement and beauty, occasionally mischievous, and not heavily intellectual. Leighton's less anecdotal classicism is not all that different. The great majority of his classical scenes depict a restrained, often doleful, but always majestic existence. This classical world is above all civilized, adorned with architecture and sculpture, incapable of excessive strain or torment. The heroes are gentlemen, the maidens all fair, and mankind rarely appears without a refined veneer. A critic in 1871 characterized British classicism as "a certain *dolce far niente* style, with a general Sybarite state of mind which rests on art and aestheticism as the be-all and end-all of existence."[38] And indeed, most of its practitioners depicted a realm of luxurious leisure. *Flaming June* epitomizes that ideal: a sensuous, perfumed life without action, where dreams can breed, and where sleep and death are reinforcements of stasis. The morally righteous dedication to labor and diligence advocated by Thomas Carlyle and others at mid-century has been denied.[39] It is as if a first generation of hard-nosed industrial magnates had given birth to a race of sensitive *Buddenbrooks* degenerates who consume rather than create wealth.

Leighton's figure in *Flaming June* is virtually nude: the diaphanous draperies reveal rather than conceal the body, and this nudity is an essential part of classicism. Although the Victorian period is often thought of as prudish, overdressed, and puritanical, artistic nudity (and its inevitably attendant sexuality) was not forbidden. But in Victorian England (in contrast to nineteenth-century France), the nude was rarely posed in licentious contexts or with an inviting gaze. In a few of Leighton's nudes from the 1860s, the emphatic creases between thigh and pudendum and the tender friction of pert breasts produce a mildly sensual warmth. But in most instances, *Flaming June* included, Leighton's nudes primarily declare highmindedness, the dignity of humanity as conceived by the ancient Greeks, the simplicity and completeness of classical ideals. Nudity meant "high art." Leighton's nudes may appear limp, lifeless, and unstable when compared to his High Renaissance and classical Greek models.[40] But Leighton's figures are not totally hollow imitations, nor are they trivialized smiling cuties or realist carcasses. In the history of the nude in nineteenth-century British painting, Leighton most faithfully upheld the calm proportions and harmony of Greek ideals. From the 1820s through the 1840s William Etty painted nudes (fig. 79), but despite their classical associations, they are inarticulate Rubensian fields of energy, as were the mannered, Michelangelesque bodies of William Blake and Henry Fuseli in earlier years. At mid-century, William Mulready's bathers (fig. 80) may have postures redolent of classical statuary and High Renaissance masters, but they are bland, small-scale, fragile, and seemingly sheathed in transluscent leotards. The nudes of G. F. Watts, contemporary with those of Leighton, are never harmoniously beautiful; anxiety, ungainliness, and ugliness creep into his figures. And in the Edwardian period the nudes of Edward Poynter possess a naughty prurience.

79. William Etty, *Venus and Her Satellites*. c. 1835. Oil on panel, 30½ × 42½ in. Museo de Arte de Ponce, Fundación, Luis A. Ferré, Puerto Rico.

Leighton's Michelangelism is like his classicism, de-energized and sweetened (whereas earlier British artists had appreciated that master for his *terribilità*). Michelangelo's influence runs through much of Leighton's mature career, a source of inspiration approved by established convention but denigrated by the Pre-Raphaelites' defender John Ruskin.[41] Leighton even illustrated an anecdote from the master's life, *Michelangelo Nursing his Dying Servant* (1862; untraced), in which the artist, usually described as an irritable and passionate giant, appears tender and maternal. *Lieder ohne Wörter* (1861; Tate Gallery, London) first displayed Leighton's attraction to Michelangelo. But this picture of a girl, Michelangelesque in form and drapery, who lethargically listens to the sounds of water and birds, lacks Michelangelo's strength and muscular potential. Even when Michelangelo's figures are at rest (for example, fig. 70) their bodies are active, composed of forces that push and pull. *Flaming June* depends upon Michelangelo's *Night,* but loosens and calms the strains and conflicts of the original. Leighton's attraction to *Night* may stem not only from the beauty, fame, and dignity of the statue, but also from Michelangelo's poem on *Night.* The verses were published in most of the popular and scholarly Michelangelo literature of Leighton's day and express the longing for dreamy oblivion that seems to underlie *Flaming June:* "Sweet to me is slumber, and still sweeter to be in marble. Not to see, not to feel, is happiness in these days of baseness and dishonour. Wake me not then, I pray thee, but speak low."[42]

Titles of paintings in the 1890s are often oblique, effectively thwarting any attempt to read an aesthetic picture as an anecdote or narrative. Nevertheless, the title *Flaming June* still invites an interpretation of the painting as a representation of the month of June, or summer in general. "Summer" appears in the titles of other sleep images by Leighton, and he turned to the subject of the seasons more overtly several times in his career. For example, he envisioned *The Death of the Year* in the mid-1860s as a quattrocentoesque funeral procession and dealt with Spring's revival allegorically in *The Return of Persephone* in 1891. Leighton was attracted to the universal and many-leveled themes of the calendar, the changing yet constant cycle of nature, the repetitive death and rebirth of the earth. On a mundane level *Flaming June* can be viewed as a genre depiction of summer in the antique world, and expressive of enervating heat. Sleeping figures sometimes appear in the naturalistic tradition of the labors of the month (for example, the dozing peasant in

80. William Mulready, *Bathers Surprised.* C. 1852–53. Oil on panel,
23¼ × 17½ in. National Gallery of Ireland, Dublin.

Brueghel's *Harvesters*, Metropolitan Museum of Art, New York). But the idealization, symmetry, and grandeur of *Flaming June* favor a more abstract interpretation. The figure personifies the summer season, instead of merely illustrating the actual appearance and activities of the time of the year. Leighton's orange, wheel-like woman can further be construed as an embodiment of the June sun itself, golden, glowing, and full; the draperies act like vital solar heat waves. Richard and Leonée Ormond have pointed out that a number of Leighton's classical works are hymns to sunlight as a divine and saving force, as a symbol of his artistic and spiritual aspirations.[43] But if *Flaming June* is a radiant emblem of fulfillment, or a personification of the time of the year when the earth is young, ripe, and warm, this shining vision is strangely darkened. The deathlike sleep and poisonous oleander violate suggestions of fertility and life.

One may speculate about the artist's intention to depict the sun's whole course through the year, eros and thanatos entwined, or the ultimate ruin of beauty and goodness. But finally one is faced with mixed metaphors and an insolvable puzzle. The contradictory suggestions of life and death in *Flaming June* produce paradox— a feeling that the world is unknowable. Leighton's painting is not an untroubled depiction of classical nobility, but an evocative mystery filled with uncertain meanings. *Flaming June* is a haunting work where all is implied and nothing clearly stated. No specific myth is illustrated and no identifiable personage is depicted. Love and death commingle in a hushed world of narcotic beauty. There is no obvious explanation of this contorted sleeper in an antique realm. *Flaming June*, so otherworldly, sensuous, and dreamy, is an exemplary symbolist painting, generally akin to contemporary images of universal mystery by Odilon Redon, Ferdinand Khnopff, Max Klinger, and Gustave Moreau. For all these symbolists, the imaging of enigmas was a means to declare that reality cannot be wholly understood in terms of bare material facts or common rationality.

The symbolist ambiguity of *Flaming June* was probably encouraged by Leighton's close friend George Frederic Watts, another painter whose later works are part of symbolism. Allen Staley has noted that Watts's famous painting titled *Hope* (fig. 81) surely lies behind *Flaming June*.[44] The disposition of the figure in *Hope* is basically that of the woman in *Flaming June*. The centrality, simplicity, gazeless head, and silence of *Hope* also find echoes in Leighton's painting. Even the typical ungainliness of Watts's figure is vaguely recalled by the knotted complexity of Leighton's woman. In both works Michelangelesque postures have become languid.

Hope, like most of Watts's allegories and like *Flaming June*, is not straightforward. The painting is disturbingly indefinite and liable to multiple and even contradictory interpretations—G. K. Chesterton went so far as to declare that Watts's *Hope* should be subtitled *Despair*.[45] And truly the bandaged, sightless woman, crouching atop a barren globe, who tries to hear the sound of the one remaining string on a rickety lyre, seems an emblem of hopelessness. The somber enigma never completely clarifies. Wisps of fog pervade a fathomless universe, and

81. George Frederic Watts, *Hope*. 1886. Oil on canvas, 56 × 44 in. Tate Gallery, London.

we are left with only half-glimpses of some grandiose idea. *Flaming June* possesses a parallel inexplicability, and both works evince the late Victorian effort to believe that there are great unknowns, mysterious truths beyond the trivia of daily existence.

Conclusion

In looking over the material presented in the foregoing chapters several general developments become apparent. Victorian art in its early stages (Landseer and Ward) is composed of small forms, loosely woven together, set within baroque spaces, and dependent upon light and dark contrasts. At mid-century (Brett and Hunt) Pre-Raphaelitism rejects baroque chiaroscuro, angled viewpoints, and fluent space, and emphasizes the tenuous relationship of forms. Objects and figures become more discreet within the image; forms are dispersed over the complex surface, and color and line become the dominant means of description. From the mid-1860s onward (Whistler, Forbes, Leighton), a new structural discipline, grandeur, and reductiveness appear. Simpler, more planar compositions arise; large forms mark out the compositions with clear architectonic strength. The niggling details of Pre-Raphaelitism, as well as the half-obscurity and complex weavings of earlier baroque styles, fall away.

The stylistic journey from Landseer to Leighton is also one of growing concern with pictorial unity. The description of individual textures and stuffs is more notable in Landseer, Ward, and the Pre-Raphaelites. In Whistler's art verisimilitude is reduced in favor of unified design. And despite Forbes's realist subject and devotion to plein-airism, the square-brush technique gives an insistent uniformity to his picture. Leighton's work is a calm harmony where all parts are firmly integrated.

One may also note that sentimentality, emotion, and narrative become less conspicuous in Victorian art in the last three decades of the century. Forbes as a genre painter is so much more sober and undramatic than previous British painters in the field, and Whistler and Leighton move toward an iconic art, less active, less heart-tugging, less theatrical than art between the 1830s and 1860s. The manner in which the subject of death is treated by Landseer and Leighton is indicative of great changes. For Landseer death is a grim and tearful story, whereas for Leighton death is only an implication, inexplicable, soft, attractive, an ideal state of passivity.

Attitudes toward modernity and contemporary issues also undergo a devel-

opment. The art of Landseer, Ward, and the Pre-Raphaelites contain allusions to topical questions—economic, religious, scientific. There are wistful returns to earlier periods and to primitive societies, but the problems of the age still surface. In the works of Whistler and Leighton art retreats into a private aesthetic world, and in the work of Forbes the interest in poor fisherfolk is at heart an escape from modern industrialized Britain.

There are, to be sure, major exceptions to these general trends. For example, the social commitment, emotive force, chiaroscuro, and emphatic narratives of painters such as Fildes, Holl, and Herkomer in the 1870s run counter to much that has been stated above. Various problem-picture artists and painters of modern-life subjects were also active and successful at the same time as Whistler and Leighton. The delineation of general movements given here is not meant to be all-encompassing, but a picture of predominant changes and directions.

The artistic sources of Victorian art are varied, and naturally in accord with the changing styles of the period. In the nineteenth century, when past art could be seen in public collections and in reproduction to a far greater extent than in previous eras, the artist had a wide choice of models, and in many instances the model chosen had some fairly specific meanings or associations. The Little Dutch Masters, who lie behind *The Old Shepherd's Chief Mourner*, represented humble realism. Hogarth, who inspired Ward, was associated with nationalism, middle-class morality, and the linkage of art and literature. The masters of the quattrocento were admired by the original Pre-Raphaelites for their unsophisticated sincerity, faith, and simple truthfulness. Velasquez, for Whistler, was a master of sobriety, cool balance, and elegant design. The art of classical antiquity, Michelangelo, and the High Renaissance that inspired Leighton stood for high art, high-mindedness, tradition, and perfect beauty.

The art of earlier centuries was not some ordered progression for Victorian artists, but a marvelous treasure house to be raided at will. Styles borrowed from the past were not evolutions, but selections, and a sense of eclecticism pervades the entire century, both outside and within Britain. Victorian artists' attitude toward past art in part explains the astonishing diversity of their productions, and the lack of any simple coherent progression in the period. The development of Victorian art is not an even flow, but a series of starts, halts, experiments, and reactions. One cannot foresee Pre-Raphaelitism or the art of Leighton in the paintings of Landseer in the 1830s.

The most dramatic shifting of gears came at mid-century, when the Pre-Raphaelites rejected most of the established art and traditions of their time. Plein-airism, realist aesthetics, minutely detailed and colorful styles, and the imitation of fifteenth-century painting had all appeared in some measure earlier in British art. But all these elements came together in a new and vital form in the hands of the Pre-Raphaelites in 1848, and many links with the past were broken.

Nevertheless, there are some continuities in Victorian art. For example, the dreamy, archaistic art of Rossetti was elaborated by Burne-Jones and his followers,

gradually acquired rhythmic patterns and High Renaissance figures, and became part of that mysterious and sensuous symbolist world of which *Flaming June* is representative. And classical subject matter and form, which arose in the 1860s, continued through the 1890s. But such ongoing currents of imagery or style were not universal or consistently dominant over the decades. One could point to modern genre subjects, for example, as a continuous strain in Victorian art, perhaps strongest in the 1850s, but nevertheless markedly present as well in following decades. But this continuity of subject matter is more notable for its alterations than its consistency. A work such as William Quiller Orchardson's *The First Cloud* (1887, fig. 82), which portrays modern marital disharmony, is thoroughly different from Augustus Egg's earlier *Past and Present* (1858, fig. 18) on the same theme. Egg's pointedness, morality, and energy have been replaced by a psychological study in a wispy, nuanced style. Orchardson's couple stand in their elegant drawing room, each in a separate space; the woman turns away toward a darkened room; the man thrusts his hands into his pockets and sets his jaw firmly. What for Egg was clear, dramatic, and a matter of public decency has become a more equivocal affair, private, internal, inactive, and subtle.

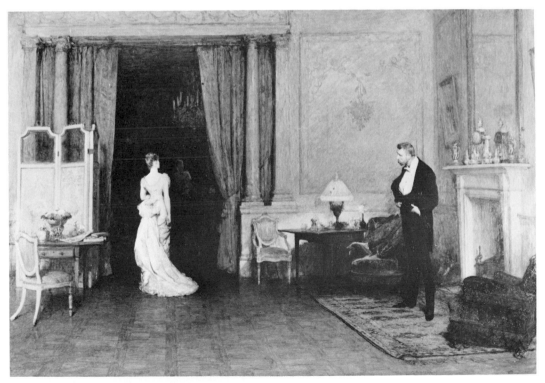

82. William Quiller Orchardson, *The First Cloud*. 1887. Oil on canvas, 76 × 52 in. National Gallery of Victoria, Melbourne.

The contemporary foreign art that influenced or bears similarities to Victorian art is as diverse as the art borrowed from the past. The French troubador style, the Nazarenes, Courbet, Degas, Bastien-Lepage, and classicism on the Continent are among the foreign connections referred to in previous chapters. There was no lack of contact between the Continent and Britain. Every one of the seven painters discussed traveled outside Britain, and Ward, Whistler, Forbes, and Leighton trained abroad. But Continental art never overwhelmingly directed the course of Victorian painting except in the 1880s, when young painters such as Forbes imitated French art as a rebellious symbol of progress. And even then Forbes chose his subject matter partly to appeal to British nationalism. Virtually every Victorian image has affinities with, and sometimes a dependence upon, Continental works. But the distinctive character of British art is nearly always apparent. The animals of Delacroix or Rosa Bonheur do not feel or act in the human fashion of Landseer's beasts. Ingres's painting of Molière and Louis xiv does not exhibit the concern with human distress and social injustice that mark Ward's *Dr. Johnson.* The realism of Courbet and the plein-airism of the impressionists led to nothing like the intensely detailed work of Brett. The sweet and idealized figures of the Nazarenes find no echo in the individualized characters of Hunt's Protestant *Finding.* Whistler's *Mother* is more strict, more drained of emotion and humanity than any work by Degas. Leighton's classicism is more luxurious than that of Puvis de Chavannes and Feuerbach, and more prim than that of Bouguereau. There is no question of British art being considered a minor variant of Continental art. In fact, art historians have neglected Victorian art in the past precisely because of its insularity, its eccentricities, its failure to accord with the developments of French art. In all fairness, Victorian artists should be appreciated on their own terms.

Notes

NOTES TO CHAPTER 1: LANDSEER

1. On Landseer see James Dafforne, *Pictures by Sir Edwin Landseer, R.A.* (London, 1873); Algernon Graves, *Catalogue of the Works of the Late Sir Edwin Landseer, R.A.* (London, 1876); F. G. Stephens, *Memoirs of Sir Edwin Landseer, R.A.* (London, 1874); W. C. Monkhouse, *The Works of Sir Edwin Landseer, R.A.* (London, 1877); *Paintings and Drawings by Sir Edwin Landseer, R.A.*, exhibition catalogue (Royal Academy of Arts, London, 1961); Campbell Lennie, *Landseer: The Victorian Paragon* (London, 1976); *Sir Edwin Landseer*, exhibition catalogue by Richard Ormond (Philadelphia Museum of Art, Tate Gallery, London, 1981).

2. Although I have been unable to find mention of such a funereal ritual in Scotland, the twigs were described as mourners' tokens by most nineteenth-century critics of the picture; see, for example, John Ruskin, *The Works of John Ruskin*, eds. E. T. Cook and A. Wedderburn (London, 1903–12), III, 88–89.

3. For example, see the Monument to Sarah, Baroness Braye (died 1862), St. Nicholas Church, Stanford, Northamptonshire, by Mary Thornycroft. On Victorian sculpture see Benedict Read, *Victorian Sculpture* (New Haven and London, 1982).

4. On the traditional meanings of dogs see Cesare Ripa, *Iconologia* (Padua, 1611), pp. 166, 262; Henriette s'Jacob, *Idealism and Realism: A Study of Sepulchral Symbolism* (Leiden, 1954), pp. 23, 24, 38, 82, 87, 230. Dogs may have numerous meanings and associations other than fidelity; see, for example: Seymour Slive, *Frans Hals* (London, 1970), pp. 79, 179–80; Richard Thomson, "'Les Quat Pattes': The Image of the Dog in Late Nineteenth-Century French Art," *Art History* (September 1982): 323–35.

5. On the mythic associations of Scotland in the eighteenth and nineteenth centuries see *The Discovery of Scotland*, exhibition catalogue by James Holloway and Lindsay Errington (National Gallery of Scotland, Edinburgh, 1978). On the popularity of *Ossian* see Robert Rosenblum, *Transformations in Late Eighteenth Century Art* (Princeton, 1970), pp. 46–48.

6. Gustav Waagen, *Treasures of Art in Great Britain* (London, 1854), III, 291.

7. Ibid. On Scott's international popularity and influence on art see *The Discovery of Scotland*, 1978; Klaus Massmann, *Die Rezeption der historischen Romane Sir Walter Scotts in Frankreich* (Heidelberg, 1972); Catherine Gordon, "The Illustration of Sir Walter Scott: Nineteenth-century Enthusiasm and Adaptation," *Journal of the Warburg and Courtauld Institutes* 34 (1971): 297–317; Catherine Gordon, "Scott's Impact on Art," *Apollo* (July 1973): 36–39; Beth Segal Wright, "Scott's Historical Novels and French Historical Painting 1815–1855," *Art Bulletin* (June 1981): 268–87. Landseer's connections with Scott are discussed in *Landseer*, 1981, pp. 61ff.

8. For example, Landseer illustrated scenes from Scott's *The Talisman* (see Graves, *Catalogue*, p. 16), *The Antiquary* (see *Landseer*, 1981, no. 70), and *The Bride of Lammermoor* (see *Landseer*, 1981, no. 69).

9. A vivacious portrait of Scott by Landseer, probably from 1824, is in the National Portrait Gallery, London. Landseer also portrayed Scott's pets (e.g., *A Scene at Abbotsford*, 1827; Tate Gallery, London).

10. On Wilkie see Allan Cunningham, *The Life of Sir David Wilkie*, 3 vols. (London, 1843); *Sir David Wilkie*, exhibition catalogue by John Woodward (Royal Academy of Arts, London, 1958).

11. See Martin Butlin and Evelyn Joll, *The Paintings of J. M. W. Turner* (New Haven and London, 1977), no. 68.

12. On the enthusiasm for Dutch art among English collectors in the early nineteenth century see Katherine Moore Heleniak, *William Mulready* (New Haven and London, 1980), p. 51.

13. Most, but not all, of Wilkie's rustics are quaint and sweet. Those in *Distraining for Rent* (1815; National Gallery of Scotland, Edinburgh) are otherwise, and that picture is one of the few tough social statements by Wilkie.

14. On Landseer's dependence upon Rubens see Joseph Rishel, "Landseer and the Continent: The Artist in International Perspective," in *Landseer*, 1981, pp. 25–41.

15. Among the most famous problem-picture painters in the last decades of the century were William Frederick Yeames and John Collier.

16. See *Landseer*, 1981, no. 61.

17. See Fred Licht, "Friendship," in *Art the Ape of Nature: Essays in Honor of H. W. Janson* (New York, 1981), pp. 559ff.

18. Reproduced in *Landseer*, 1981, no. 60.

19. On animals in art see Kenneth Clark, *Animals and Men: Their Relationship as Reflected in Western Art from Pre-History to the Present Day* (New York, 1977).

20. On Stubbs see Basil Taylor, *George Stubbs, 1724–1806* (London, 1971). On the sublime, the eighteenth- and nineteenth-century taste for the terrifying, the horrific, the vast, and the dark, see *Turner and the Sublime*, exhibition catalogue by Andrew Wilton (Art Gallery of Ontario, Toronto; Yale Center for British Art, New Haven; British Museum, London; 1980), which includes many bibliographical references.

21. On Sawrey Gilpin see Richard and Samuel Redgrave, *A Century of British Painters* (Ithaca, N.Y., 1981), p. 137; Samuel Redgrave, *A Dictionary of Artists of the English School* (London, 1878).

22. On James Ward see J. Frankau, *William and James Ward* (London, 1904); C. R. Grundy, *James Ward: His Life and Works* (London, 1909); *James Ward*, exhibition catalogue by Dennis Farr (Arts Council, London, 1960).

23. On Landseer's seventeenth-century sources see Rishel, in *Landseer*, 1981, pp. 25–41.

24. On Hogarth's *Self-Portrait* see Ronald Paulson, *Hogarth: His Life, Art, and Times* (New Haven and London, 1971), II, 1–5. Landseer's humanization of dogs was linked to Hogarth by Monkhouse, *Works of . . . Landseer*, p. 148.

25. This is pointed out in *Landseer*, 1981, no. 65.

26. Landseer's pigs were etched in 1818 by his brother, Thomas, and these prints are now in the British Museum; reproduced in *Landseer*, 1981, nos. 7 and 8.

27. On Victorian animal laws and the new sensibility see James Turner, *Reckoning with the Beast: Animals, Pain and Humanity in the Victorian Mind* (Baltimore, 1980).

28. Emotional sermons, filled with heart-rending tales to bring the congregation to tears and thereby foster a rebirth of childlike innocence, were most often preached by Evangelical and Dissenting ministers but were not limited to those denominations. For a vivid example of the concept and practice see the works of the famous English Baptist preacher of mid-century, Charles Haddon Spurgeon (1834–92), *The Autobiography of Charles H. Spurgeon . . . ,* 4 vols. (Cincinnati, Chicago, St. Louis, 1898).

29. Ruskin, *Works*, III, 88–89.

30. Monkhouse, *Works of . . . Landseer*, p. 63.

31. Richard Ormond, "Sir Edwin Landseer: A Biography," in *Landseer*, 1981, pp. 1–24.

32. On macadam roads see "John Loudon McAdam," *Dictionary of National Biography*, ed. Leslie Stephen and Sidney Lee (London, 1921–22), XII, 395–97.

33. The impoverished economic state of Scotland in the early nineteenth century is analyzed in Robert Forsyth, *The Beauties of Scotland* (Edinburgh, 1805), I, 386–405.

34. On pastoral imagery in general see J. F. Congleton, *Theories of Pastoral Poetry in England, 1684–1798*, 2d ed. (New York, 1968). Also see John Barrell, *The Dark Side of the Landscape* (Cambridge, 1980) for some political and social interpretations of "pastoral" figures in British art.

35. On the popularity of *The Gentle Shepherd* see Allan Ramsay, *The Works of Allan Ramsay . . .* , 3 vols. (London, 1851).

36. On the "Et in Arcadia Ego" theme see Erwin Panofsky, *Meaning in the Visual Arts* (New York, 1955), pp. 295–320.

NOTES TO CHAPTER 2: WARD

1. On the decoration of the new Westminster Palace see T. S. R. Boase, "The Decoration of the New Palace of Westminster, 1841–1863," *Journal of the Warburg and Courtauld Institutes* 17, (1954): 319–58; David Robertson, *Sir Charles Eastlake and the Victorian Art World* (Princeton, 1978), chap. 4 and appendix D.

2. On Ward see James Dafforne, *The Life and Works of Edward Matthew Ward, R.A.* (London, 1879); Hugh Willoughby Sweney, "Our Living Artists: Edward Matthew Ward, R.A.," *Magazine of Art* 1 (1878): 14–19; "E. M. Ward, R.A.," *Illustrated London News* (March 31, 1855): 301–02; Henrietta (Mrs. E. M.) Ward, *Memories of Ninety Years*, ed. I. G. McAllister (London, c. 1924); *Art Journal* n.s. 18 (1879): 68, 72, 84; Campbell Dodgson, "Edward Matthew Ward," *Dictionary of National Biography* XX, 771–72.

3. On the success of *Dr. Johnson* see Dodgson, "Edward Matthew Ward." Ward was elected an A.R.A. one year later, in 1846.

4. James Boswell, *Boswell's Life of Johnson*, ed. G. B. Hill and L. F. Powell (Oxford, 1934–50), I, 261.

5. Ibid. I, 256.

6. See ibid., I, 257.

7. On Chesterfield House see Isaac Ware, *A Complete Body of Architecture* (London, 1756); A. E. Richardson and C. Lovett Gill, *London Houses from 1660 to 1820* (London, n.d.), pls. 38, 39; John Summerson, *Architecture in Britain, 1530 to 1830* (Baltimore, 1969), pp. 215, 255.

8. On Lady Chesterfield's less than beautiful features see Samuel Shellabarger, *Lord Chesterfield and His World* (Boston, 1951), pp. 170–71. Petronilla Melusina von der Schulenberg, Countess of Walsingham (1693–1778), was a daughter of George I and immensely wealthy, yet she married only at the age of thirty-eight. I have been unable to locate any portraits of her. On Chesterfield's life and mistresses see Shellabarger, *Lord Chesterfield*; Lord Chesterfield, *The Letters of Philip Dormer Stanhope, 4th Earl of Chesterfield*, ed. with intro. by Bonamy Dobrée (London and New York, 1932), I; Sidney Lee, "Philip Dormer Stanhope, 4th Earl of Chesterfield," *Dictionary of National Biography*, XVIII, 911–24.

9. George Colman's verses are cited in Chesterfield, *Letters*, I, 224. The complete verses can be found in David Garrick, *The Plays of David Garrick*, ed. H. W. Pedicord and L. Bergman (Carbondale, Ill., 1980), II, 254–55.

10. On Chesterfield's role as Lord Chester in *Barnaby Rudge* see Lee, "Philip Dormer Stanhope," 923. On Chesterfield's poor reputation following his death and throughout the nineteenth century see Chesterfield, *Letters*, I, 223ff. See also Dafforne, *Life and Works*, pl. 5.

11. On the portraits of Johnson see Boswell, *Life of Johnson*, IV, 421–22, 447–64.

12. On Johnson's eccentric and unseemly features see ibid.

13. On Hogarth see Paulson, *Hogarth*. In 1863 Ward exhibited at the Royal Academy a painting of *Hogarth's Study, 1739* (York City Art Gallery), in which the artist exhibits his portrait of the philanthropist Captain Coram to grateful foundlings.

14. George Augustus Sala, *William Hogarth* (London, 1866), pp. 7–8.

15. For example, Hogarth's "improprieties" are noted in ibid., p. 8, and in Charles Lamb, "Essay on the Genius and Character of Hogarth," in *Anecdotes of William Hogarth*, ed. J. B. Nichols (London, 1833), p. 96.

16. On Egg's triptych see T. J. Edelstein, "Augustus Egg's Triptych: A Narrative of Victorian Adultery," *Burlington Magazine* (April 1983): 202–10.

17. Byron, letter to John Cam Hobhouse and Douglas Kinnaird, Venice, Jan. 19, 1819, in *Byron: Selected Prose,* ed. Peter Gunn (Harmondsworth, 1972), p. 289. For various unrepellent Victorian pictures of unsavory subjects see Lynda Nead, "Seduction, Prostitution, Suicide: *On the Brink* by Alfred Elmore," *Art History* (September 1982): 310–22.

18. For a brief essay on the general traits and aims of Evangelicalism see Geoffrey Best, "Evangelicalism and the Victorians," in *The Victorian Crisis of Faith,* ed. Anthony Symondson (London, 1970), pp. 37–57. See also Owen Chadwick, *The Victorian Church,* 2 vols. (New York, 1966–70), and Muriel Jaeger, *Before Victoria* (London, 1956).

19. See, e.g., John Pye, *Patronage of British Art* (London, 1845), p. 40; Lamb, "Essay on . . . Hogarth," pp. 92, 99; Sala, *William Hogarth,* pp. 1–10.

20. On Ward's literary and theatrical acquaintances see Henrietta Ward, *Memories.*

21. James Dafforne, in commenting on Ward's painting of Johnson (Dafforne, *Life and Works,* pl. 5). noted "the stern and independent spirit of the great lexicographer." For mid-century assessments of Johnson's character and values see Thomas Babington Macaulay, "Samuel Johnson," in *Critical and Historical Essays Contributed to the Edinburgh Review* (London, 1843); Henry, Lord Brougham, *Lives of Men of Letters in the Time of George III* (London, 1845); Thomas Carlyle, "Samuel Johnson," in *Biographical Essays* (London, 1853); Matthew Arnold, "Johnson's Lives," *Macmillan's Magazine,* 38 (1878): 155.

22. Pye, *Life and Works.* On the hardships of artists as an issue in the 1840s and 1850s see Hilarie Faberman, "Augustus Egg's 'Self-Portrait as a Poor Author,'" *Burlington Magazine* (April 1983): 224–26.

23. For the story of Johnson and Goldsmith see: Henrietta Ward, *Memories,* p. 45; Royal Academy exhibition catalogue, 1843, no. 218.

24. On the Guild of Literature and Art, founded by Dickens and Bulwer-Lytton in 1850, see Faberman, "Augustus Egg's 'Self-Portrait,'" pp. 224–26; Henrietta Ward, *Memories,* p. 235.

25. Ward's painting of Defoe, with his rejected manuscript of *Robinson Crusoe* (location unknown) was no. 318 at the Royal Academy in 1849. An engraving after Ward's painting of Goldsmith on his travels (*Scene from the Early Life of Oliver Goldsmith,* 1844) is pl. 4 in Dafforne, *Life and Works.* Ward's painting of Grinling Gibbons was accompanied by the following information in the Royal Academy catalogue of 1869 (no. 144):

 Grinling Gibbons's first introduction at Court. "I caused Mr. Gibbons to bring to Whitehall his excellent piece of carving, where, being come, I advertised His Majesty. . . . No sooner was he entered and cast his eye on the work, but he was astonished at the curiosity of it. . . . He commented it should be immediately carried to the Queen's side to show her. It was carried up into her bedchamber, where she was, and the King being called away, left us with the Queen, believing she would have bought it, it being a crucifix; but His Majesty was gone, a French peddling woman, one Madame de Boord; who used to buy petticoats, and fans, and baubles out of France to the ladies, began to find fault with several things in the work, which she understood no more than an ass or a monkey, so as in a kind of indignation I caused the person who brought it to carry it back to the chamber, finding the Queen so much governed by an ignorant French woman, and this incomparable artist had his labour for his pains."—Evelyn's Diary.

26. On Ward's family see Dafforne, *Life and Works;* Henrietta Ward, *Memories;* Dodgson, " "Edward Matthew Ward."

27. Henrietta Ward, *Memories,* p. 34.

28. Ibid., p. 40.

29. On Ward's public career, as described below, see the literature cited in n. 2, above.

30. On Cornelius and the Parliament frescoes see William Vaughan, *German Romanticism and English Art* (New Haven and London, 1979).

31. Ward's paintings in the corridor of Commons (1851 to the 1860s) were first painted in oil, but then repainted in fresco on portable frames (because the oil paintings were too glossy to be seen

clearly); see Robertson, *Sir Charles Eastlake*, pp. 199, 333. Ward's eight seventeenth-century subjects in the corridor are: *Jane Lane Assisting Charles II to Escape after the Battle of Worcester; The Executioner Tying Wishart's Book Round the Neck of Montrose; Monk Declaring for a Free Parliament; Charles II Landing at Dover; Dame Alice Lisle Concealing the Fugitives after the Battle of Sedgemoor; The Last Sleep of the Marquess of Argyll; The Acquittal of the Seven Bishops; The Lords and Commons Presenting the Crown to William and Mary in the Banqueting House.*

32. See Henrietta Ward, *Memories*.

33. See the reviews (mostly favorable, but some critical) excerpted in Robertson, *Sir Charles Eastlake*, pp. 360, 368, 377, 388, 423. On the Pre-Raphaelites' dislike of the younger established artists in the 1840s, which would include Ward, see Allen Staley, *Pre-Raphaelite Landscape*, (Oxford, 1973), p. 1.

34. Henrietta Ward, *Memories*, pp. 45–46.

35. Ibid., p. 34.

36. *Athenaeum* (May 17, 1845), p. 495. The critic's description of the fashionable lady as a singer or actress is debatable. She was not so identified by Ward's widow.

37. On the prevalence of eighteenth-century subjects in British art of the 1830s and 1840s, especially episodes from *The Vicar of Wakefield*, see Heleniak, *William Mulready*, pp. 137–40.

38. A major exception is *Chelsea Pensioners* (1822; Wellington Museum, London). See also chap. 1, n. 13, above.

39. See Graham Reynolds, *Painters of the Victorian Scene* (London, 1953); Christopher Wood, *Victorian Panorama: Paintings of Victorian Life* (London, 1976).

40. On British history painting see E. K. Waterhouse, *Painting in Britain, 1530–1790* (London, 1953); Rosenblum, *Transformations in Late Eighteenth Century Art*; Robert Rosenblum, "The Dawn of British Romantic Painting, 1760–1780," in P. Hughes and D. Williams, eds., *The Varied Pattern: Studies in the 18th Century* (Toronto, 1971); *Romantic Art in Britain*, exhibition catalogue by Frederick Cummings and Allen Staley (Detroit Institute of Arts, Philadelphia Museum of Art, 1968). On Haydon, see Benjamin Robert Haydon, *The Diary of Benjamin Robert Haydon*, ed. W. B. Pope, 5 vols. (Cambridge, Mass., 1960–63).

41. On Mulready see Heleniak, *William Mulready*. On Wilkie see Cunningham, *Life of . . . Wilkie*.

42. On archaistic painting in England in the 1840s see Vaughan, *German Romanticism*, and the literature cited in Robertson, *Sir Charles Eastlake*, p. 440.

43. On this movement in France see *Le Style Troubadour*, exhibition catalogue (Musée de l'Ain, Bourg-en-Bresse, 1971), and *French Painting, 1774–1830: The Age of Revolution*, exhibition catalogue (Grand Palais, Paris; Detroit Institute of Arts; Metropolitan Museum of Art, New York; 1975).

44. On Daniel Maclise see W. J. O'Driscoll, *A Memoir of Daniel Maclise, R.A.* (London, 1871); Richard Ormond, "Daniel Maclise," *Burlington Magazine* (December 1968): 685–93; *Daniel Maclise, 1806–1870*, exhibition catalogue by Richard Ormond (National Portrait Gallery, London; National Gallery of Ireland, Dublin; 1972).

45. Sweney, "Our Living Artists," p. 14.

46. On the disenchantment of the public and the Fine Arts commissioners with the Parliament frescoes see Boase, "Decoration," pp. 357–58; *Maclise, 1972*, no. 123.

NOTES TO CHAPTER 3: BRETT

1. *The Glacier of Rosenlaui* was no. 1124 at the Royal Academy exhibition of 1857. On Brett see Staley, *Pre-Raphaelite Landscape*, pp. 124–37; Staley, "Some Water-Colours by John Brett," *Burlington Magazine* (February 1973): 86–93; David Cordingly, "'The Stonebreaker': An Examination of the Landscape in a Painting by John Brett," *Burlington Magazine* (March 1982): 141–45.

2. On the geological issue of "erratic boulders" before the acceptance of the glacial theory see

Albert V. Carozzi, intro. to Louis Agassiz, *Studies on Glaciers, Preceded by the Discourse of Neuchâtel*, ed. A. V. Carozzi (New York and London, 1967); Bert Hansen, "The Early History of Glacial Theory in British Geology," *Journal of Glaciology* 9 (1970): 135–41; John and Katherine Imbrie, *Ice Ages* (Short Hills, N.J., 1979), chaps. 1, 2. On Agassiz see E. Lurie, *Louis Agassiz: A Life in Science* (Chicago, 1960).

3. On the ice-raft theory see the literature cited in n. 2. On Lyell, see E. Bailey, *Charles Lyell* (London, 1962).

4. Agassiz's glacial theory was first proposed in a lecture at the annual meeting of the Société Neuchâteloise des Sciences Naturelles, July 24, 1837. On the theory see Carozzi, intro. to Agassiz, *Studies.*

5. Louis Agassiz, *Etudes sur les glaciers* (Neuchâtel, 1840).

6. Charles Lyell, *Principles of Geology*, 9th rev. ed. (London, 1853), pp. 155, 226–27.

7. Carozzi, intro to Agassiz, *Studies*, p. xxiii.

8. John Phillips, *Manual of Geology. Practical and Theoretical* (London and Glasgow, 1855), pp. 419–25.

9. See Carozzi, intro. to Agassiz, *Studies*, p. xxvi.

10. On Brett's scientific bent and his publications in the Royal Astronomical Society see Staley, *Pre-Raphaelite Landscape*, p. 126. Brett's cooly objective descriptions of art can be found in John Brett, "The Functions of Texture in Art," *Art Journal* n.s. 32 (1893): 117–20. On Brett's portable easel see "Minor Topics of the Month," *Art Journal* 5 (1853): 207.

11. Ruskin, *Works*, XXXVI, 493–94; see Staley, *Pre-Raphaelite Landscape*, p. 134.

12. See John Murray, *Murray's Handbook for Travellers in Switzerland* (London, 1838), p. 80.

13. Lyell, *Principles*, p. 226.

14. On the formation and aims of the Pre-Raphaelite Brotherhood see William Holman Hunt, *Pre-Raphaelitism and the Pre-Raphaelite Brotherhood*, 2 vols. (London, 1905); Staley, *Pre-Raphaelite Landscape*, chap. 1; Timothy Hilton, *The Pre-Raphaelites* (London, 1970); *The Pre-Raphaelites*, exhibition catalogue by Alan Bowness (Tate Gallery, London, 1984). For an extensive bibliography of Pre-Raphaelite literature see William E. Fredeman, *Pre-Raphaelitism: A Bibliocritical Study* (Cambridge, Mass., 1965).

15. On the Nazarenes see Keith Andrews, *The Nazarenes: A Brotherhood of German Painters in Rome* (Oxford, 1964). On Nazarene influence on British art see Vaughan, *German Romanticism.*

16. Ruskin, *Works*, III, 623–24.

17. On Ruskin's complex understanding of perception, truth, and imagination note his statement (Ruskin, *Works*, V, 114): "All great men *see* what they paint before they paint it,—see it in a perfectly passive manner,—cannot help seeing it if they would; whether in their mind's eye, or in bodily fact, does not matter; very often the mental vision is, I believe, in men of imagination, clearer than the bodily one; but vision it is, of one kind or another,—the whole scene, character, or incident passing before them as in second sight, whether they will or no." The role of imagination in Ruskin's realist art theories is discussed in Robert Hewison, *John Ruskin: The Argument of the Eye* (Princeton, 1976), and Geoffrey F. DeSylva, *John Ruskin's Modern Painters I & II: A Phenomenological Analysis* (Ann Arbor, Mich., 1981).

18. Examples of Pre-Raphaelite images of rocks and pebbles include J. E. Millais, *The Waterfall*, 1853, Wilmington Society of Fine Arts, Wilmington, Del.; J. E. Millais, *John Ruskin*, 1854, Priv. Coll.; W. Holman Hunt, *The Haunted Manor*, 1849, Tate Gallery, London; W. Holman Hunt, *A Converted British Family Sheltering a Christian Priest*, 1849–50, Ashmolean Museum, Oxford; J. N. Paton, *The Bluidie Tryste*, 1855, Glasgow Art Gallery; Alfred William Hunt, *Gwm Trifaen—The Track of an Ancient Glacier*, c. 1858, Tate Gallery, London; William Dyce, *The Man of Sorrows*, c. 1859, Priv. Coll; William Dyce, *Welsh Landscape with Figures*, 1860, Coll. Sir David Scott; J. W. Inchbold, *The Cuillin Ridge, Skye*, 1856, Ashmolean Museum, Oxford; William Lindsay Windus, *The Stray Lamb*, 1864, Walker Art Gallery, Liverpool. All of the above works are illustrated in Staley, *Pre-Raphaelite Landscape.*

19. On the violent critical reaction to the Pre-Raphaelite Brotherhood and its possibly religious inspiration see Alastair Grieve, "The Pre-Raphaelite Brotherhood and the Anglican High Church," *Burlington Magazine* (May 1969): 295.
20. Cordingly, "'The Stonebreaker,'" p. 141.
21. Staley, *Pre-Raphaelite Landscape*, 1973, pp. 124–25, where the encounter between Inchbold and Brett is also described. Inchbold was at work on a view of the Jungfrau (location unknown), not the painting illustrated here (fig. 27), when he met Brett.
22. Letter of Nov. 6, 1880, to Ruskin, in Marcia Allentuck, "William Holman Hunt, Monk and Ruskin: An Unpublished Letter," *Apollo* (February 1973): 156–57.
23. Ruskin's turning point in visual understanding at Norwood in May of 1842 is described in *Praeterita*, Ruskin, *Works*, XXXV, 311. On Ruskin's emphasis on the moral and religious value of truthful seeing and truthful description see his *Modern Painters*. He declared, "The greatest thing a human soul ever does in this world is to see something, and tell what it saw in a plain way. . . . To see clearly is poetry, prophecy, and religion,—all in one." (Ruskin, *Works*, V, 333).
24. Staley, *Pre-Raphaelite Landscape*, p. 125.
25. On Ruskin's contributions to Brett's painting of the Val d'Aosta see ibid., pp. 128–33.
26. Ibid., p. 126.
27. Ruskin probably met Brett in 1857, after the latter's return to London from the Alps.
28. John Brett, "Landscape at the National Gallery," *Fortnightly Review* (April 1895): 623–29.
29. On Turner's will see Robertson, *Sir Charles Eastlake*, pp. 301–02.
30. On the history of British landscape painting see Waterhouse, *Painting in Britain*; Luke Herrmann, *British Landscape Painting in the Eighteenth Century* (London, 1973); Allen Staley, "British Landscape Painting, 1760–1860," in *Romantic Art in Britain*, 1968, pp. 25–30; *Landscape in Britain, 1750–1850*, exhibition catalogue (Tate Gallery, London, 1973); Staley, *Pre-Raphaelite Landscape*, chap. 14; *Landscape in Britain, 1850–1950*, exhibition catalogue (Hayward Gallery, London; Bristol City Art Gallery; Stoke-on-Trent Art Gallery; and Mappin Art Gallery, Sheffield; 1983).
31. On this change of taste see Camillo von Klenze, *The Interpretation of Italy during the Last Two Centuries* (Chicago, 1907).
32. On Alpine imagery in English art see Staley, "British Landscape Painting," pp. 25–30. On mountains and the sublime see *Turner and the Sublime*, 1980.
33. Of *Chill October* Millais wrote: "I chose the subject for the sentiment it always conveyed to my mind", the site depicted is below Kinfauns, near Perth. See J. G. Millais, *The Life and Letters of Sir John Everett Millais* (Toronto, 1900), II, 29.
34. See Kenneth Clark, *Landscape into Art* (London, 1949).

NOTES TO CHAPTER 4: HUNT

1. On Hunt see William Holman Hunt, *Pre-Raphaelitism and the Pre-Raphaelite Brotherhood*, 2 vols. (London, 1905); *William Holman Hunt*, exhibition catalogue, compiled by Mary Bennett (Walker Art Gallery, Liverpool, 1969); [F. G. Stephens], *William Holman Hunt and His Works: A Memoir of the Artist's Life with a Description of His Pictures* (London, 1860). Much of the material in this chapter was included in my dissertation, "The Portrayal of the Middle East in British Painting, 1835–1860," Columbia University, 1979.
2. The passage from Luke (2.41–42) is as follows: Now his parents went to Jerusalem every year at the feast of passover. And when he was twelve years old, they went up to Jerusalem after the custom of the feast. And when they had fulfilled the days, as they returned, the child Jesus tarried behind in Jerusalem; and Joseph and his mother knew not of it. But they, supposing him to have been in the company, went a day's journey, and they sought him among their kinfolk and acquaintance. And when they found him not, they turned back again to Jerusalem, seeking him. And it came to pass, that after three days they found him in the temple, sitting in the midst of the

doctors, both hearing them, and asking questions. And all that heard him were astounded at his understanding and answers. And when they saw him, they were amazed: and his mother said unto him, Son, why hast thou thus dealt with us? behold thy father and I have sought thee sorrowing. And he said unto them, How is it that ye sought me? Wist ye not that I must be about my Father's business? And they understood not the saying which he spake to them, and came to Nazareth, and was subject to them: but his mother kept all those sayings in her heart. And Jesus increased in wisdom and stature, and in favour with God and man.

3. *Athenaeum* (April 21, 1860), reprinted in the appendix of Stephens, *William Holman Hunt*, p. 86.

4. Stephens, *William Holman Hunt*, pp. 70–71.

5. See ibid., pp. 96, 98, 115.

6. Ibid., p. 77.

7. Ibid., p. 60. Hunt was closely involved in writing his friend Stephens's pamphlet of 1860, as is indicated by a letter from Hunt to Stephens, Nov. 22, 1860 (Bodleian Library, Oxford, MS Don. e. 66, fol. 53).

8. See Ruskin, *Works*, IV, 264–65. On the importance of Ruskin's symbolic reading of Tintoretto's *Annunciation* see George P. Landow, *William Holman Hunt and Typological Symbolism* (New Haven, 1979).

9. On Hunt's readings, which included Josephus, the Talmud, and John Lightfoot, as well as the Bible, see Hunt, *Pre-Raphaelitism*, I, 406, 408. On the date of the temple's completion see Josephus, "Antiquities," *The Works of Flavius Josephus* (London, 1825), bk. 15, chap. 11, p. 5; John Lightfoot, *The Temple: Especially as It Stood in the Dayes of Our Saviour* (London, 1650), p. 45; Matthew 2.15, 19. Hunt probably consulted Lightfoot's descriptions of the temple in the thirteen-volume edition of Lightfoot's works that was published in London in 1825.

10. Stephens, *William Holman Hunt*, p. 71.

11. *Mr. Holman Hunt's Picture "The Shadow of Death,"* exhibition catalogue (Agnews, Ltd., London, 1873).

12. Hunt, *Pre-Raphaelitism*, I, 355–56. Hunt acknowledged the stimulus of Carlyle for his religious paintings; see William Holman Hunt, "Christ and the Doctors: An Exposition of the Design for the Mosaic in Clifton College Chapel," *Contemporary Review* (August 1890): 186. Hunt also quoted Carlyle at the head of a chapter in his autobiography (Hunt, *Pre-Raphaelitism*, II, 115): "This is the everlasting duty of all men, black and white, who are born into this world. To do competent work, to labour honestly according to the ability given them" On Carlyle and the Victorian devotion to work see Walter Houghton, *The Victorian Frame of Mind* (New Haven, 1957), pp. 242–62.

13. Hunt, *Pre-Raphaelitism*, I, 407.

14. Stephens, *William Holman Hunt*, pp. 63–68.

15. Hunt, letter from Jerusalem to J. E. Millais, Nov. 10, 1854 (British Library, London, Add. MS 41340, fol. 156).

16. *Daily News* (April 23, 1860), reprinted in Stephens, *William Holman Hunt*, p. 110.

17. On typology in general and with specific reference to the *Finding* see Landow, *Typological Symbolism*, esp. pp. 7–14 on the definitions of this method of symbolism.

18. On the early appearance and widespread employment of typology in medieval art see Emil Mâle, *The Gothic Image* (New York, 1958), bk. 4, chap. 1.

19. See, e.g., Erwin Panofsky, *Problems in Titian, Mostly Iconographic* (New York, 1969), p. 34; L. D. and Helen S. Ettlinger, *Botticelli* (New York, 1977), pp. 53, 59.

20. Hunt, *Pre-Raphaelitism*, I, 323.

21. On Tractarianism, see R. W. Church, *The Oxford Movement: Twelve Years, 1833–1845* (London, 1892).

22. On the Tractarian allegiance of Hunt's patron Thomas Combe see Mary Lutyens, "Letters from

Sir John Everett Millais, Bart., P.R.A. and William Holman Hunt, O.M. in the Henry E. Huntington Library, San Marino, California," *Walpole Society* 44 (1972–74): 52; Grieve, "High Church," p. 295; and Mary Lutyens, "Selling the Missionary," *Apollo* (November 1967): 380–87.

23. The subject of Hunt's *Dr. Rochecliffe* (Royal Academy exhibition 1847, no. 300) is discussed by Lindsay Errington in her Ph.D. diss., "Social and Religious Themes in English Art, 1840–1860" (Courtauld Institute of Art, London, 1973). See Sir Walter Scott, *Woodstock, or The Cavalier: A Tale of the Year 1651* (Edinburgh, 1826), I, i–viii, 4–5; II, 8–9.

24. On *Canon Jenkins* (also titled *New College Cloisters*), which was painted for the Reverend A. Hackman in Oxford in June of 1852, see *Hunt*, 1969, no. 21. Canon Jenkins wears about his neck an amice, a vestment worn by Catholic-Tractarian ministers. On the amice see A. W. Pugin, *The Glossary of Ecclesiastic Ornament and Costume* (London, 1846), I, 4–8; II, pls. 2–3.

25. On the Tractarianism in Rossetti's family see Grieve, "High Church," p. 295.

26. On Collinson's conversion see ibid., p. 295.

27. See ibid., p. 295.

28. Ibid., p. 295.

29. On the riots and disputes over Tractarianism in the 1840s and 1850s see James F. White, *The Cambridge Movement: The Ecclesiologists and the Gothic Revival* (Cambridge, 1962); Grieve, "High Church," p. 295; *Hierurgia Anglicana* (1848), in *The Library of Litany and Ecclesiology for English Readers*, ed. Vernon Staley (London, 1902.-03), pt. 1, pp. 205–08. For an example of Protestant vituperation see "Puseyism or the Oxford Tractarian School," *Edinburgh Review* (April 1843): 501–62.

30. On Hunt's conversion in 1851 see William Bell Scott, *Autobiographical Notes* (New York, 1970), pp. 312–13. See also George P. Landow, "William Holman Hunt's 'The Shadow of Death,'" *Bulletin of the John Rylands University Library of Manchester* (Autumn 1972): 212–17.

31. On the *Awakening Conscience* see *Hunt*, 1969, no. 27. Hunt repainted the face of the woman in the *Awakening Conscience* at the same time that he was painting Jesus in the *Finding*: see Hunt, *Pre-Raphaelitism*, I, 418n., and *Hunt*, 1969, no. 27.

32. Stephens, *William Holman Hunt*, p. 71.

33. Excerpts of the harsh criticism of 1850 are included in *Exhibition of the Works of Sir John Millais, Bt., R.A.*, exhibition catalogue with notes by F. G. Stephens (Grosvenor Gallery, London, 1886), no. 4.

34. This idea is discussed at length in Errington, "Social and Religious Themes."

35. Charles Kingsley, *Yeast: A Problem* (1851; reprint, London, 1908), p. 83.

36. On Hunt's aims in the East see Hunt, *Pre-Raphaelitism*, I, 275. On the idea of the Near East as a living museum of antiquity see, e.g., *Penny Magazine* (July 27, 1839): 284–86; *Athenaeum* (May 10, 1856): 589; James Fergusson, "Ethnology from an Architectural Point of View," in *History of the Modern Styles of Architecture* (London, 1862), p. 527.

37. On Wilkie's aims in the Near East see Cunningham, *Life of . . . Wilkie*, III, 417.

38. On Vernet see Amédée Durande, *Joseph, Carle et Horace Vernet* (Paris, 1864). On the appreciation of Vernet in England see John Steegman, *Victorian Taste: A Study of the Arts and Architecture from 1830 to 1870* (Cambridge, Mass., 1970), pp. 272–73. On Hunt's familiarity with Vernet's orientalized religious scenes, see Hunt, *Pre-Raphaelitism*, I, 149–50.

39. On the books read by Hunt in preparing the *Finding* see Hunt, *Pre-Raphaelitism*, I, 406, 408.

40. Hunt, "Christ and the Doctors," p. 187.

41. Hunt, Letter to Thomas Combe, Jerusalem, Aug. 21, 1854 (Bodleian Library, Oxford, MS Eng. Lett. C. 296, fols. 42–43).

42. Hunt, *Pre-Raphaelitism*, I, 148–49.

43. Stephens, *William Holman Hunt*, p. 61.

44. Josephus, *Works*, bk. 15, chap. 11, p. 632.

45. On Hunt's study of local rocks for the temple floor see Hunt, *Pre-Raphaelitism*, II, 36. On the Talmud's description of the temple floor see "Sukkah," in *The Babylonian Talmud, Seder mo'ed*, trans. with notes, glossary, and indices under the editorship of I. Epstein (London, 1935–48), p. 224.

46. Stephens, *William Holman Hunt*, p. 69.

47. On Hunt's reading of Lightfoot see Hunt, *Pre-Raphaelitism*, I, 408. See Lightfoot, *The Temple*, pp. 62–63.

48. Hunt, *Pre-Raphaelitism*, I, 408.

49. Hunt, Journal, Nov. 15, 1855 (John Rylands Library, Manchester, Eng. MS 1211, fol. 80).

50. Lightfoot, *The Temple*, pp. 62–63.

51. Ibid., p. 62.

52. Stephens, *William Holman Hunt*, pp. 57–58. On Place's discoveries see Victor Place, *Ninive et l'Assyrie*, 3 vols. (Paris, 1867–70); Maurice Pillet, "Un pionnier de l'Assyriologie, Victor Place, consul de France à Mossoul, explorateur du palais de Sargon II à Khorsabad . . . ," *Cahiers de la Société Asiatique*, no. 16 (1962).

53. Stephens, *William Holman Hunt*, pp. 57–58.

54. On Layard and the fad for things Assyrian see Gordon Waterfield, *Layard of Nineveh* (New York, 1968), esp. pp. 114ff.

55. On Hunt's knowledge of Lewis's harem scenes see Hunt, *Pre-Raphaelitism*, I, 270, 273. On the similarities between the *Finding* and Lewis's art see *The Critic* (May 5, 1860), in Stephens, *William Holman Hunt*, p. 104.

56. See *Hunt*, 1969, no. 31; Scott, *Autobiographical Notes*, II, 35.

57. For a scholarly reference to this conception see Joseph Bonomi, *Nineveh and Its Palaces: The Discoveries of Botta and Layard, Applied to the Elucidation of Holy Writ* (London, 1852), p. 235. For a popular expression of the idea see the illustration of Jeremiah (22.14) in *The Domestic Bible* (London: Partridge & Oakey, 1847), which is also reproduced in *The Art-Union* (November 1847): 402.

58. See, e.g., Hunt, Journal, April 7, 1855, and Nov. 12, 1855 (John Rylands Library, Manchester, Eng. MS 1211, fols. 16, 78); and Hunt, *Pre-Raphaelitism*, II, 9, where he subscribes to the theory of James Fergusson that the Mosque of Omar in Jerusalem had originally been the Byzantine church built by Constantine over the sepulcher of Jesus.

59. For some mid-nineteenth-century descriptions of the Near East as a hodgepodge of nationalities, patterns, colors, etc. see James Ballantine, *The Life of David Roberts, R.A.* (Edinburgh, 1866), p. 81; Edward Lear, *Journal of a Landscape Painter in Albania, Etc.* (London, 1851), p. 5; William Powell Frith, *Further Reminiscences* (London, 1888), p. 189; William James Muller, "An Artist's Tour in the East," *The Art-Union* (September 1839): 131. On Western notions of Eastern irrationality see Edward Said, *Orientalism* (New York, 1979).

60. On Hunt's changes in the 1860s see Allen Staley's comments on Hunt's *Il dolce far niente* (1867), in *The Royal Academy (1837–1901) Revisited: Victorian Paintings from the Forbes Magazine Collection*, exhibition catalogue (Metropolitan Museum of Art, New York, 1975).

61. William Holman Hunt, "Religion and Art," *Contemporary Review* (January 1897): 43, 46.

62. On West's religious pictures, see J. D. Meyer, "Benjamin West's Chapel of Revealed Religion: A Study in Eighteenth-Century Protestant Religious Art," *Art Bulletin* (June 1975): 247–65, in which additional bibliographical references are noted.

63. See, e.g., J. R. Herbert, *Moses's Descent from Sinai* (1866–67, Kunsthalle, Hamburg); F. M. Brown, *Elijah Restoring the Widow's Son* (1868, Victoria and Albert Museum, London); Simeon Solomon, *The Mother of Moses* (Coll. Robert Isaacson, New York); Edward John Poynter, *Visit of the Queen of Sheba to King Solomon* (1890, Art Gallery of New South Wales, Sydney [fig. 36]). On the influence of Hunt's *Finding* see also George P. Landow, "William Holman Hunt's 'Oriental Mania' and His Uffizi *Self-Portrait*," *Art Bulletin* (December 1982): 646–54.

NOTES TO CHAPTER 5: WHISTLER

1. An extensive bibliography of Whistler literature is in the essential catalogue raisonné of Whistler's oeuvre: Andrew McLaren Young, Margaret MacDonald, Robin Spencer, *The Paintings of James McNeill Whistler*, 2 vols. (New Haven and London, 1980). For a discussion of the dating, execution, and sources of *Whistler's Mother* see Margaret F. MacDonald, "Whistler: The Painting of the 'Mother,'" *Gazette des Beaux-Arts* s.6, 85 (1975): 73–88. The best overall analysis of Whistler's art remains Denys Sutton, *Nocturne: The Art of James McNeill Whistler* (London, 1963).
2. Elizabeth Mumford [Bessie Judith Jones and Elizabeth Herzog], *Whistler's Mother: The Life of Anna McNeill Whistler* (London and Melbourne, c. 1940), p. 7.
3. Ibid., p. 8.
4. The picture was exhibited with this title in 1872 at the Royal Academy in London (no. 941).
5. For a catalogue of Whistler's etchings see E. G. Kennedy, *The Etched Work of Whistler* (New York, 1910). *Black Lion Wharf* is K. 42, part of *Sixteen Etchings*, called the "Thames Set."
6. On these suggested sources see MacDonald, "Whistler," and McLaren Young, *Paintings*, no. 101.
7. On Whistler's circle of artistic friends and their cross-influences see *From Realism to Symbolism: Whistler and His World*, exhibition catalogue by Allen Staley et al. (Wildenstein Gallery, New York; Philadelphia Museum of Art, 1971).
8. It is uncertain whether Whistler would have been familiar with this painting by Redgrave. Its provenance is unknown, and I have been unable to locate any engraving of the work.
9. This is reported in a letter from Mrs. Whistler to Kate Palmer, Nov. 3, 1871, published in MacDonald, "Whistler," p. 80: "Mrs. Leyland writes me that she thinks the full length Portrait he has begun of herself will be as lifelike as she is sure mine is! Jemie sent me a sketch of mine as the centre Mr. Leylands Portrait and a painting of Velasquez the two on either side of mine covering the wall one whole side of the great dining room called the banquetting hall, and that the two Portraits bore the comparison with the Spanish Artist to his satisfaction." The particular work by Velasquez, presumably owned by F. R. Leyland, is unknown.
10. Ibid., p. 80.
11. On the taste for Spanish art in France and its realist associations see Ilse Hempel Lipschutz, *Spanish Painting and the French Romantics* (Cambridge, Mass., 1972), pp. 167–68.
12. For example, *La Mère Gerard*, 1858–59, coll. B. C. Solomon, Los Angeles (McLaren Young, *Paintings*, pl. 9), and *Head of Old Man Smoking*, c. 1859, Musée National du Louvre, Paris (ibid., pl. 20).
13. This altered view of Velasquez was not just an idiosyncracy of Whistler, visible only in his art. It became a standard interpretation of the Spanish master among even the most pedestrian of critics by the end of the century. Whereas in 1836 Henri Cornille could say of Velasquez, "Pour lui, l'art n'est que la nature, et rien n'y fait sentir l'intervention de l'homme" ("For him, art is only nature, and nothing in his art suggests the artist's intervention") (*Souveniers d'Espagne* [Paris, 1836], I, 318). Marion Hepworth Dixon in 1895 could say of Velasquez's *Don Balthazar Carlos*, "For although the slightly elongated features and sensual mouth of Philip IV are indicated in the face of his ill-starred son, the magic of the master's art—the lighting—which seems to depict atmosphere filtering as it were through some medium of mellow silver; the dignified yet perfectly natural disposition of the upright figure; the subtle and felicitous harmonies of a colour scheme which ranges from buff to steely-blue and black:—all these various elements go to make so harmonious a whole as to justify the term beautiful being applied alike to subject and the work" ("Fair Children," *Magazine of Art* 15 [1895]: 330).
14. Millais's devotion to Velasquez and his change in style in the 1860s are manifested in his diploma work of 1867, *Souvenir of Velasquez* (fig. 43). On Millais see M. H. Spielmann, *Millais and His*

Works (Edinburgh, 1898); J. G. Millais, *Life and Letters; Millais,* exhibition catalogue by Mary Bennett (Walker Art Gallery, Liverpool, 1967).

15. In 1859 Whistler had appreciated Millais's *Vale of Rest* (Tate Gallery, London) at the Royal Academy, an un-Velasquezian picture, which however includes a seated nun in black and white, her body in profile but her head turned toward the viewer. See *From Realism to Symbolism,* 1971, no. 103; E. R. and J. Pennell, *The Life of James McNeill Whistler* (London and Philadelphia, 1908), I, 76–77; Léonce Bénédite, "Artistes contemporains: Whistler," *Gazette des Beaux-Arts* s.3, 33 (1905): 510.

16. *The Times* (May 17, 1860).

17. See the illustrations in McLaren Young, *Paintings,* II.

18. On the date of the title *Symphony in White, No. 1* see ibid., no. 38.

19. Jules Castagnary, "Salon de 1863: Les Refusés," *Le Courier du Dimanche* (June 14, 1863):4–5.

20. See the copy after François Boucher's *Diane au bain,* McLaren Young, *Paintings,* pl. 5. On Oudry see Hal N. Opperman, *Jean-Baptiste Oudry,* 2 vols. (New York, 1977).

21. On *Ecce Ancilla Domini!* see Virginia Surtees, *The Paintings and Drawings of Dante Gabriel Rossetti, 1828–1882: A Catalogue Raisonné* (Oxford, 1971), no. 44. Rossetti wrote to F. G. Stephens on April 25, 1874: "In point of time it is the ancestor of all the *white* pictures which have since become so numerous" (Surtees, *Rossetti,* no. 44).

22. On Rossetti's influence on Whistler see *From Realism to Symbolism,* 1971. Whistler did not actually meet Rossetti until July 28, 1862. But he certainly might have heard of Rossetti's most famous work, dominated by white. On Whistler and Pre-Raphaelitism see Alastair Grieve, "Whistler and the Pre-Raphaelites," *Art Quarterly* 34 (1971): 219–28.

23. For example, *Harmony in Flesh Color and Black: Mrs. Louise Jopling,* 1877, Hunterian Art Gallery, Glasgow; *Arrangement in Black: Lady Meux,* 1881–82, Honolulu Academy of Arts.

24. On Whistler's mother, Anna Matilda McNeill Whistler, see Mumford, *Whistler's Mother.* A popular work on Whistler's father, Major George Washington Whistler, is Albert Parry, *Whistler's Father* (Indianapolis, 1939).

25. Mrs. Whistler's letter of Nov. 3–4, 1871, describing the beginning of the painting after the model for *Annabel Lee* (fig. 48) failed to appear, is excerpted in MacDonald, "Whistler," p. 75, and McLaren Young, *Paintings,* nos. 77 and 101. Mrs. Whistler noted that "I was not as well then as I am now, but never distress jemie by complaints, so I stood bravely, two or three days, whenever he was in the mood for studying me his pictures are *studies,* and I *so interested* stood as a statue! but realized it to be too great an effort, so my dear patient Artist who is gently patient as he is never wearying in his perseverance concluded to paint me sitting perfectly at my ease." (MacDonald, "Whistler," p. 76).

26. A. C. Swinburne, "Mr. Whistler's Lecture on Art," *Fortnightly Review* (June 1888), reprinted in J. A. M. Whistler, *The Gentle Art of Making Enemies* (London, 1890), pp. 250–58.

27. Pennell, *Life,* II, 44–45.

28. These contradictory interpretations are noted even in such popular literature as Parry's *Whistler's Father,* intro.

29. *Academy* (May 15, 1872). Mrs. Whistler wrote that "it was a Mothers unceasing prayer while being the painters model gave the expression which makes the attractive charm" (McLaren Young, *Paintings,* no. 101).

30. Mumford, *Whistler's Mother,* p. 8.

31. For Mrs. Whistler's letters see ibid.; and K. Abbott, ed., "The Lady of the Portrait: Letters of Whistler's Mother," *Atlantic Monthly* 136 (1925): 310–28.

32. J. A. M. Whistler, "The Red Rag," *The World* (May 22, 1878), reprinted in Whistler, *Making Enemies,* pp. 126–28.

33. Whistler's biography is related in a number of works, e.g.: Pennell, *Life,* and Roy McMullen, *Victorian Outsider: A Biography of J. A. M. Whistler* (New York, 1973).

34. On Whistler's father see Pennell, *Life;* Parry, *Whistler's Father;* McMullen, *Victorian Outsider.*

35. See McLaren Young, *Paintings*, I, lviii.
36. On the unlocated portrait of Whistler's mother of 1867 see MacDonald, "Whistler," pp. 73–74.
37. On the uncertain date of the etching see ibid., pp. 76–77, and Kennedy, *Etched Work*, no. 97.
38. See Whistler's letter to Henri Fantin-Latour, September 1867, in Bénédite, "Artistes contemporains," *Gazette des Beaux-Arts* s.3, 32 (1905): 231–34.
39. Reportedly Carlyle was persuaded by Mme E. Venturi to sit for Whistler only after he had seen the *Mother;* see McLaren Young, *Paintings*, no. 137.

NOTES TO CHAPTER 6: FORBES

1. On Forbes see Norman Garstin, "The Works of Stanhope Forbes, A.R.A.," *Studio* 23 (1901): 81–88; Mrs. Lionel Birch, *Stanhope A. Forbes and Elizabeth Stanhope Forbes* (London, 1906); C. Lewis Hind, "Stanhope A. Forbes, R.A.," *Art Journal*, Christmas number (1911); Frederick Dolman, "Mr. Stanhope Forbes, A.R.A.," *Strand Magazine* (November 1901): 483–94; Wilfrid Meynell, "Stanhope Forbes," *Art Journal* n.5.31 (1892): 65–69; *Artists of the Newlyn School, 1880–1900*, exhibition catalogue by Caroline Fox and Francis Greenacre (Newlyn Art Gallery, Plymouth City Art Gallery, Bristol City Art Gallery, 1979).
2. On Bastien-Lepage and his impact on British art see A. Theuriet, *Jules Bastien Lepage and His Art* (London, 1892); George Clausen, "Bastien Lepage and Modern Realism," *Scottish Art Review* (October 1888); Kenneth McConkey, "Bastien Lepage and British Art," *Art History* (September 1978): 371–82. When Forbes learned of Bastien-Lepage's death in December 1884, he wrote to his mother from Newlyn, "So the greatest artist of our age is dead. . . . His influence on all the young painters already so great will become more powerful than ever." This and the other letters by Forbes quoted in this chapter are in the Forbes material housed in the Newlyn-Orion Art Gallery, Newlyn. When letters are undated, I have used the postmark date on the envelope. I wish to thank Mr. John Halkes for kindly permitting me to examine this material. Excerpts from many of these letters are published in *Artists of the Newlyn School, 1979*.
3. See, e.g., R. L. Stevenson, "Fontainebleau: Villages and Communities of Painters, IV," *Magazine of Art* 6 (1884): 340–45. The briefest glance at British art journals of the 1880s reveals the great interest in J. F. Millet and other Barbizon painters. See also Anna Gruetzner, "Great Britain and Ireland: Two Reactions to French Painting in Britain," in *Post-Impressionism: Cross Currents in European Painting*, exhibition catalogue (Royal Academy of Arts, London, 1979), pp. 178–82. Forbes himself wrote, "In France the movement [toward plein-air painting] had made great headway, if indeed, it did not wholly originate there, fostered by the great school of painters who had made famous the little village of Barbizon in the Forest of Fontainebleau. Under the spell of the genius of Jean François Millet, and the more recent, and then living Bastien Lepage, most of us young students were turning our backs on the great cities, forsaking the studios with their unvarying north light, to set up our easels in country districts—under the open sky" (S. A. Forbes, "Cornwall from a Painter's Point of View," an address reprinted from the annual report of the Royal Cornwall Polytechnic Society for 1900, Falmouth, 1901, pamphlet, p. 5).
4. On Gauguin at Pont-Aven see Wladyslawa Jaworska, *Paul Gauguin et l'Ecole de Pont-Aven*, trans. Simon Laks (Neuchâtel, 1971); *Gauguin and the Pont-Aven Group*, exhibition catalogue (Tate Gallery, London, 1966); *Claude-Emil Schuffenecker and the School of Pont-Aven*, exhibition catalogue (Norman Mackenzie Art Gallery, University of Regina, Saskatchewan, 1977).
5. "Art in June," *Magazine of Art* 7 (1885): xxxiii.
6. On the New English Art Club see William James Laidlay, *The Origin and First Two Years of the New English Art Club* (London, 1907); Alfred Thornton, *Fifty Years of the New English Art Club* (London, 1935); *The Early Years of the New English Art Club*, Exhibition catalogue, intro. by Bevis Hillier (Fine Arts Society, London, 1968); Gruetzner, "Two Reactions."
7. See Gruetzner, "Two Reactions"; McConkey, "Bastien Lepage"; On Sickert see Robert Em-

mons, *The Life and Opinions of Walter Richard Sickert* (London, 1941); Lillian Browse, *Sickert* (London, 1960); Wendy Baron, *Sickert* (London, 1973).

8. On Clausen see D. Hussey, *George Clausen* (London, 1923); McConkey, "Bastien Lepage"; and see n. 2; R. A. M. Stevenson, "George Clausen," *Art Journal* n.s. 29 (1890): 289–94; Dewey Bates, "George Clausen," *The Studio* 5 (1895): 3–8; W. Armstrong, "George Clausen," *Magazine of Art* 17 (1896): 401–06; *George Clausen*, exhibition catalogue by Kenneth McConkey (Laing Art Gallery, Newcastle upon Tyne, 1980).

9. On Dagnan-Bouveret see Gabriel Weisberg, "Vestiges of the Past: The Brittany 'Pardons' of Late Nineteenth-Century French Painters," *Arts Magazine* (November 1980): 136–37. Forbes was not totally indifferent to religious life, for he began work in April of 1880 on a picture of a woman praying in church (letter of April 30 to his mother, Paris).

10. On painters in Brittany and Brittany's associations see Denise Delouche, *Peintres de la Bretagne: Découvert d'une province* (Librairie C. Klincksieck, 1977); Fred Orton and Griselda Pollock, "Les Donnés brettonnantes: La prairie de représentation," *Art History* (September 1980): 314–44; Weisberg, "Vestiges," pp. 136–37.

11. For example, in a letter to his mother, Newlyn, February 1884, Forbes wrote: "I am in a hot tub of narrow minded bigotry and bigotry of the worst kind—Oh ye railers at the blind papists and at the wicked ways of people across the water, come down here and study these people. Study the effect of religion upon ignorance."

12. Letter to mother, Cancale, September 1881. Quoted in *Artists of the Newlyn School*, 1979, no. 1.

13. Forbes wrote to his mother from Quimperlé, Nov. 12, 1882, "I've finished 'Far from the Madding.' It's the best book I've read for some time."

14. Letter to mother, Newlyn, Feb. 19, 1884.

15. Letter to mother, Newlyn, June 8, 1884.

16. Letter to mother, Newlyn, Feb., 1884.

17. Letter to mother, Newlyn, Feb. 24, 1884.

18. His ideas for a picture of a boy with a toy boat on the beach are noted in a letter to his mother, Newlyn, June 8, 1884. One example of this subject by Israëls is in the Stedlijk Museum, Amsterdam; another is in the collection of Queen Elizabeth II.

19. Letter to father, Newlyn, Feb. 17, 1884.

20. Ibid.

21. Letter to mother, Newlyn, March 17, 1884.

22. See Forbes's reported comments in P. G. Hamerton, "*The Lighthouse* Painted by Stanhope Forbes, A.R.A.," *Scribner's Magazine* (June 1894): 688–91.

23. Letter to mother, Newlyn, Feb. 10, 1884.

24. Forbes's antagonistic attitude toward Whistler is expressed in a letter to Elizabeth Armstrong from London, April 27, 1887, after he had viewed the NEAC exhibition.

25. On aestheticism see Walter Hamilton, *The Aesthetic Movement in England* (London, 1882); Elizabeth Aslin, *The Aesthetic Movement: Prelude to Art Nouveau* (London, 1969); Allen Staley, "The Condition of Music," *Art News Annual: The Academy* 32 (1967): 80–87; *The Aesthetic Movement, 1869–1890*, exhibition catalogue Camden Arts Center, 1973).

26. Forbes, "Cornwall", pp. 13–14.

27. Stanhope Forbes, "The Treatment of Modern Life in Art," unpublished essay, c. 1890 (kindly made available to me by Francis Greenacre, Bristol City Art Gallery), p. 14.

28. Forbes, "Cornwall," p. 7.

29. Letter to mother, Newlyn, Aug. 3, 1884.

30. On James Clarke Hook see A. H. Palmer, *James Clarke Hook* (London, 1888); F. G. Stephens, *James Clarke Hook: His Life and Works* (London, 1890).

31. "Current Art II," *Magazine of Art* 7 (1885): 392.

32. Letter to Elizabeth Armstrong, Newlyn, Sept. 23, 1887.

33. Letter to mother, Newlyn, (June?), 1884.

34. Letter to mother, (June?), 1884.
35. Letter to mother, Newlyn, June 22, 1884.
36. Letter to mother, Newlyn, Aug. 3, 1884, and Feb. 29, 1884.
37. See Ben Batten and Eric Richards, "A Short History of Newlyn," in *Artists of the Newlyn School,* 1979, pp. 39–51.
38. Forbes's father was manager of the Midland Great Western Railway of Ireland and later held similar posts on the Continent and in England. His brother also managed English railways and the London underground as well; see Birch, *Stanhope A. Forbes.*
39. See *Artists of the Newlyn School,* 1979.
40. On the Barbizon School see *Barbizon Revisited,* exhibition catalogue by Robert Herbert (Museum of Fine Arts, Boston, 1962).
41. On the Cranbrook Colony see *The Cranbrook Colony,* exhibition catalogue (Central Art Gallery, Wolverhampton; and Laing Art Gallery, Newcastle upon Tyne; 1977). In the 1840s a colony of artists also grew up around David Cox in the summers at Bettws-y-Coed in North Wales.
42. Forbes, "Cornwall," p. 6.
43. See n. 3.
44. Letter to mother, Newlyn, May 24, 1885.

NOTES TO CHAPTER 7: LEIGHTON

1. On Leighton see Mrs. Russell Barrington, *Life, Letters, and Works of Frederic Leighton,* 2 vols. (London, 1906); Ernest Rhys, *Frederic Lord Leighton* (London, 1900); Edgecumbe Staley, *Lord Leighton of Stretton, P. R. A.* (London, 1906); *Victorian High Renaissance,* exhibition catalogue by Allen Staley, Richard and Leonée Ormond, Gregory Hedberg, and Richard Dorment (Manchester City Art Gallery, Minneapolis Institute of Arts, Brooklyn Museum, 1978); Leonée and Richard Ormond, *Lord Leighton* (London, 1975).
2. On Leighton's drawings from male models for *Flaming June* see *Victorian High Renaissance,* 1978, no. 61.
3. *Flaming June* was no. 195 at the Royal Academy exhibition of 1895.
4. *Magazine of Art,* 17 (1895): 243.
5. On the various versions of the myth of Ariadne see *The Oxford Classical Dictionary,* 2d ed., ed. N. G. L. Hammond and H. H. Scullard (Oxford, 1970).
6. There are a number of drawings of drapery, apparently studied from above, in the collection at Leighton House, London.
7. The symbolic meanings of pomegranates in the West largely derive from the myth of Persephone, who ate some pomegranate seeds in Pluto's realm of death, Hades, and thus had to return to the underworld for part of each year—fall and winter. Their connections with Persephone, a goddess of spring, also make pomegranates emblematic of rebirth and the eternal cycle of nature. On the myths of Persephone see *Oxford Classical Dictionary.*
8. On the exhibition of Lachrymae with *Flaming June* in Leighton's studio see Barrington, *Life,* II, 335.
9. On *The Daphnephoria* see Ormond, *Lord Leighton,* p. 92.
10. *Victorian High Renaissance,* 1978, no. 61. On Leighton's high regard for *Night* as "a supreme work" see Frederic Leighton, "Address to the Liverpool Art Congress," *Contemporary Review* (January 1889): 35.
11. On the Medici chapel see Howard Hibbard, *Michelangelo* (New York, 1974), pp. 177–212.
12. On Hodler in general see Sharon Hirsh, *Ferdinand Hodler* (New York, 1982).
13. On the death imagery of *Summer Slumber* see Ormond, *Lord Leighton,* p. 130.
14. Homer/ *Iliad,* 16. 831.

15. Robert Browning, "The Return of the Druses: A Tragedy," in *The Complete Works of Robert Browning* (New York, 1921), p. 277. On the friendship of Leighton and Browning see Ormond, *Lord Leighton,* chap. 9.

16. On sleep imagery of late-nineteenth-century British art see Staley, "The Condition of Music," pp. 80–87.

17. On the link between *Flaming June* and Moore's *Midsummer* see Robin Gibson, "Albert Moore at Newcastle," *Burlington Magazine* (December 1972): 888; *Victorian High Renaissance,* 1978, no. 83.

18. On Moore see Alfred Lys Baldry, *Albert Moore: His Life and Works* (London, 1894); *Albert Moore and His Contemporaries,* exhibition catalogue by Richard Green (Laing Art Gallery, Newcastle upon Tyne, 1972).

19. For Burne-Jones's images of sleep see *Burne-Jones: The Paintings, Graphic and Decorative Works,* exhibition catalogue by John Christian (Hayward Gallery, London, 1975); Martin Harrison and Bill Waters, *Burne-Jones* (New York, c. 1973); Georgianna Burne-Jones, *Memorials of Edward Burne-Jones,* 2 vols. (New York, 1904).

20. On Waterhouse see Anthony Hobson, *The Art and Life of J. W. Waterhouse* (New York, 1980). St. Cecilia was exhibited at the Royal Academy in 1895 (no. 97) with a quotation from Tennyson's *Palace of Art:* "In a clear walled city on the sea, Near gilded organ pipes—slept S. Cecily." The painting was formerly with the Maas Gallery, London.

21. On Alma-Tadema see Vern G. Swanson *Alma-Tadema: The Painter of the Victorian Vision of the Ancient World* (New York, 1977).

22. On C. W. Cope's *Home Dreams* (fig. 75) see *The Substance or the Shadow: Images of Victorian Womanhood,* exhibition catalogue by Susan Casteras (Yale Center for British Art, New Haven, 1982). On the seamstress theme see T. J. Edelstein, "'They Sang the Song of the Shirt': The Visual Iconology of the Seamstress," *Victorian Studies* (Winter 1980): 186–89.

23. On Brown's *Work,* as described by himself, see Ford Madox Ford (Hueffer), *Ford Madox Brown: A Record of His Life and Work* (London, 1896), pp. 189–97.

24. On Rossetti's influence see Staley, "The Condition of Music," pp. 80–87.

25. F. G. Stephens, *Dante Gabriel Rossetti* (London, 1894), pp. 41–42.

26. For Rossetti's pervasive concern with the theme of love see D. G. Rossetti, *The Collected Works of Dante Gabriel Rossetti,* ed. W. M. Rossetti (London, 1897).

27. On Lewis's relation to later nineteenth-century images of indolence see K. Bendiner, "Albert Moore and John Frederick Lewis," *Arts Magazine* (February 1980): 76–79.

28. For the interpretation of sleep in Moore's art as a means to remove expressive human emotions, so as to concentrate on aesthetic aspects, see *Victorian High Renaissance,* 1978, no. 80.

29. For a contemporary interpretation of Moore as an abstractionist see Baldry, *Albert Moore.*

30. On the history of art-for-art's-sake theories in the nineteenth century see Louise Rosenblatt, *L'Idée de l'art pour l'art dans la litterature anglaise pendant la période victorienne* (Paris, 1931); Rose Egan, "The Genesis of the Theory of 'Art for Art's Sake' in Germany and England," *Smith Studies in Modern Languages* (July 1921) and (April 1924); Ruth C. Child, *The Aesthetic of Walter Pater* (New York, 1940).

31. *The Times* (May 4, 1895), p. 12.

32. On the sleeping Venus theme and its history see Millard Meiss, "Sleep in Venice," *Stil und Überlieferung in der Kunst des Abendlandes,* Akten des 21. Internationalen Kongresses für Kunstgeschichte in Bonn, 1964, III (Berlin, 1967), pp. 271–79.

33. Leighton, letter to his sister, Naples, Oct. 18, 1895, in Barrington, *Life,* II, 326.

34. Walter Pater, *Appreciations, with an Essay on Style,* in *The Macmillan Library Edition of The Works of Walter Pater* (London, 1910), V, 60–61.

35. On Victorian classicism see *Victorian High Renaissance,* 1978.

36. On Dorothy Dene as a model for *Flaming June* see Ormond, *Lord Leighton,* p. 135. and pl. 193.

37. On neoclassicism of the eighteenth and early nineteenth centuries see Rosenblum, *Transforma-*

tions in Late Eighteenth Century Art; David Irwin, *English Neo-Classical Art* (London, 1966); *The Age of Neo-Classicism* exhibition catalogue (Royal Academy of Arts, Victoria and Albert Museum, London, 1972); Rosenblum, "Dawn of British Romantic Painting."

38. *Art Journal* n.s. 10 (1871): pp. 171–77; cited in *Victorian High Renaissance*, 1978, p. 13.

39. See Houghton, *Victorian Frame of Mind*, pp. 242–62.

40. For a view of Leighton's nudes as feeble and hollow see Kenneth Clark, *The Nude: A Study in Ideal Form* (New York, 1956), pp. 163–64.

41. On Ruskin's dislike of Michelangelo see Ruskin, *Works*, XXII, 75ff.

42. These verses appear, e.g., in Charles Clément, *Michelangelo* (London, 1880), p. 60, and in other nineteenth-century studies of Michelangelo, popular and scholarly.

43. Ormond, *Lord Leighton*, p. 127.

44. *Victorian High Renaissance*, 1978, no. 31. On Watts see M. S. Spielmann, "The Works of Mr. George Frederic Watts, R.A.," *Pall Mall Gazette*, extra number 22 (1886); M. S. Watts, *George Frederic Watts: The Annals of an Artist's Life*, 3 vols. (London, 1912); *G. F. Watts: A Nineteenth Century Phenomenon*, exhibition catalogue by John Gage and Chris Mullen (Whitechapel Art Gallery, London, 1974); Wilfrid Blunt, *"England's Michelangelo": A Biography of George Frederic Watts, O.M., R.A.* (London, 1975).

45. G. K. Chesterton, *G. F. Watts* (London, 1904), pp. 94–108.

Selected List of Books and Exhibition Catalogues on Victorian Art since 1960

GENERAL

Bell, Quentin. *Victorian Artists.* London, 1967.

British Sculpture, 1850–1914. Exhibition catalogue by Lavinia Handley-Read. Fine Art Society, London, 1968.

Brook-Hart, Denys. *British 19th-Century Marine Painting.* London, 1974.

Chapel, Jeannie. *Victorian Taste: The Complete Catalogue of Paintings at the Royal Holloway College.* London, 1982.

Conrad, Peter. *A Victorian Treasure House.* London, 1973.

Dictionary of British Portraiture. Ed. Richard Ormond and Malcolm Rogers. Vol. 3, *The Victorians.* Comp. Elaine Kilmurray. New York, 1981.

Farr, Dennis. *The Oxford History of English Art.* Vol. 11, *1870–1940.* London, 1979.

Great Victorian Pictures: Their Paths to Fame. Exhibition catalogue by Rosemary Treble. Royal Academy of Arts, London, 1978.

Hardie, Martin. *Water-Colour Painting in Britain.* Vol. 3, *The Victorian Period.* London, 1968.

Hardie, William. *Scottish Painting, 1837–1939.* London, 1976.

Irwin, David and Francinia. *Scottish Painters at Home and Abroad, 1700–1900.* London, 1975.

Johnson, Jane and Anna Gruetzner. *The Dictionary of British Artists, 1880–1940.* Woodbridge, Suffolk, 1976.

Landscape in Britain, 1850–1950. Exhibition catalogue. Hayward Gallery, London; Bristol City Art Gallery; Stoke-on-Trent City Art Gallery; Mappin Art Gallery, Sheffield; 1983.

Lister, Raymond. *Victorian Narrative Paintings.* London, 1966.

Maas, Jeremy. *Victorian Painters.* London, 1969.

Ormond, Richard. *National Portrait Gallery: Early Victorian Portraits.* London, 1973.

Paintings and Drawings by Victorian Artists in England. Exhibition catalogue. National Gallery of Canada, Ottawa, 1965.

Paviere, S. H. *A Dictionary of Victorian Landscape Painters.* London, 1960.

Read, Benedict. *Victorian Sculpture.* New Haven and London, 1982.

Reynolds, Graham. *Victorian Painting.* London, 1966.

Romantic Art in Britain. Exhibition catalogue by Frederick Cummings and Allen Staley. Detroit Institute of Arts, Philadelphia Museum of Art, 1968.

The Royal Academy Revisited, 1837–1901: Victorian Paintings from the Forbes Magazine Collection. Exhibition catalogue by Christopher Forbes and Allen Staley. Metropolitan Museum of Art, New York, 1975.

Victorian Olympians. Exhibition catalogue. Art Gallery of New South Wales, Sydney, 1975.

Wood, Christopher. *The Dictionary of Victorian Painters.* 2d revised edition. Woodbridge, Suffolk, 1978.

———. *Victorian Panorama: Paintings of Victorian Life.* London, 1976.

SPECIFIC MOVEMENTS AND THEMES

The Aesthetic Movement, 1869–1890. Exhibition catalogue. Camden Arts Center, 1973.

Artists of the Newlyn School, 1880–1900. Exhibition catalogue by Caroline Fox and Francis Greenacre. Newlyn Art Gallery, Plymouth City Art Gallery, Bristol City Art Gallery, 1979.

Beattie, Susan. *The New Sculpture.* London and New Haven, 1983.

Bell, Quentin. *A New and Noble School: The Pre-Raphaelites.* London, 1982.

———. *The Schools of Design.* London, 1963.

The Cranbrook Colony. Exhibition catalogue. Central Art Gallery, Wolverhampton; Laing Art Gallery, Newcastle upon Tyne; 1977.

Christian, John. *The Oxford Union Murals.* Chicago, 1981.

The Early Years of the New English Art Club. Exhibition catalogue by Bevis Hillier. Fine Art Society, London, 1968.

The Etruscan School. Exhibition catalogue. Fine Art Society, London, 1976.

Fleming, G. H. *That Ne'er Shall Meet Again.* London, 1971.

Fredeman, W. E. *Pre-Raphaelitism: A Bibliocritical Study.* Cambridge, Mass., 1965.

The Glasgow Boys. Exhibition catalogue. Scottish Arts Council, 1968.

Hilton, Timothy. *The Pre-Raphaelites.* London, 1970.

Nadel, I. B., and F. S. Schwarzbuch, eds. *Victorian Artists and the City: A Collection of Critical Essays.* New York, 1980.

Nicoll, John. *The Pre-Raphaelites.* London, 1970.

The Nude in Victorian Art. Exhibition catalogue by Jennifer Stead. Harrogate City Art Gallery, 1966.

Parris, Leslie, ed. *The Pre-Raphaelite Papers.* London, 1984.

The Pre-Raphaelites. Exhibition catalogue by Alan Bowness. Tate Gallery, London, 1984.

Spencer, Robin. *The Aesthetic Movement: Theory and Practice.* London, 1972.

Staley, Allen. *The Pre-Raphaelite Landscape.* Oxford, 1973.

The Substance and the Shadow: Images of Victorian Womanhood. Exhibition catalogue by Susan Casteras. Yale Center for British Art, New Haven, 1982.

Vaughan, William *German Romanticism and English Art.* New Haven, 1979.

Victorian High Renaissance. Exhibition catalogue by Allen Staley, Richard and Leonée Ormond, Gregory Hedberg, and Richard Dorment. Manchester City Art Gallery, Minneapolis Institute of Arts, Brooklyn Museum, 1978.

The Victorian Vision of Italy, 1825–1875. Exhibition catalogue by Hamish Miles, Lionel Lambourne, and Luke Herrmann. Leicester City Art Gallery, 1968.

Watkinson, Raymond. *Pre-Raphaelite Art and Design.* Greenwich, Conn., 1970.

Wood, Christopher. *The Pre-Raphaelites.* New York, 1981.

INDIVIDUAL ARTISTS

Lawrence Alma-Tadema

Alma-Tadema. Exhibition catalogue. Gemeentelijk Museum, Leeuwarden, 1974.

Ash, Russell. *Alma-Tadema.* Aylesbury, 1973.

Sir Lawrence Alma-Tadema. Exhibition catalogue. Sheffield Art Gallery, 1976.

Swanson, Vern G. *Alma-Tadema: The Painter of the Victorian Vision of the Ancient World*. New York, 1977.

Victorians in Togas. Exhibition catalogue by Christopher Forbes, Metropolitan Museum of Art, N.Y. 1973.

Aubrey Beardsley

Aubrey Beardsley. Exhibition catalogue by Brian Reade and Frank Dickinson. Victoria and Albert Museum, London, 1966.

Brophy, Brigid. *Beardsley and His World*. New York, 1976.

Maas, Henry, J. L. Duncan, and W. G. Wood, eds. *The Letters of Aubrey Beardsley*. London, 1971.

Reade, Brian. *Beardsley*. London, 1967.

Ford Madox Brown

Ford Madox Brown. Exhibition catalogue by Mary Bennett. Walker Art Gallery, Liverpool, 1964.

Rabin, Lucy. *Ford Modox Brown. and the Pre-Raphaelite History-Picture*. New York, 1978.

Surtees, Virginia, ed. *The Diary of Ford Madox Brown*. New Haven and London, 1981.

Edward Burne-Jones

Burne-Jones: The Paintings, Graphic and Decorative Works. Exhibition catalogue by John Christian. Hayward Gallery, London, 1975.

Fitzgerald, Penelope. *Edward Burne-Jones: A Biography*. London, 1975.

Harrison, Martin and Bill Waters. *Burne-Jones*. New York [c. 1973].

Lago, Mary, ed. *Burne-Jones Talking*. Columbia, Mo., 1981.

Spalding, Francis. *Magnificent Dreams: Burne-Jones and the Late Victorians*. Oxford, 1978.

George Clausen

George Clausen. Exhibition catalogue by Kenneth McConkey. Laing Art Gallery, Newcastle upon Tyne, 1980.

Walter Crane

Spencer, Isobel. *Walter Crane*. London, 1975.

Richard Dadd

Allderidge, Patricia. *Richard Dadd*. London and New York, 1974.

Greysmith, David. *Richard Dadd: The Rock and the Castle of Seclusion*. New York, 1973.

The Late Richard Dadd. Exhibition catalogue by Patricia Allderidge. Tate Gallery, London.

William Dyce

Pointon, Marcia. *Willaim Dyce, 1801–1864*. Oxford, 1979.

Charles Eastlake

Robertson, David. *Sir Charles Eastlake and the Victorian Art World*. Princeton, 1978.

Luke Fildes

Fildes, L. V. *Luke Fildes, R. A. : A Victorian Painter*. London, 1968.

John Atkinson Grimshaw

Phillips, G. R. *The Biography of John Atkinson Grimshaw*. London, 1972.

Arthur Boyd Houghton

Arthur Boyd Houghton. Exhibition catalogue by Paul Hogarth. Victoria and Albert Museum, London, 1975.

Arthur Hughes

Arthur Hughes. Exhibition catalogue. National Museum of Wales, Cardiff, 1971.

William Holman Hunt

Holman Hunt, Diana. *My Grandfather: His Wives and Loves*. London, 1969.
Landow, G. P. *William Holman Hunt and Typological Symbolism*. New Haven, 1979.
Maas, Jeremy. *Holman Hunt and "The Light of the World."* London, 1984.
William Holman Hunt. Exhibition catalogue by Mary Bennett. Walker Art Gallery, Liverpool, 1969.

Edwin Landseer

Lennie, Campbell. *Landseer: The Victorian Paragon*. London, 1976.
Sir Edwin Landseer. Exhibition catalogue by Richard Ormond. Philadelphia Museum of Art; Tate Gallery, London, 1981.
Sir Edwin Landseer. Exhibition catalogue by John Woodward. Royal Academy of Arts, London, 1961.

Edward Lear

Drawings by Edward Lear. Exhibition catalogue by R. R. Wark. Henry E. Huntington Library, San Marino, Ca., 1962.
Edward Lear: Painter, Poet and Draughtsman. Exhibition catalogue by E. M. Garvey. Worcester Art Museum, 1968.
Hofer, Philip. *Edward Lear*. New York, 1962.
————. *Edward Lear as a Landscape Draughtsman*. Cambridge, Mass., 1967.
Lehmann, John. *Edward Lear and His World*. New York, 1977.
Noakes, Vivien. *Edward Lear: The Life of a Wanderer*. Boston, 1969.

Frederic Leighton

Ormond, Leonée and Richard *Lord Leighton*. London, 1975.

John Frederick Lewis

John Frederick Lewis. Exhibition catalogue by Richard Green. Laing Art Gallery, Newcastle upon Tyne, 1971.
Lewis, J. M. H. *John Frederick Lewis*. Leigh-on-Sea, 1978.

John Linnel

John Linnel: A Centennial Exhibition. Exhibition catalogue by Katherine Crouan. Fitzwilliam Museum, Cambridge, 1982.

Daniel Maclise

Daniel Maclise, 1806–1870. Exhibition catalogue by Richard Ormond. National Portrait Gallery, London; National Gallery of Ireland, Dublin; 1972.

William McTaggart

Wood, H. H. *William McTaggart*. London, 1974.

Albert Moore

Albert Moore and His Contemporaries. Exhibition catalogue by Richard Green. Laing Art
 Gallery, Newcastle upon Tyne, 1972.

William Morris

Henderson, Philip. *William Morris: His Life, Work and Friends*. London, 1967.

John Everett Millais

Lutyens, Mary. *Millais and the Ruskins*. London, 1967.
Millais. Exhibition catalogue by Mary Bennett. Walker Art Gallery, Liverpool, 1967.
Millais, Geoffrey. *Sir John Everett Millais*. London, 1979.

William Mulready

Drawings by William Mulready. Exhibition catalogue by Anne Rorimer. Victoria and Albert
 Museum, London, 1974.
Heleniak, Katherine Moore. *William Mulready*. New Haven and London, 1980.

William Quiller Orchardson

William Quiller Orchardson. Exhibition catalogue. Scottish Arts Council, Edinburgh,
 1972.

Joseph Noel Paton

Fact and Fancy: Drawings and Paintings by Sir Joseph Noel Paton. Exhibition catalogue.
 Scottish Arts Council, Edinburgh, 1967.

John Phillip

John Phillip. Exhibition catalogue by Charles Carter. Aberdeen Art Gallery, 1967.

George Richmond

Lister, Raymond. *George Richmond: A Critical Biography*. London, 1981.

David Roberts

Artist Adventurer David Roberts. Exhibition catalogue. Scottish Arts Council Touring
 Exhibition, 1981.
David Roberts and Clarkson Stanfield. Exhibition catalogue by J. L. Howgego. Guildhall Art
 Gallery, London, 1967.

Dante Gabriel Rossetti

Dante Gabriel Rossetti. Exhibition catalogue. Laing Art Gallery, Newcastle upon Tyne,
 1971.
Dante Gabriel Rossetti and the Double Work of Art. Exhibition catalogue by M. W.
 Ainsworth. Yale University Art Gallery, New Haven, 1976.
Dante Gabriel Rossetti: Painter and Poet. Exhibition catalogue. Royal Academy of Arts,
 London, 1973.
Doughty, Oswald, and J. R. Wahl. *The Letters of Dante Gabriel Rossetti*. 4 vols. Cambridge,
 Mass., 1965–67.

Dunn, H. T. *Recollections of Dante Gabriel Rossetti and His Circle, or Cheyne Walk Life.* Ed. R. Mander. Westerham, Kent, 1984.

Grieve, Alastair. *The Art of D. G. Rossetti: The Pre-Raphaelite Period.* Hingham, Norfolk, 1973.

Grylls, M. G. *Portrait of Rossetti.* London, 1964.

Henderson, Marina. *Dante Gabrial Rossetti.* London, 1973.

Nicoll, John. *D. G. Rossetti.* London, 1975.

Surtees, Virginia. *The Paintings and Drawing of Dante Gabriel Rossetti, 1828–1882: A Catalogue Raisonné.* 2 vols. Oxford, 1971.

John Ruskin (as an artist)

Drawings by John Ruskin. Exhibition catalogue. Arts Council, Aldeburgh, London and Colchester, 1960.

Walton, P. H. *The Drawings of John Ruskin.* Oxford, 1972.

Frederick Sandys

Frederick Sandys. Exhibition catalogue. Brighton Art Gallery, 1974.

Walter Richard Sickert

Baron, Wendy. *Sickert.* London, 1973.

Browse, Lilian. *Sickert.* London, 1960.

Philip Wilson Steer

Laughton, Bruce. *Philip Wilson Steer.* Oxford, 1971.

James Joseph Tissot

James Jacques Joseph Tissot. Exhibition catalogue by Henri Zerner, D. S. Brooke, Michael Wentworth. Museum of Art, Rhode Island School of Design, Providence; Art Gallery of Ontario, Toronto; 1968.

J. James Tissott: Biblical Paintings. Exhibition catalogue by Gert Schiff. Jewish Museum, New York, 1982.

John William Waterhouse

Hobson, Anthony. *John William Waterhouse.* London, 1980.

John William Waterhouse. Exhibition catalogue. Sheffield Art Gallery, 1978.

George Frederic Watts

Blunt, Wilfrid *"England's Michelangelo": A Biography of George Frederic Watts, O.M. R.A.* London, 1975.

G. F. Watts: The Hall of Fame: Portraits of His Famous Contemporaries. Exhibition catalogue by Richard Ormond. National Portrait Gallery, London, 1975.

G. F. Watts: A Nineteenth Century Phenomenon. Exhibition catalogue by John Gage and Chris Mullen. Whitechapel Art Gallery, London, 1974.

James Abbott McNeill Whistler

Barbier, C. P., ed. *Correspondance Mallarmé-Whistler.* Paris, 1964.

Fleming, Gordon. *The Young Whistler.* London, 1978.

From Realism to Symbolism: Whistler and His World. Exhibition catalogue by Allen Staley. Wildenstein Gallery, New York: Philadelphia Museum of Art; 1971.

Holden, Donald. *Whistler Landscapes and Seascapes.* New York, 1969.

James McNeill Whistler. Exhibition catalogue. Arts Council of Great Britain, London, 1960.

James McNeill Whistler. Exhibition catalogue. Nationalgalerie, Berlin, 1969.

James McNeill Whistler. Exhibition catalogue by Ronald Pickvance. Nottingham University Art Gallery.

Levy, Mervyn. *Whistler Lithographs: A Catalogue Raisonné.* London, 1975.

McLaren Young, Andrew, Margaret MacDonald, and Robin Spencer. *The Paintings of James McNeill Whistler.* 2 vols. New Haven and London, 1980.

McMullen, Roy. *Victorian Outsider: A Biography of J. A. M. Whistler.* New York, 1973.

Prideaux, Tom. *The World of Whistler.* New York, 1970.

Spalding, Francis. *Whistler,* London, 1979.

The Stamp of Whistler. Exhibition catalogue by R. H. Getscher. Oberlin College, Oberlin, Ohio, 1977–78.

Sutton, Denys. *James McNeill Whistler: Paintings, Etchings, Pastels and Watercolours.* London, 1966.

_____. *Nocturne: The Art of James McNeill Whistler.* London, 1963.

Index